shanghai odyssey

the grimstone foundation homer sykes dewi lewis publishing

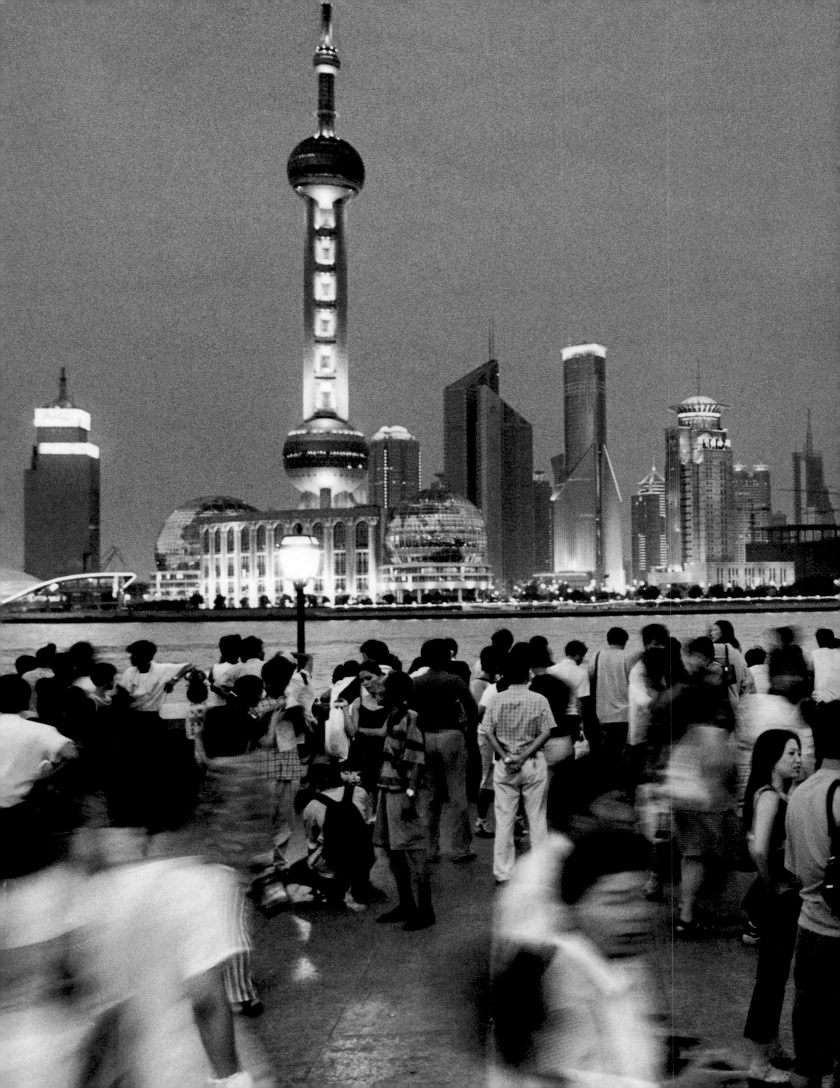

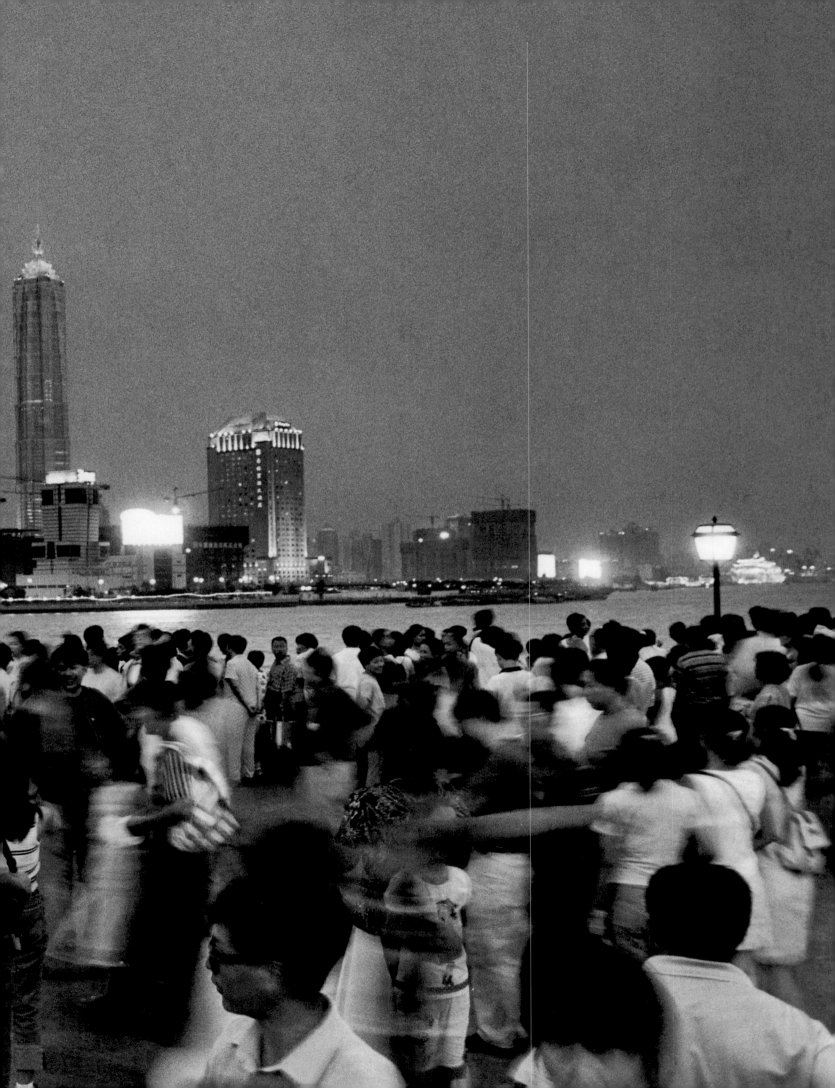

shang

hai
odyssey

上海

China is mysterious even to those who know her well, and Shanghai is China's most complicated city. The dialectics that exist there between old and new, between communism and capitalism, and between Sino and external influences could not have been anticipated by Marx and Engels as they overlook Fuxing Park from their granite pedestal, and they would no doubt have been perplexed by the contradictions and syntheses that have resulted. In the last 150 years Shanghai has passed through a wide variety of trials and tribulations. It has survived, and prospered, and is a great city.

The Grimstone Foundation has sponsored this book not only because of the artistic merit of Homer Sykes's photographs, but also as a contribution towards helping people understand one of the most successful and dynamic cities in the world. We wanted to show Shanghai as the ordinary Shanghainese live and experience it on a daily basis, not as seen through the distorted lens of the tour guide. Humour, romance, idiosyncrasy and energy all feature: the combinations may surprise.

Proceeds from this book will be used by the Foundation to assist its work in China and, in particular, to help young people from China realise their potential through educational and other support. If after reading this book you feel like visiting Shanghai, or it changes your perception of the city and its people, then it will have served its purpose.

GERRY GRIMSTONE
Chairman
The Grimstone Foundation

This book is dedicated to the people of Shanghai, to cultural understanding between nations, and to friendship between those of different nationalities and backgrounds.

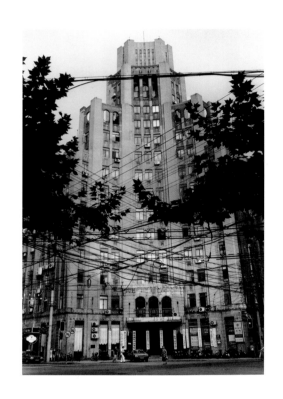

Fu Zhou Building, formerly Hamilton House

In 1946, in the euphoria that followed the ending of the Second World War, my mother and father met on board a ship sailing from Hong Kong to Shanghai. A journey of just five days, a journey that will last the rest of my life. They fell deeply in love.

My father, Homer Warwick Sykes, was working as an engineer for the China National Aviation Corporation in Shanghai. He was an American, born in Canada of English parentage. My mother, Helen Grimmitt, was travelling to a new job at the Canadian Consulate. She was Canadian, born and brought up in Hong Kong.

Just shortly before their wedding, she wrote to her four sisters: "I shall be a married woman. Mrs. Homer W. Sykes. I can't believe it as I sit here typing to you, I have to smile, I wonder what you will think? …he's a rough diamond – and I love him very very much, he is wonderful, at least I think so,…I haven't known him very long, but somehow I know I will love him always, and that he will want and love me forever – he's so wonderful. We are going to be married in the American Community Church – in Shanghai – it is not an R.C. church but one that takes in all and every religion…"

Later in the letter she describes to her sisters how her life has changed so entirely since leaving San Francisco. "It's hard to believe – life here in Shanghai in itself is fantastic, there is nothing to hold on to, no law, no order as we, of the western world know it – filth, noises and smells, and sounds unheard of, and certainly not tolerated in the occidental world, go unchecked twenty-four hours a day here…"

Further on she writes: "Its monetary system is wild – CNC$8,000 for a coke, lunches and dinners run anywhere from CNC$50,000 for a normal ordinary meal – prices change from day to day – the present black market rate is around 40,000 to 1 – the official exchange being $18,000 to one, the black market is wild and very dangerous – life here is precarious, one lives as though suspended from mid-air by a web and left to the mercy of tropical storms of which Shanghai has her full share – it's the breath of many a vagabond's existence – emotions soar from the highest peak to the lowest, all long for a new way of life but will guard the memory of life in Shanghai! I love it all."

They were married in Shanghai at the American Community Church in August 1947. Soon after their wedding they moved into a small set of rooms, a company apartment just north of the Bund, and threw themselves enthusiastically into the whirl of expatriate and consulate social life.

My mother became pregnant in April 1948. Two months later, in June, my father was tragically killed in an aviation accident at Lunghua Airfield. Devastated, my mother left for California on the SS President Wilson and returned to her parents' home in Vancouver, Canada, just before Christmas. I was born three weeks later, and named after my father.

When Gerry Grimstone asked me if I would be interested in working on a book about Shanghai, I naturally jumped at the idea. I was, after all, a product of that city. In May 2000, on my second night in Shanghai, I wandered down towards the Bund. It was dusk, and I began to think about where my parents might have lived over fifty years ago. I was walking along a busy street, which opened up into a small circle, and a cross roads. There were two tall twin Art Deco buildings, one on either side of the circle, and both had seen better days. One, The Metropole Hotel, was being restored. The other building looked faded, and down at heel.

I experienced a very strange feeling, something that I have never felt before, and I was overcome with a knowledge within myself that this was where my parents had lived. I looked inside the Metropole Hotel and wondered if they had ever had a drink in the bar.

I didn't mention this incident, these strange inner feelings, to anyone, but on my return to London I started to look through my mother's papers that I had kept in a trunk in the garage. I had had no real reason to look carefully through these files before. Amongst them, I found their address: 425 Hamilton House. I emailed Gerry, who was in Shanghai, and told him that my parents had lived at a place called Hamilton House, and that was all I knew. He checked a reference book, and Hamilton House was listed. It was now called the Fu Zhou Building at 170 Jiang Xi Lu.

On my next visit, I was determined to find it. With two students to act as interpreters, I jumped in a cab and we took off, weaving through a mass of traffic and maze of streets until we were eventually dropped off in Jiang Xi Lu. It is a very long street with no clear numbering system. We wandered along, never quite sure if we were going in the right direction. Suddenly, without realising it, I found myself in the circle where I had been at dusk on my previous trip. The twin Art Deco buildings were instantly recognisable. I called out that I was sure that this building was Hamilton House. It just had to be.

We made enquiries at the porter's desk. The old lady there thought it might have been. I was extremely excited. We asked if we could go inside to try and find number 425, explaining that my parents had lived there over 50 years ago, and I wanted to see their apartment. The liftman took us up to the fourth floor. What were once wide handsome paneled corridors were now dark and dingy. Naked low voltage bulbs threw light on dirty wash-stands and primitive cooking facilities. Cupboards filled and spilled out into the corridor. Drying laundry hung from nails knocked into the cobwebbed walls.

Eventually we found number 425, and knocked. The door opened, and through a grill we explained my presence. Could I come in and have a look, perhaps take some photographs? Reluctantly they agreed, a toddler on a bike greeted me. The apartment was neat. A large square space divided into five, a small kitchen, and a dining room. Off the dining room, was a large bathroom with a huge bathtub – the walls still clad with the original small square black-and-white ceramic tiles. The sitting room housed a small table and two arm chairs. Off that, the bedroom was dominated by a large, heavy, wooden dresser, and a huge double bed; the room in which I suspect I was conceived.

As we left, I asked if there was anyone still living there who remembered the building when it was Hamilton House. Several old ladies in the corridor shrugged their shoulders before one said that perhaps the old man at the top of the building might have been there then.

The liftman took us up to the highest floor accessible by lift, and pointed us in the right direction. From there, we walked up two floors and found a very small two-room apartment. A middle aged woman and her husband were in, and obviously just back from work. "Yes, the old man still lives here," she said. She was his daughter, and showed us into his room.

He lay there on his deathbed, eighty-nine years old. Xu Hou Shen had worked as one of the maintenance men in Hamilton House from the age of seventeen. In those days, he said, only very rich Chinese and foreigners lived in Hamilton House. When it was explained to him why I was there, he broke down in tears, weeping inconsolably. "The memory of the 'good old days' are too much for him," explained his daughter. I had tears in my eyes too.

I framed the scene in my viewfinder and focused my camera.

HOMER SYKES

These photographs are dedicated to the memory of my parents: Homer whom I never knew, and my mother Helen. To the spirit of adventure, freedom, romance and love.

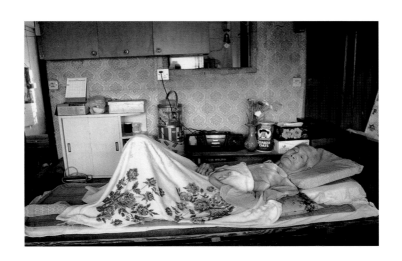

Mr Xu Hou Shen at home in Fu Zhou Building

shanghai
odyssey

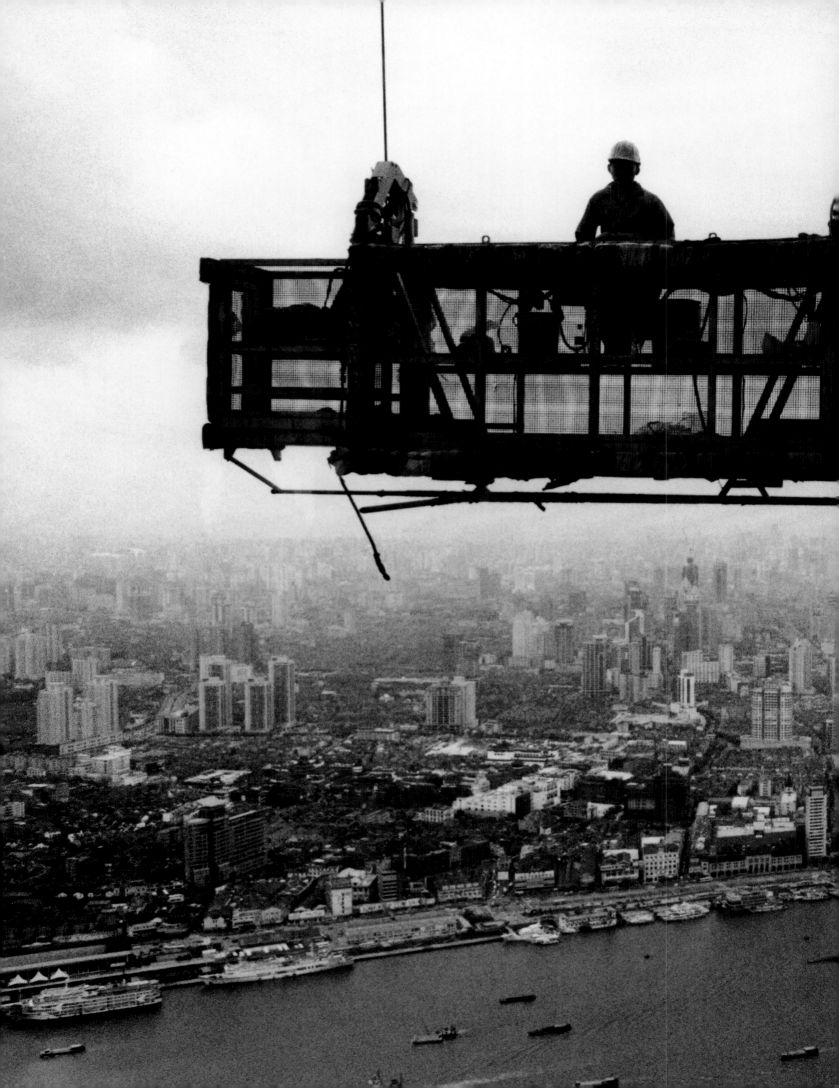

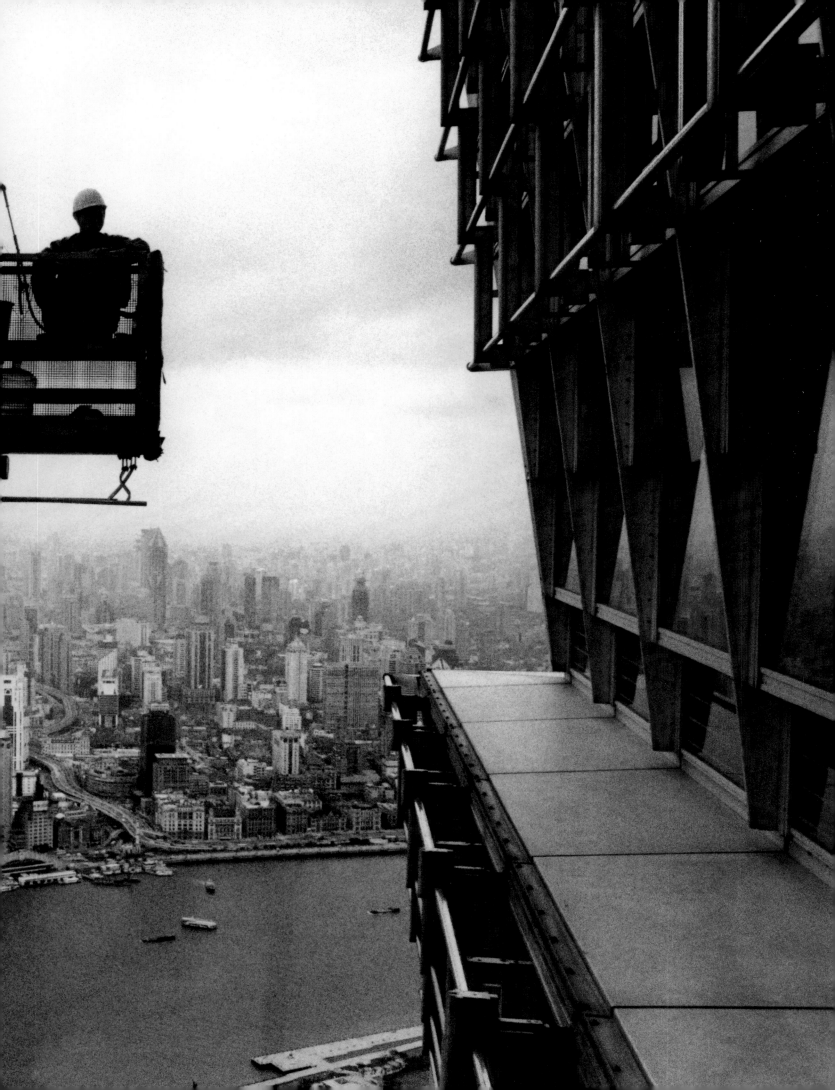

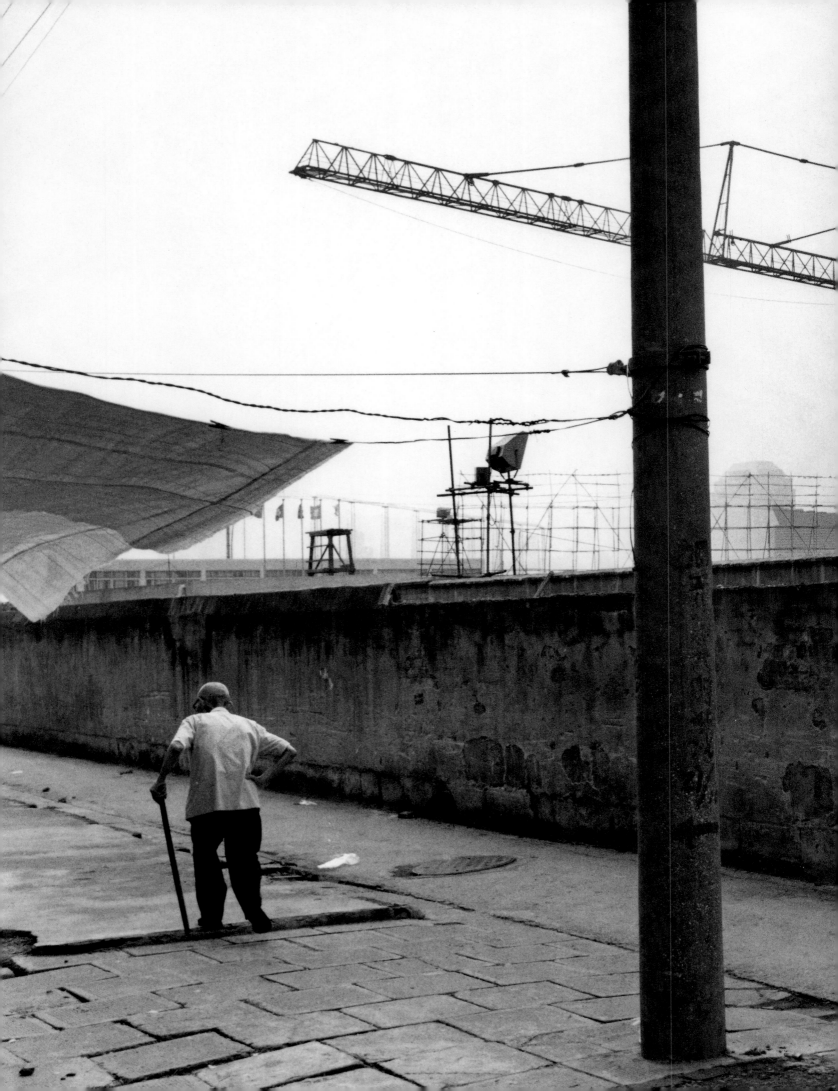

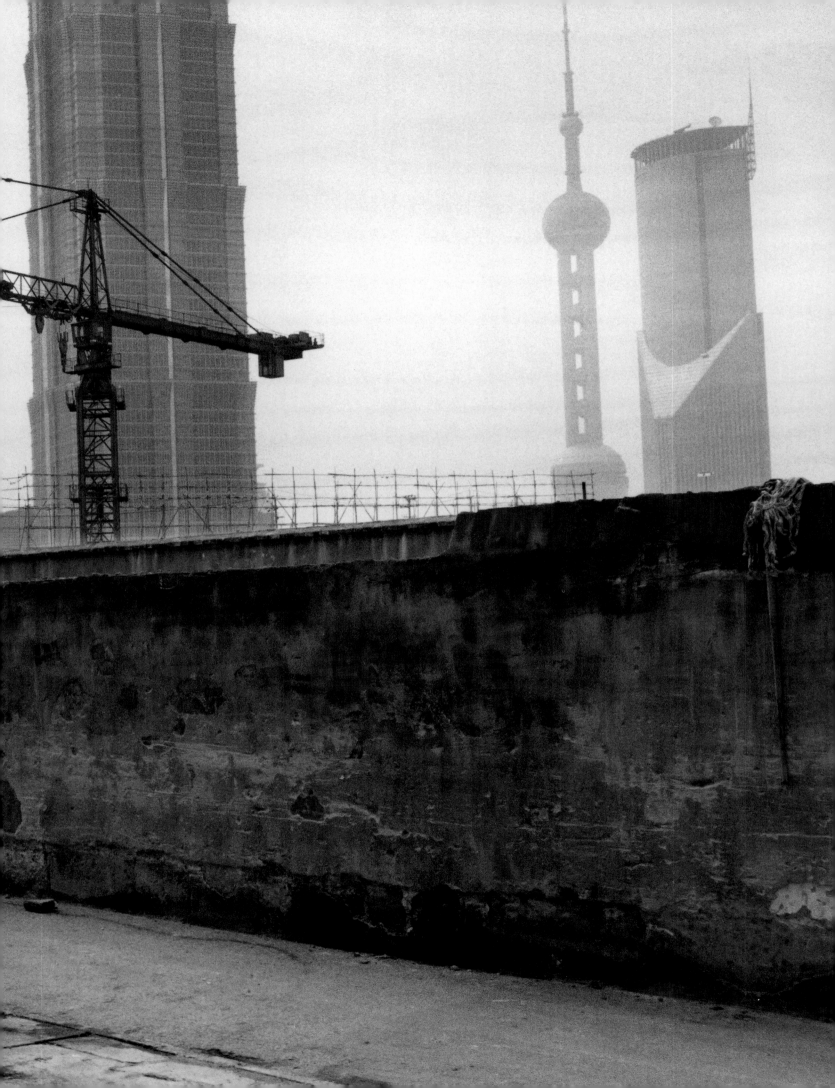

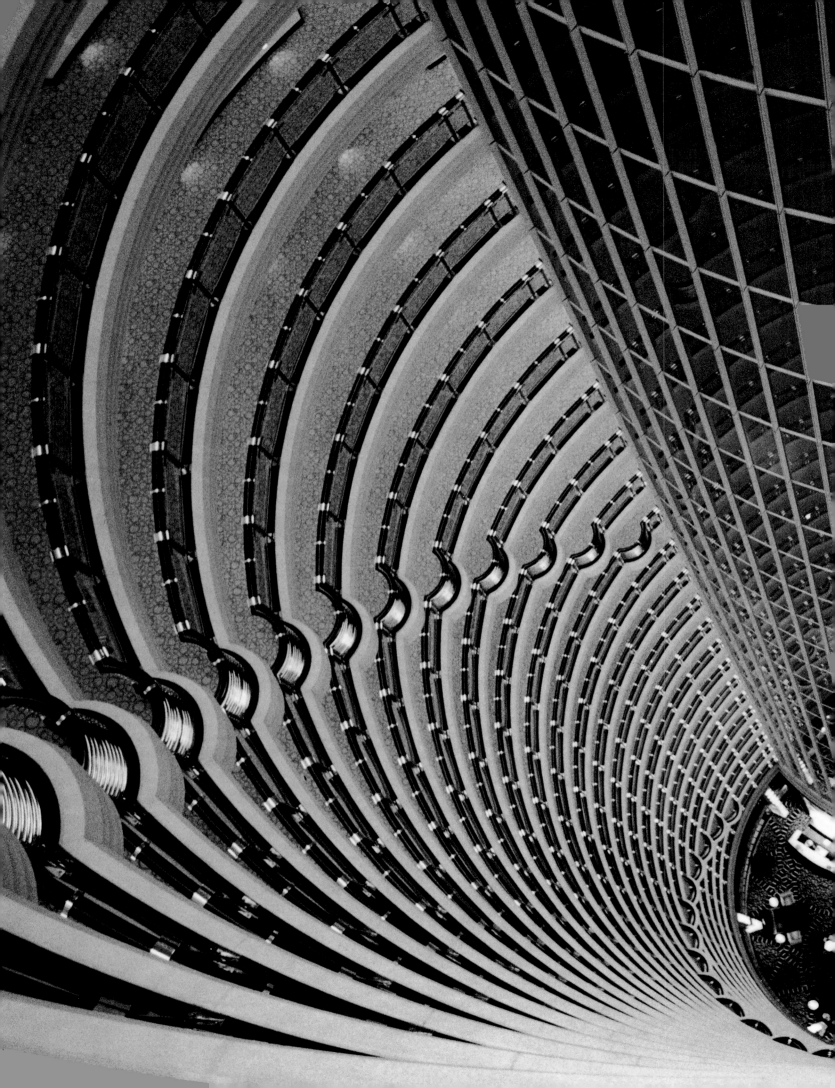

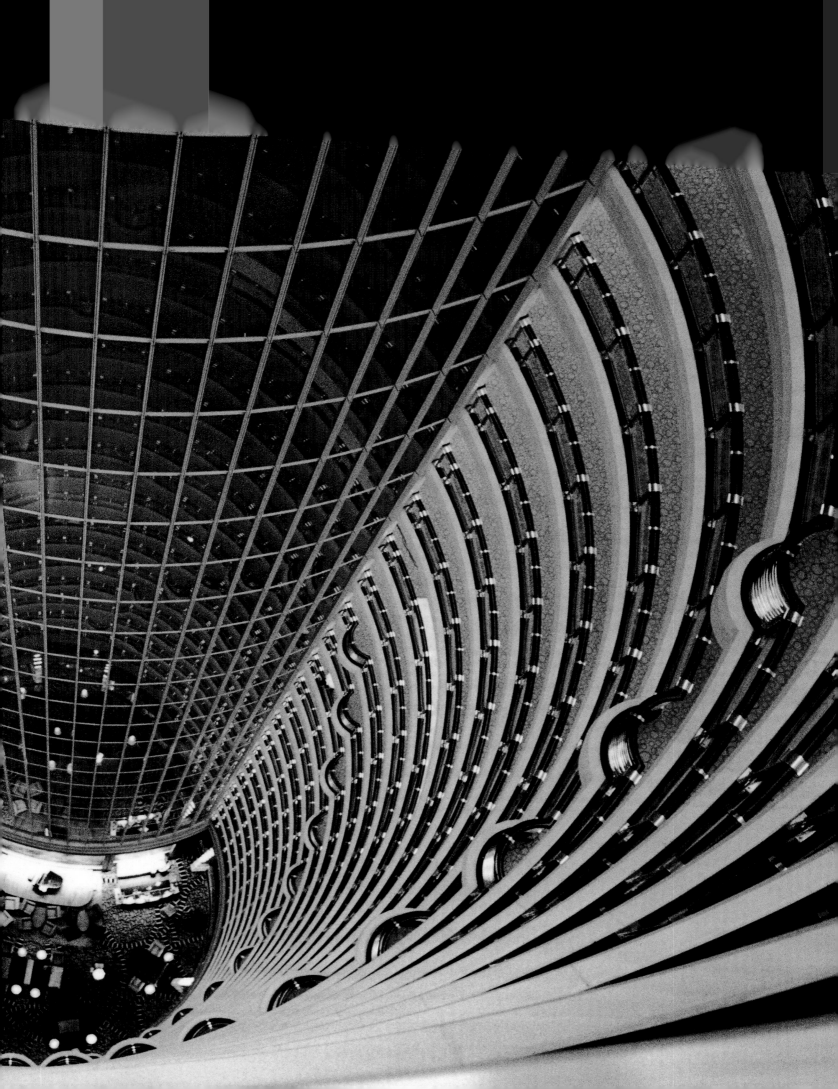

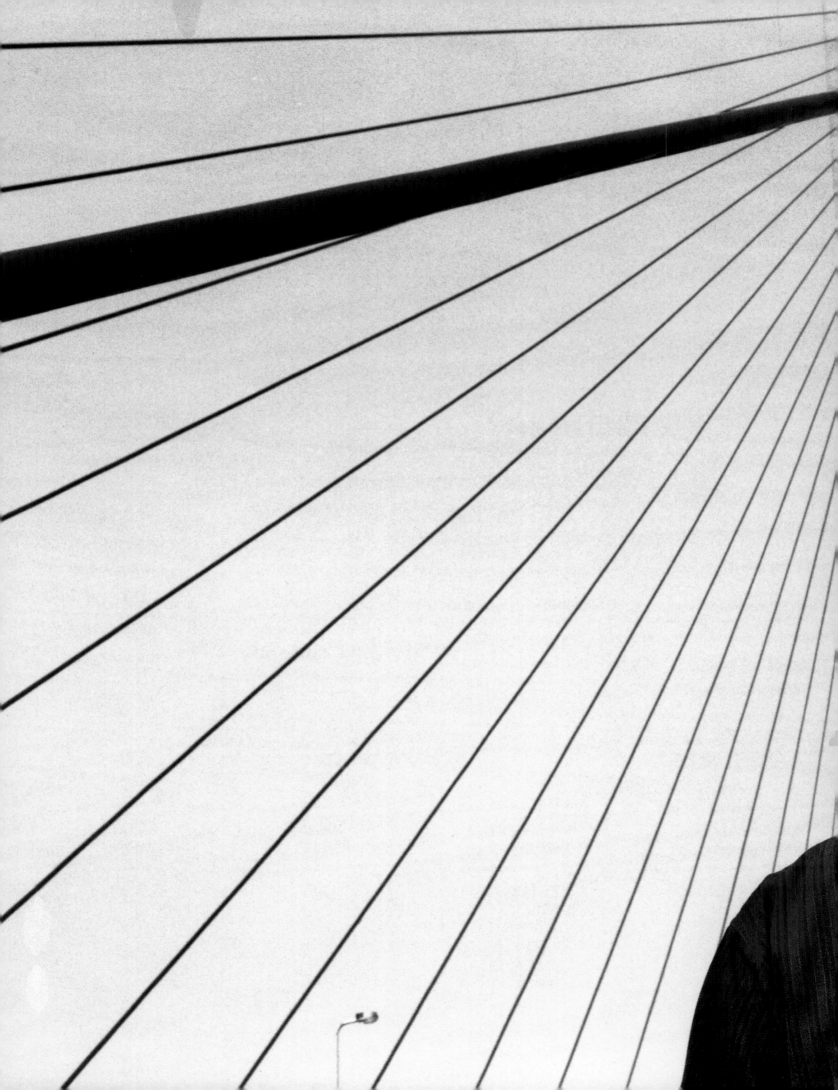

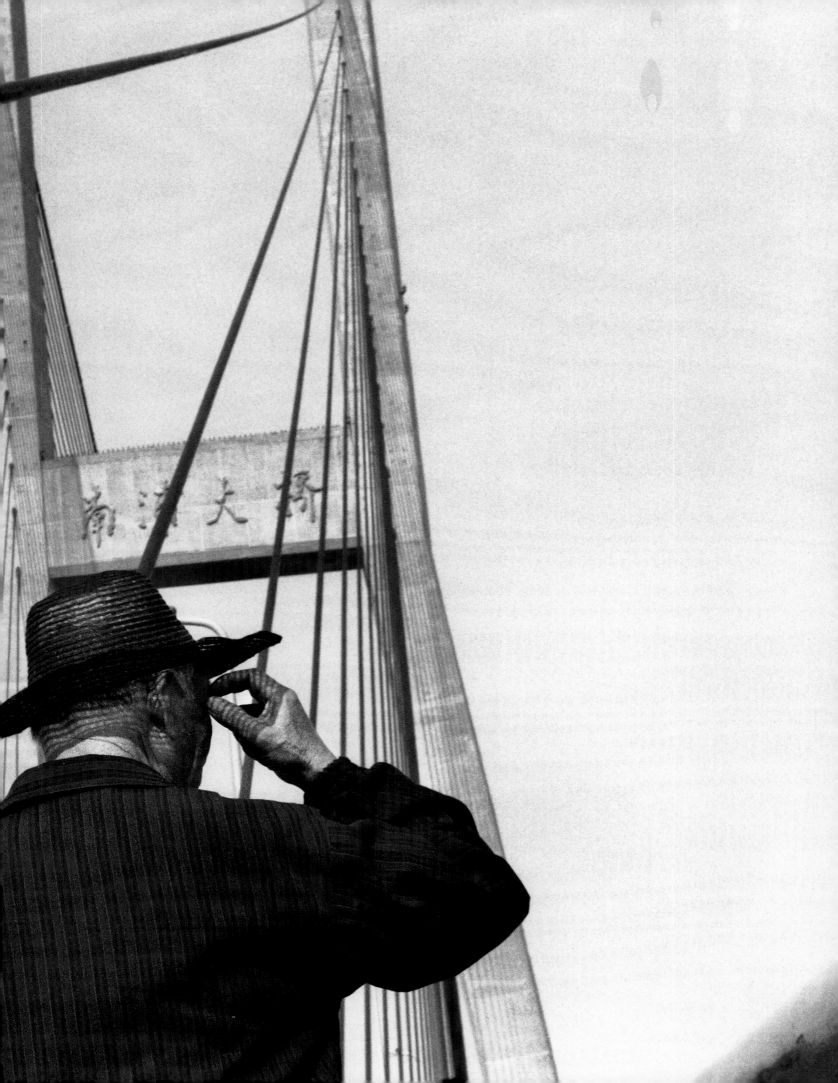

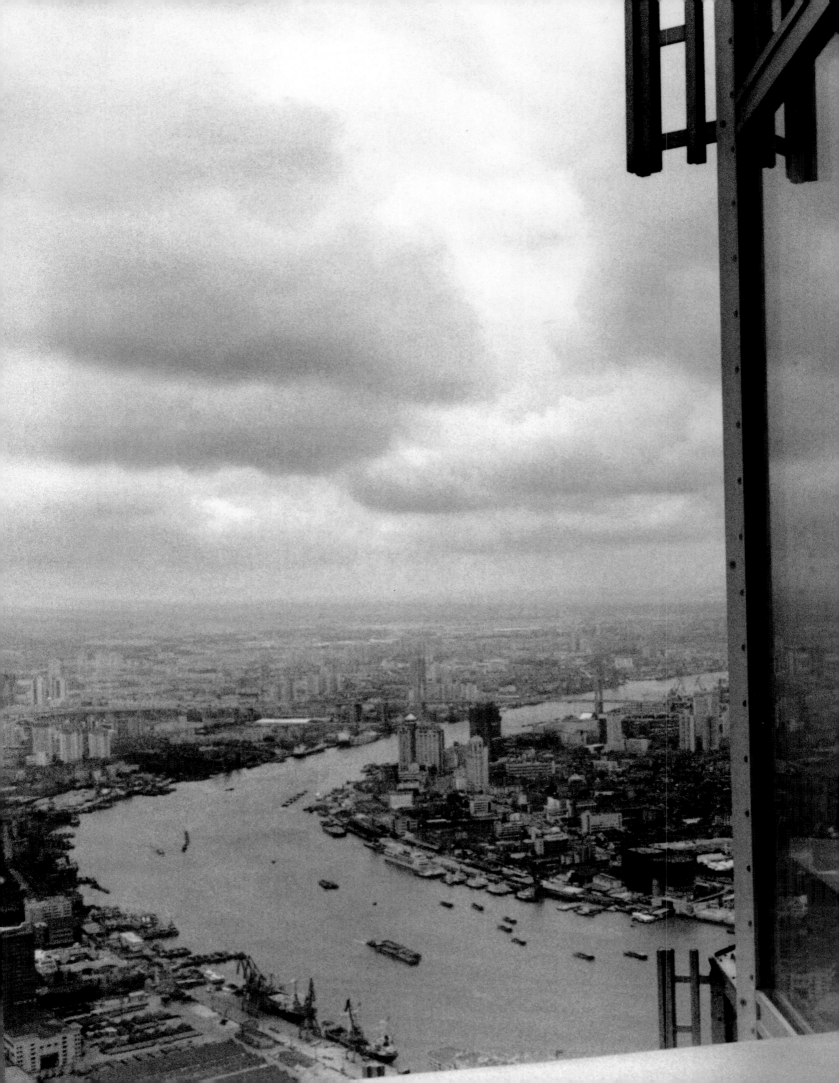

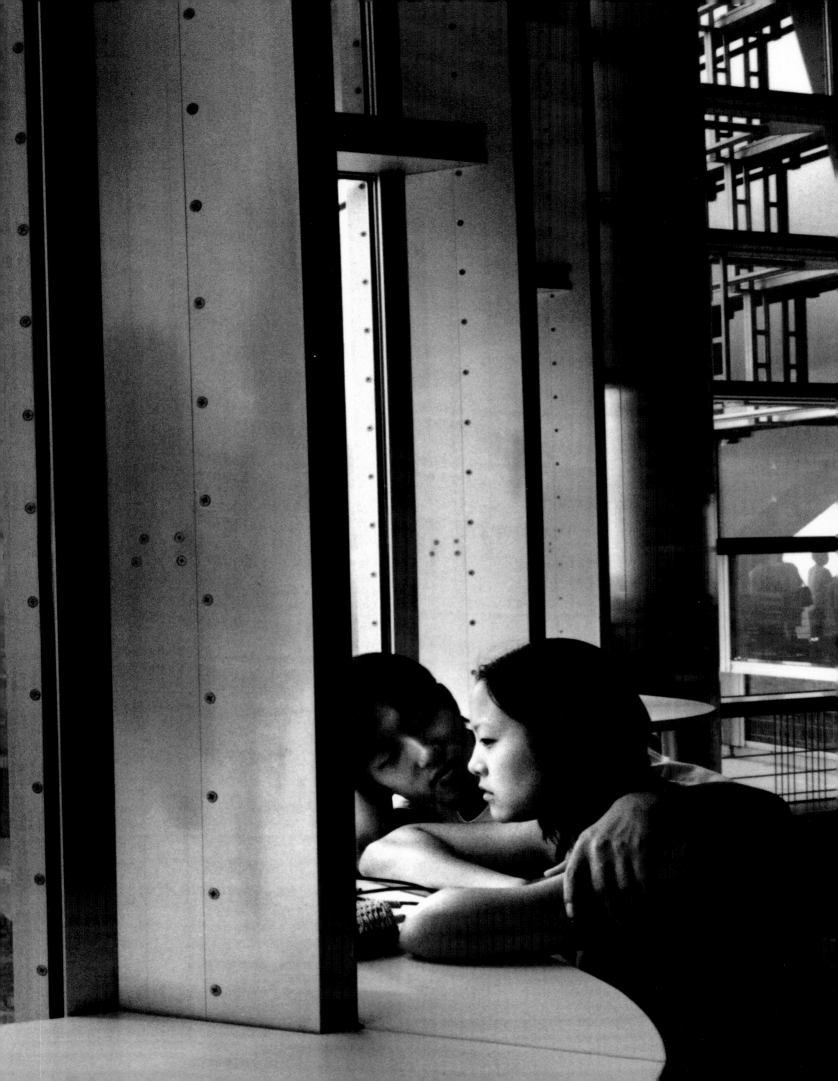

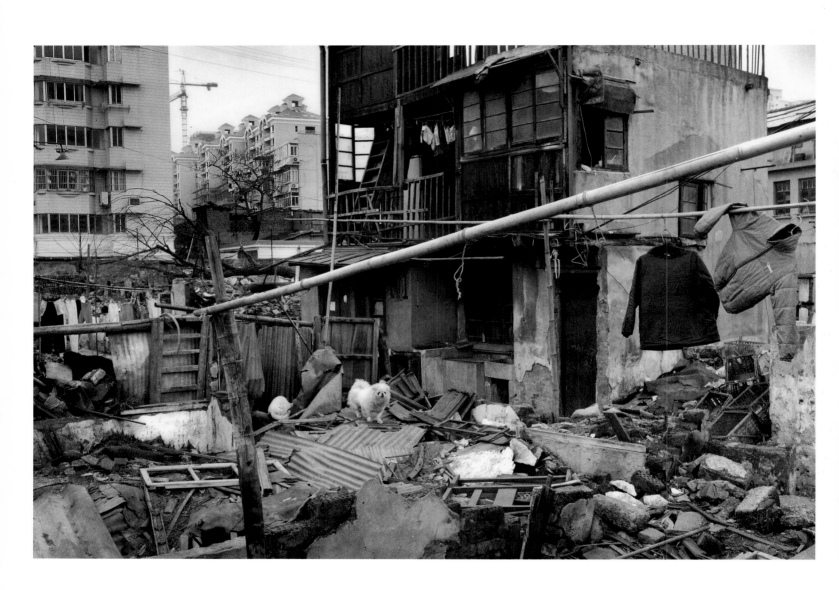

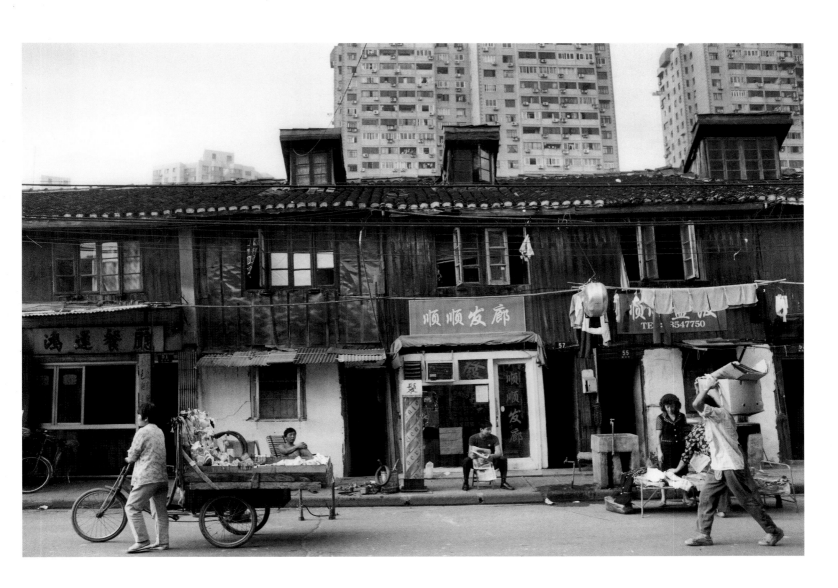

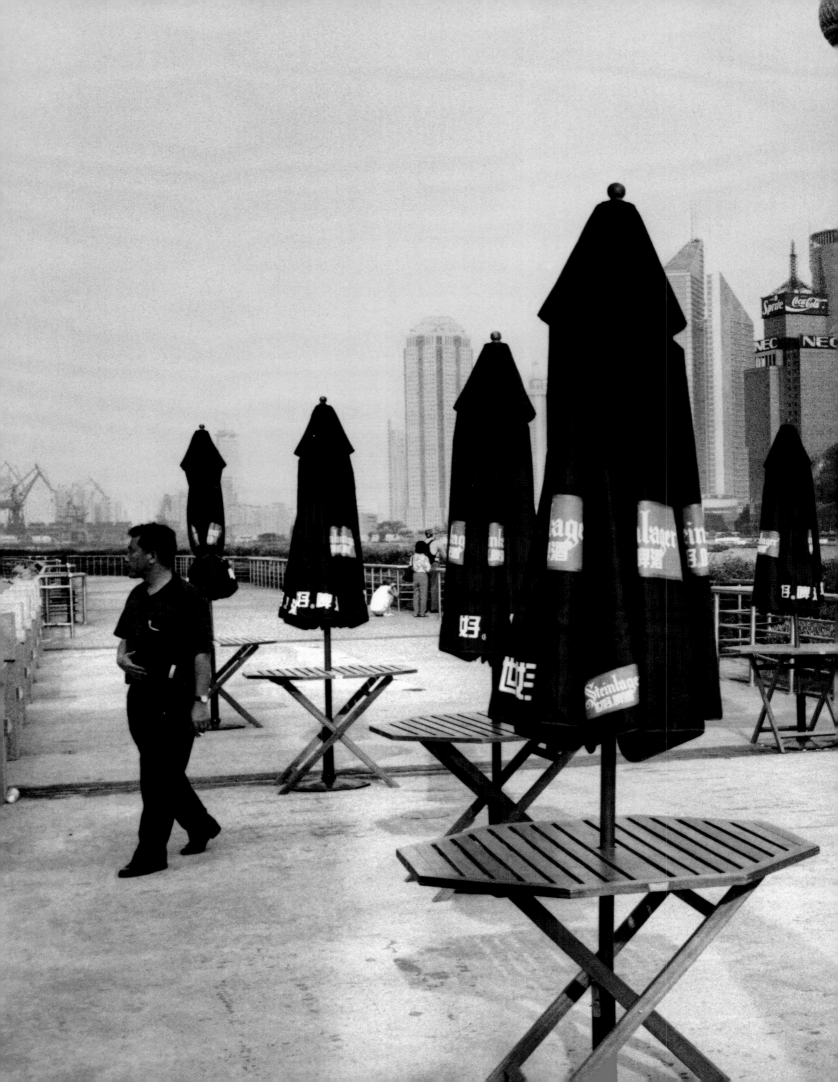

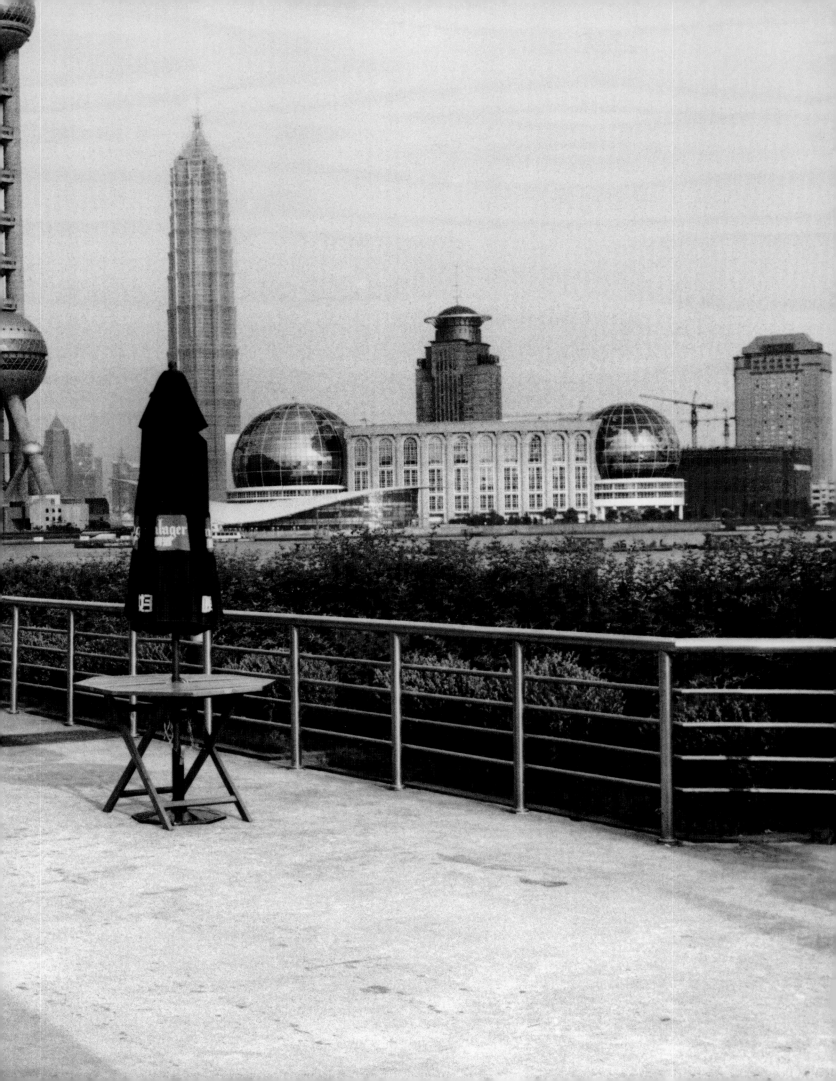

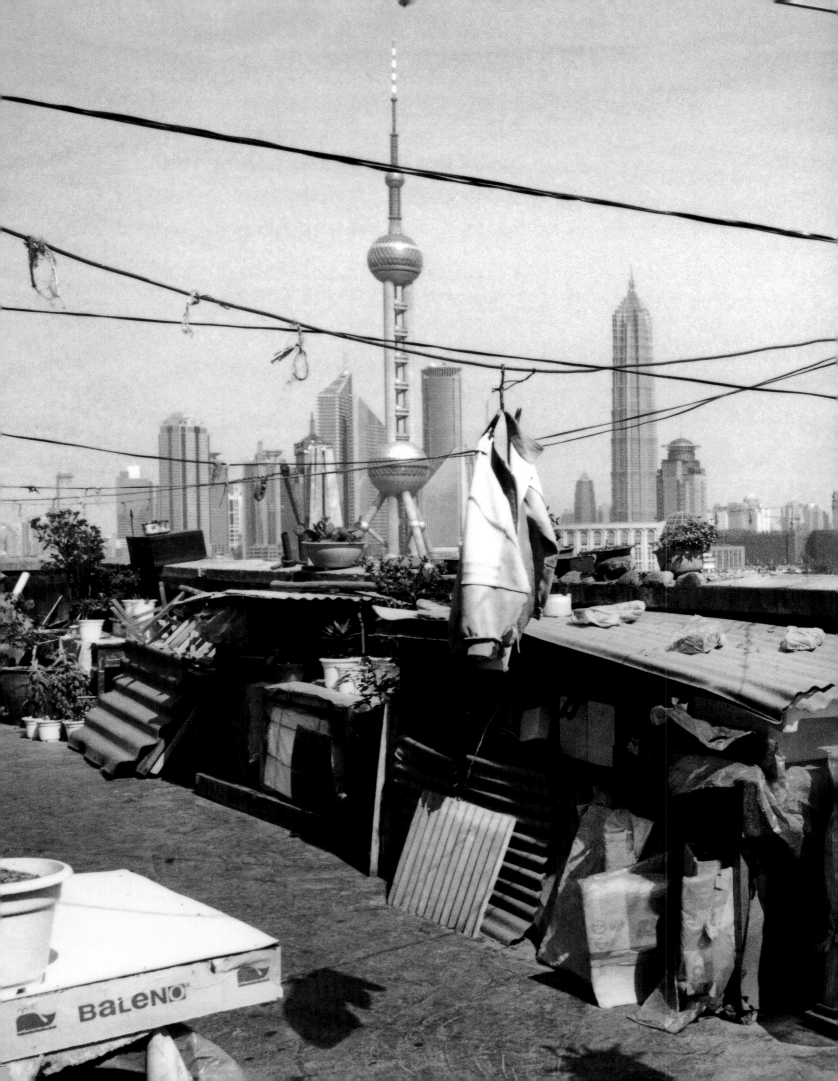

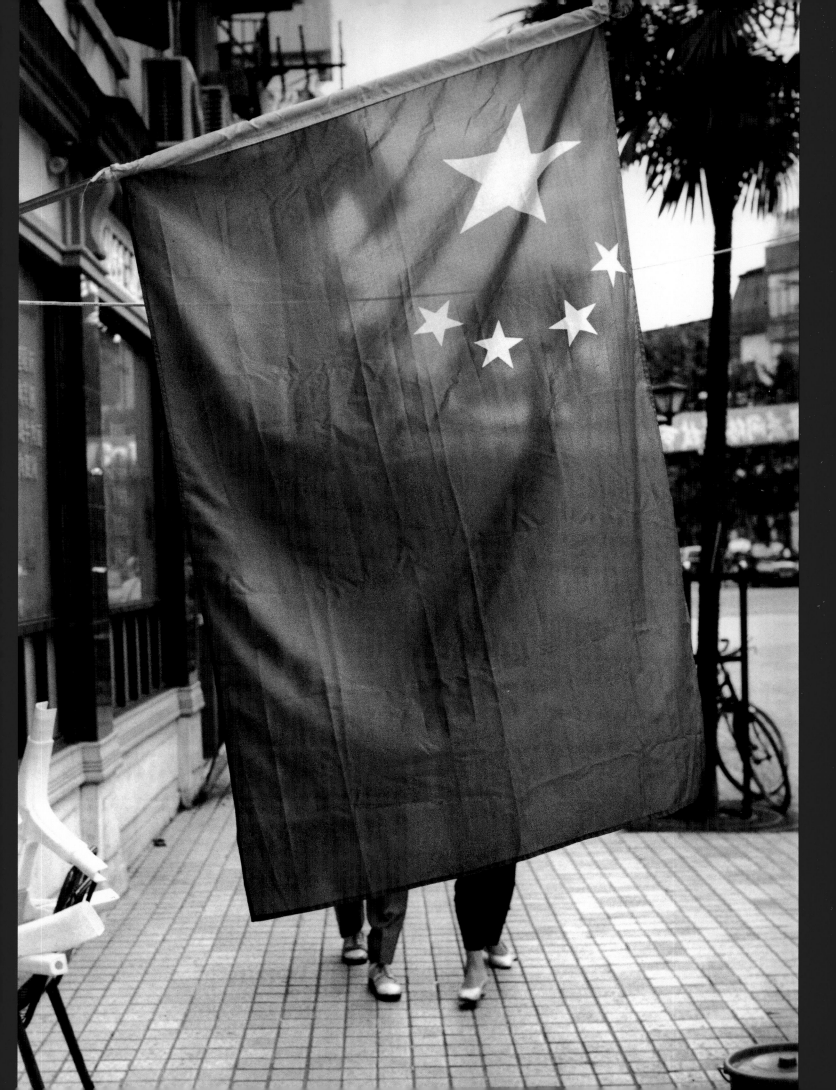

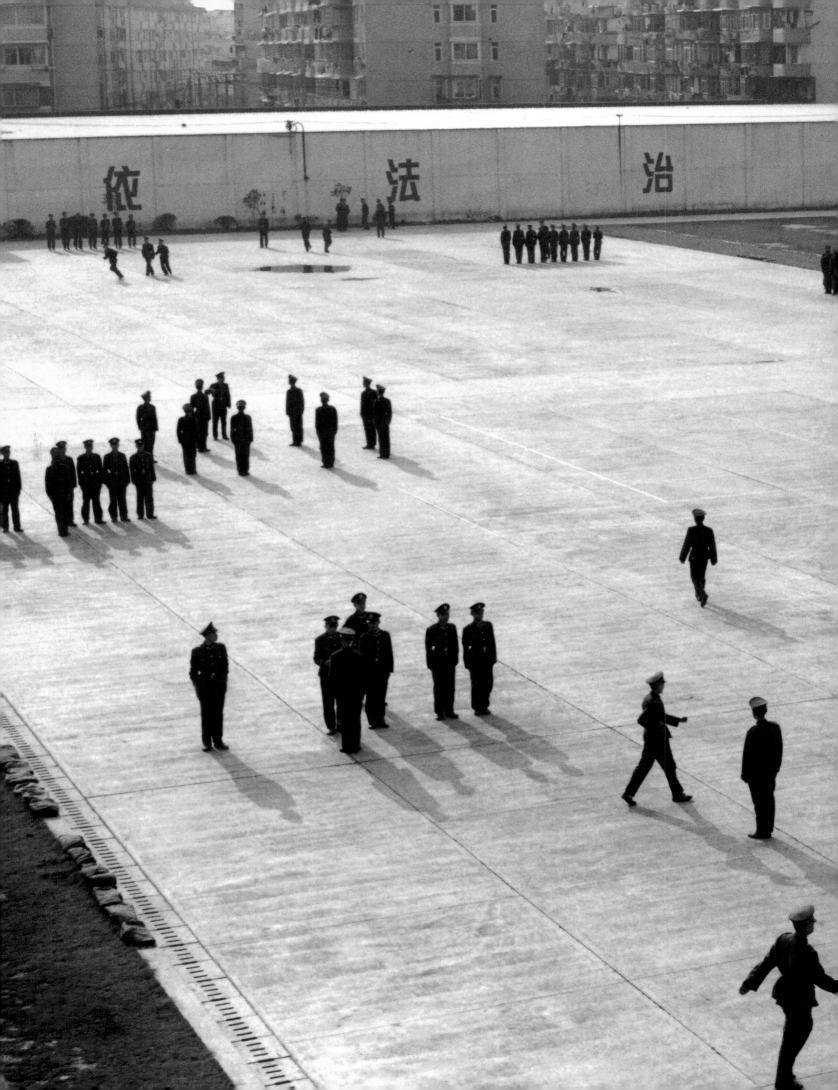

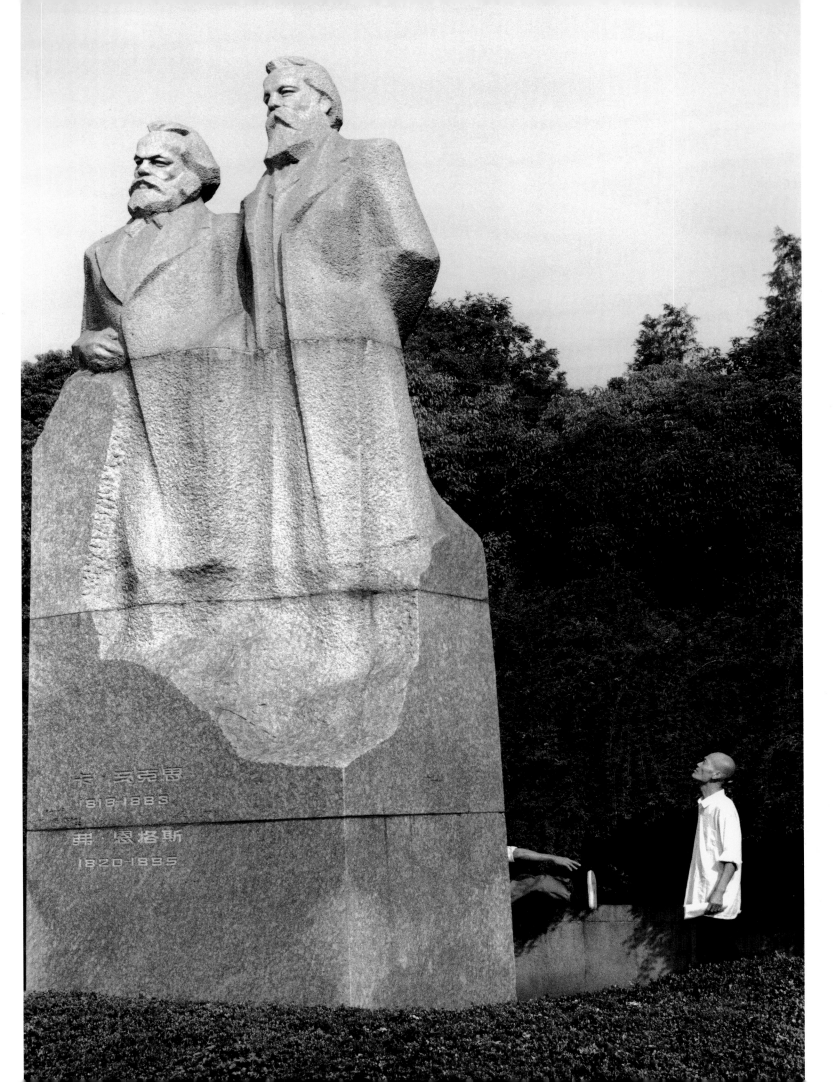

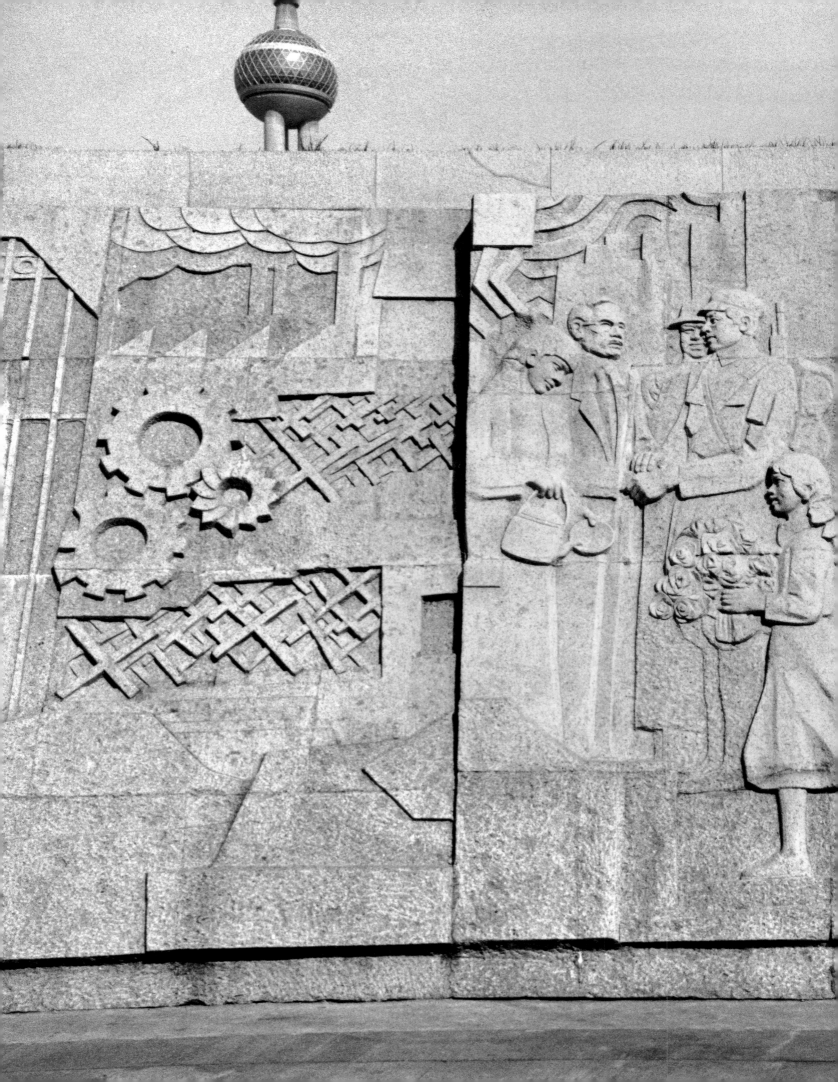

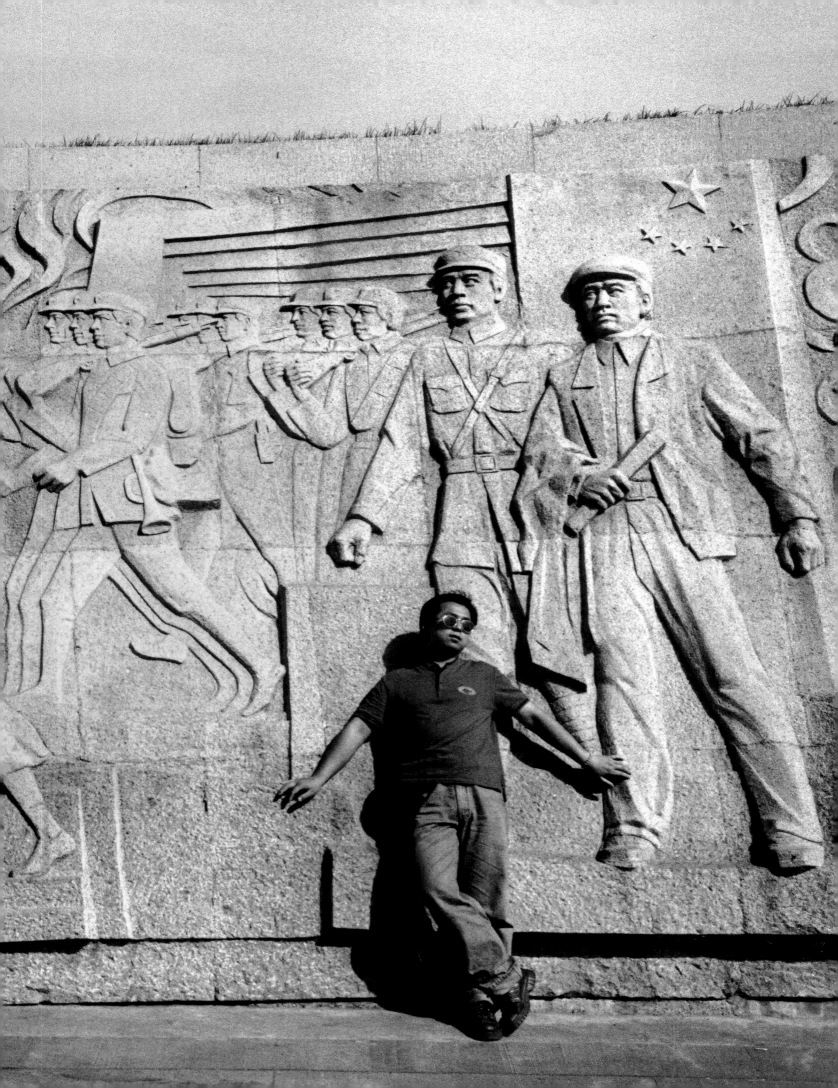

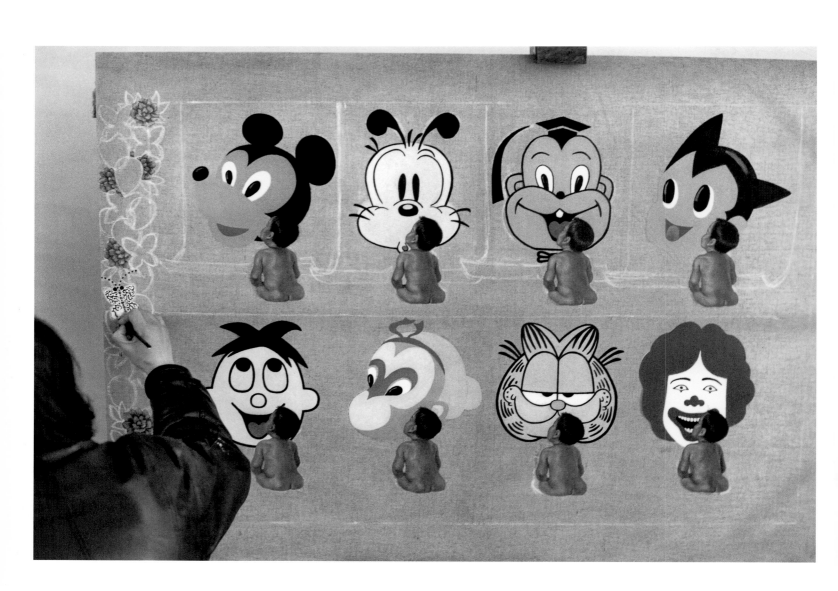

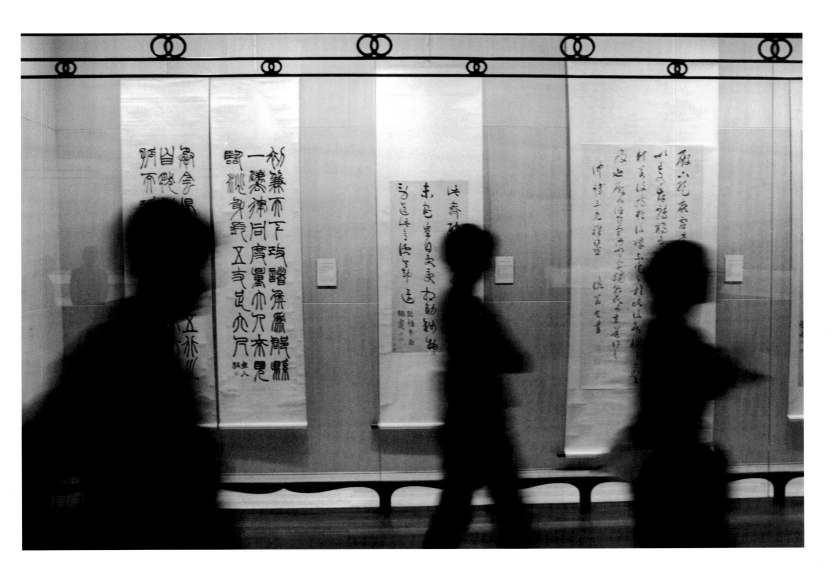

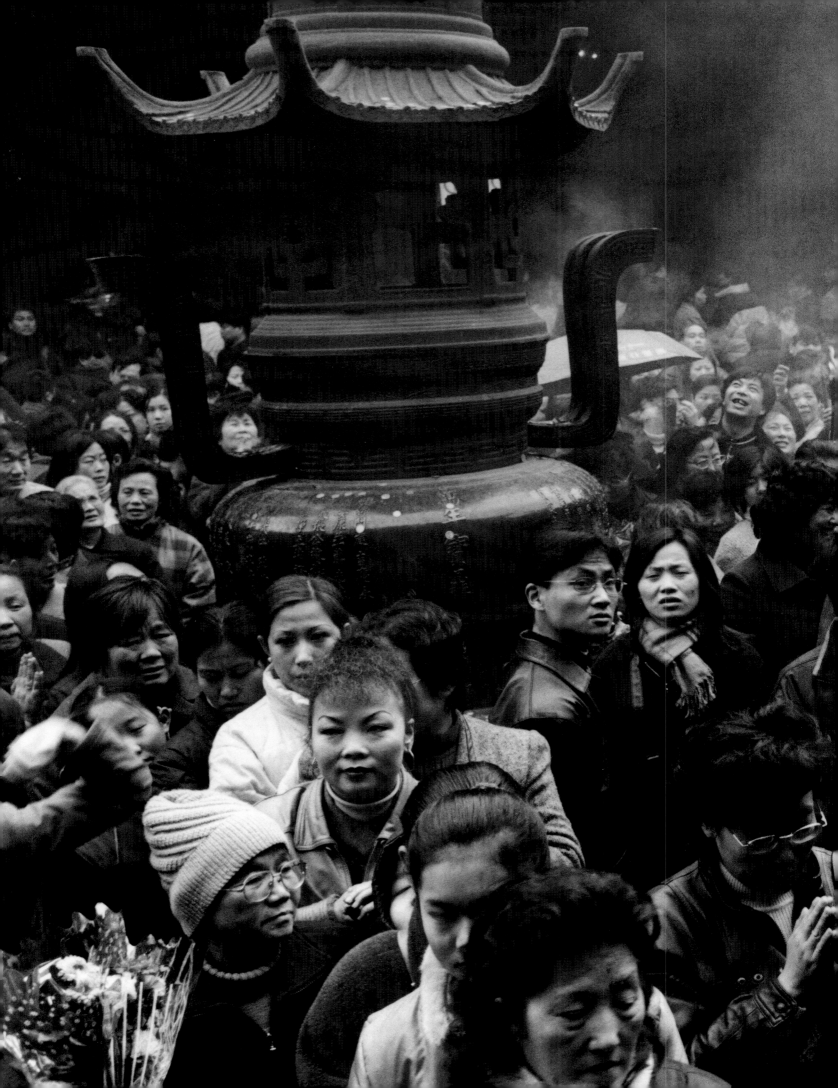

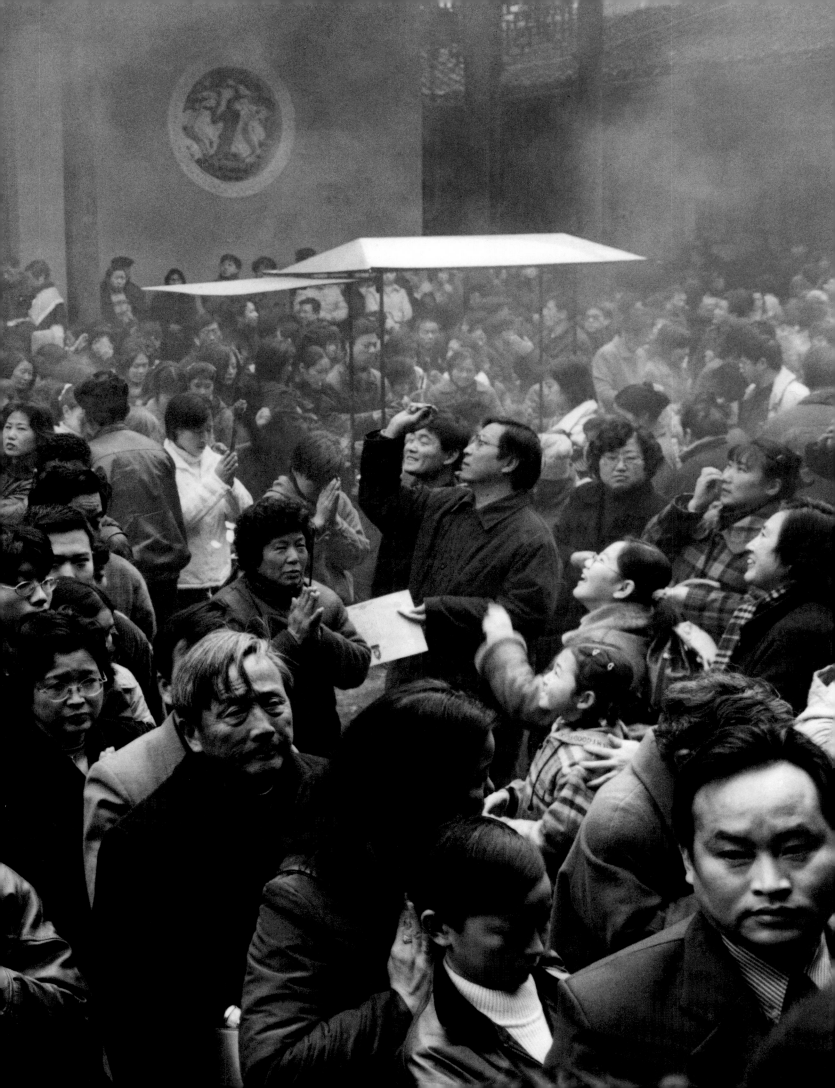

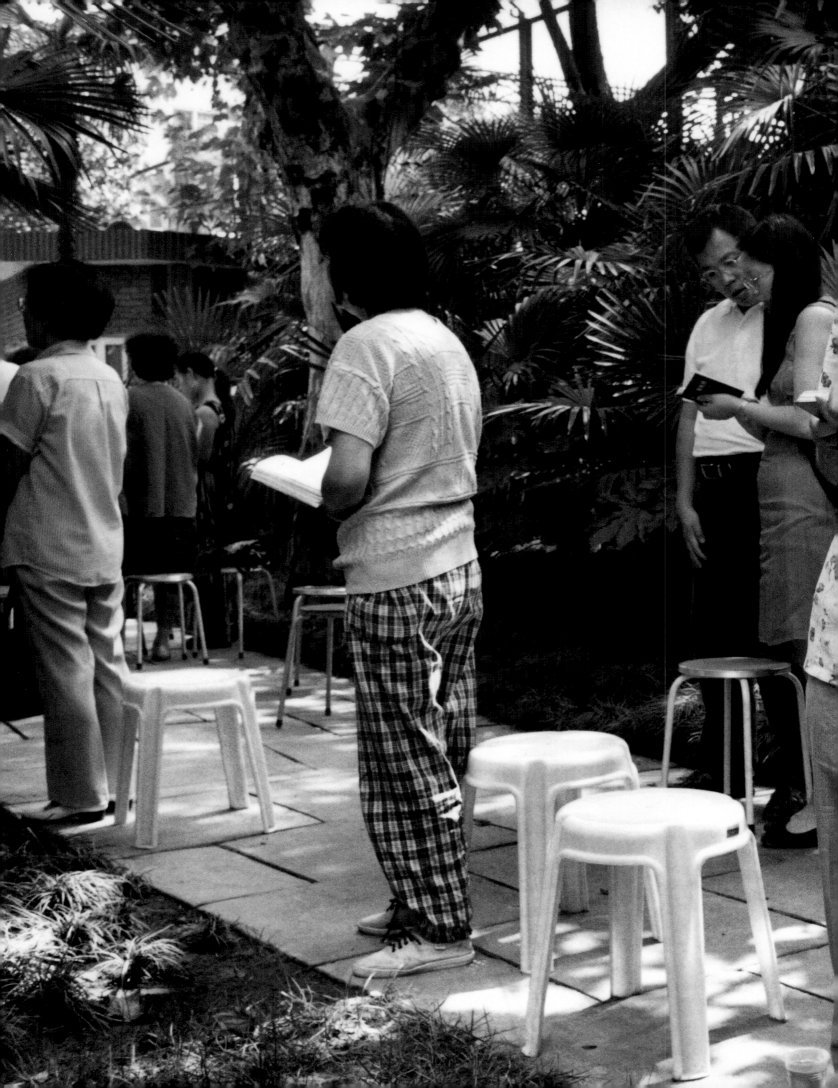

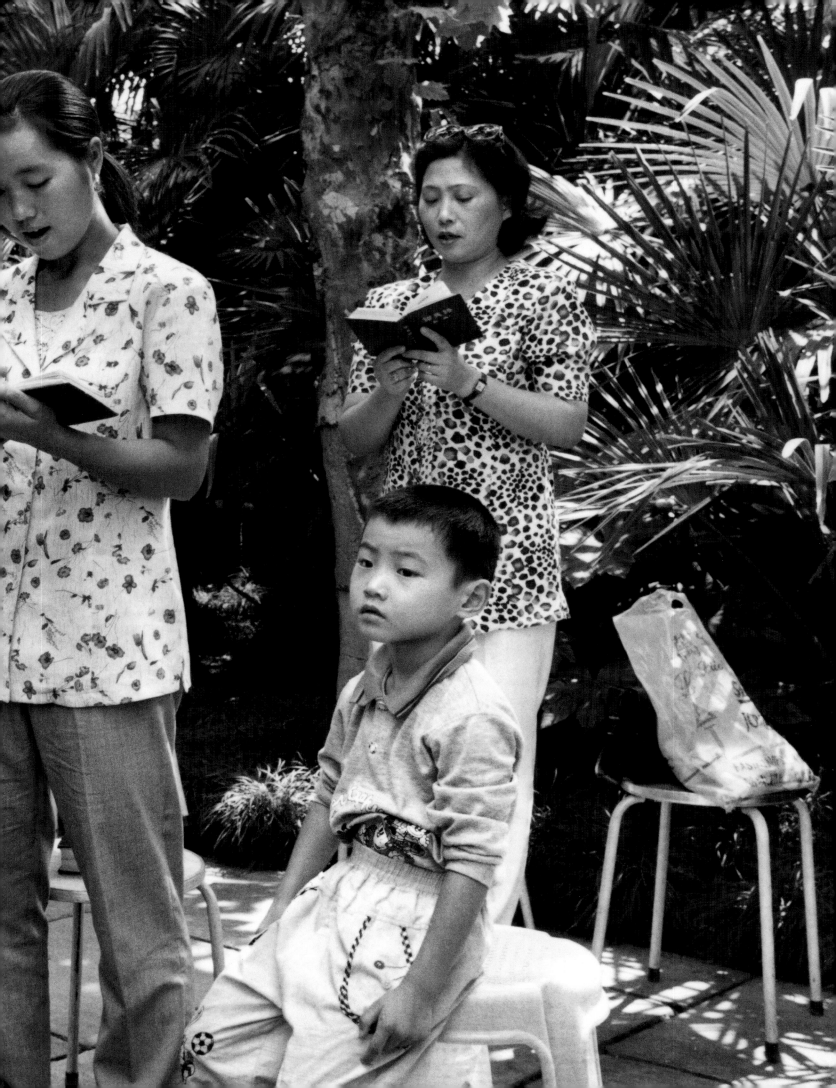

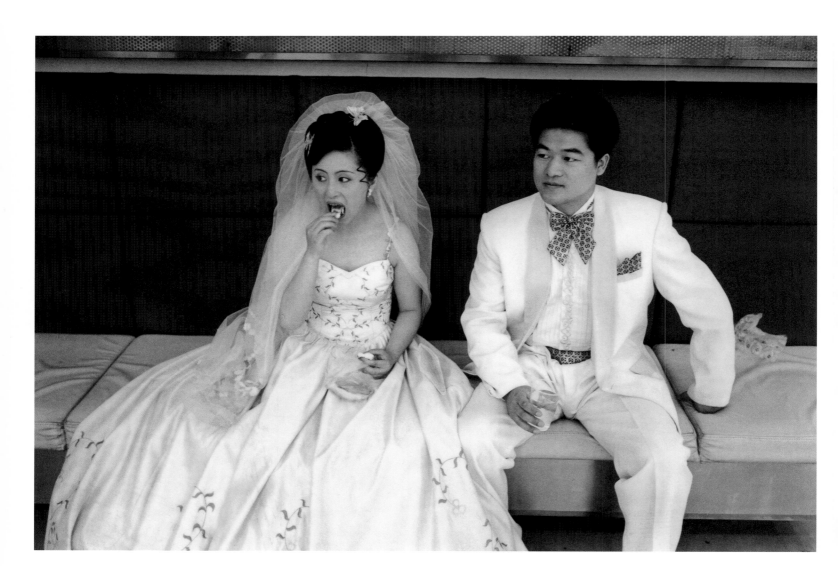

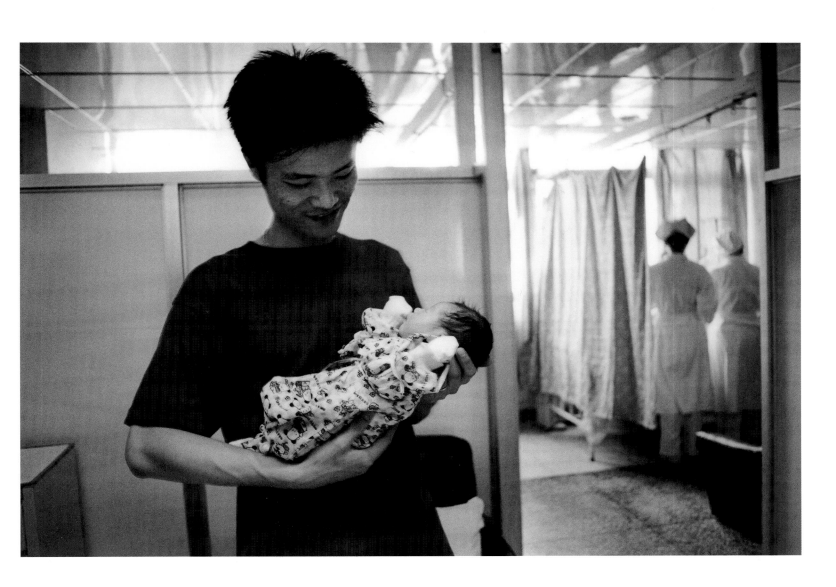

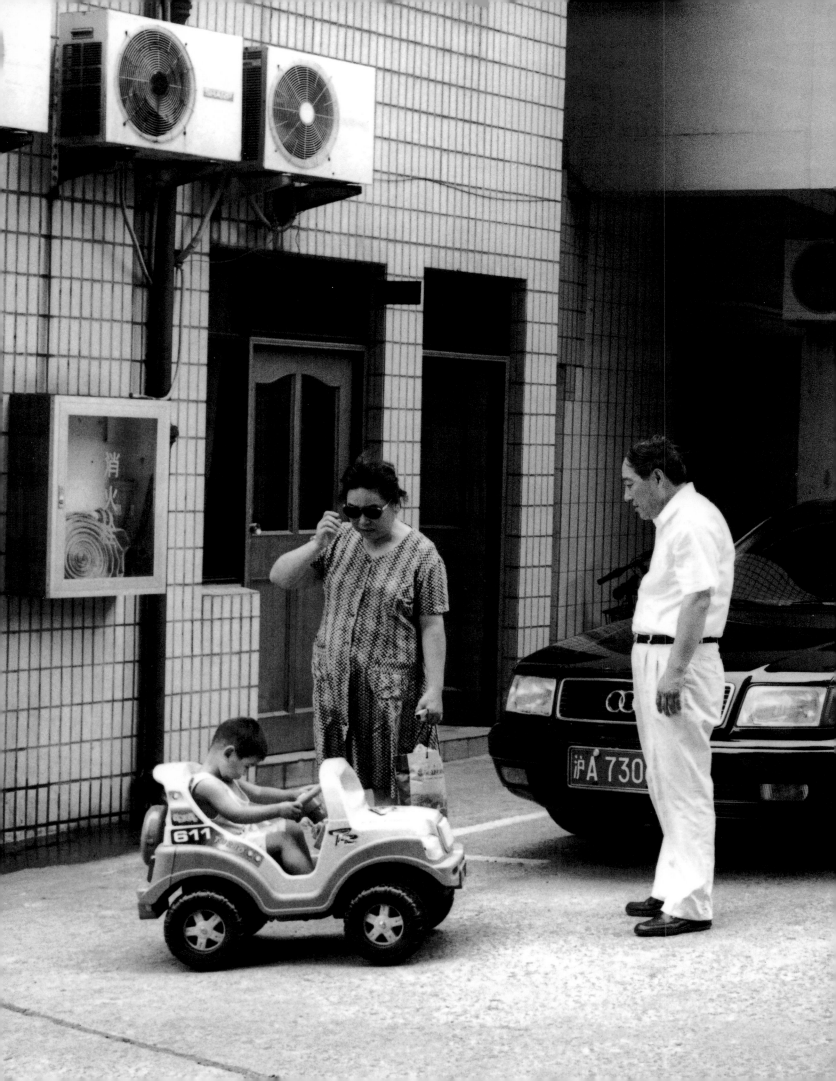

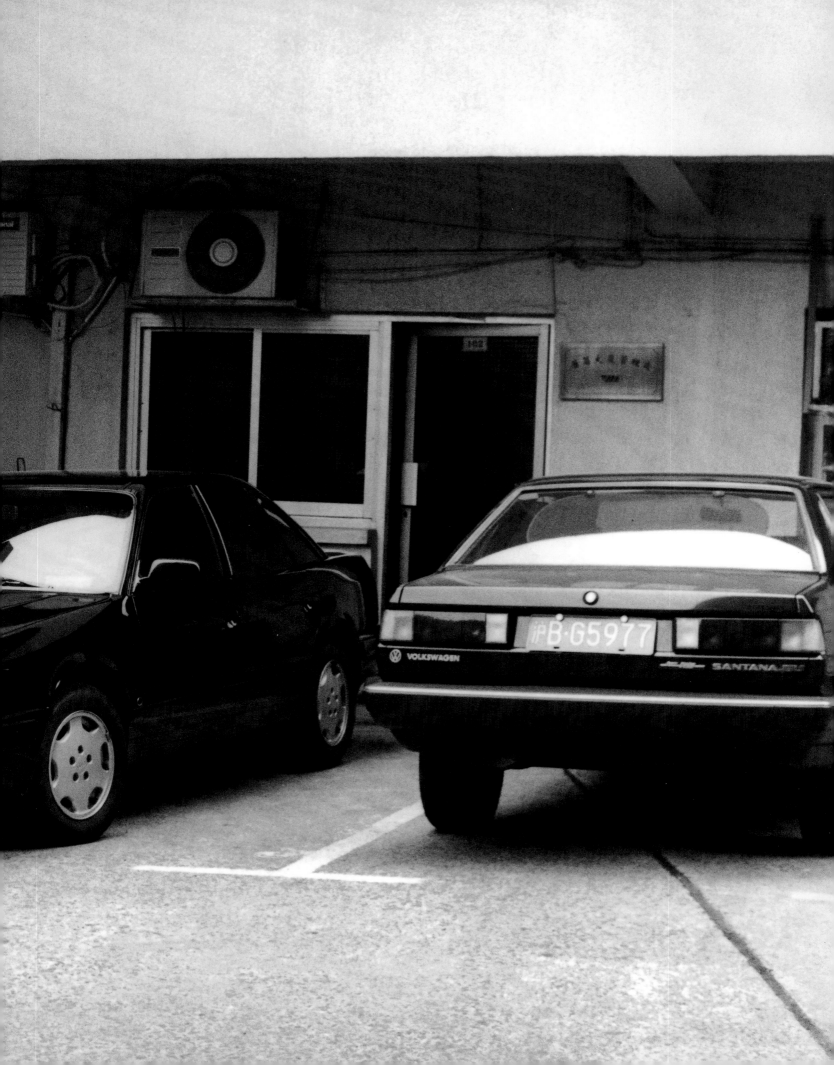

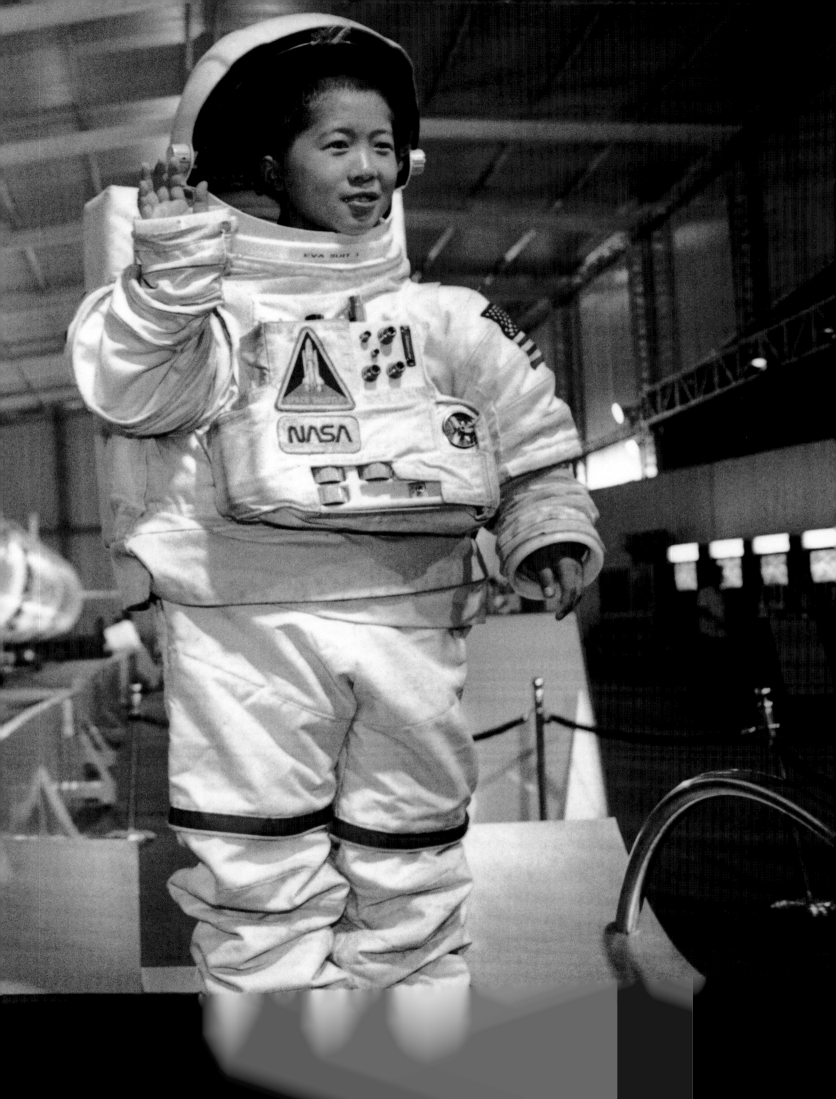

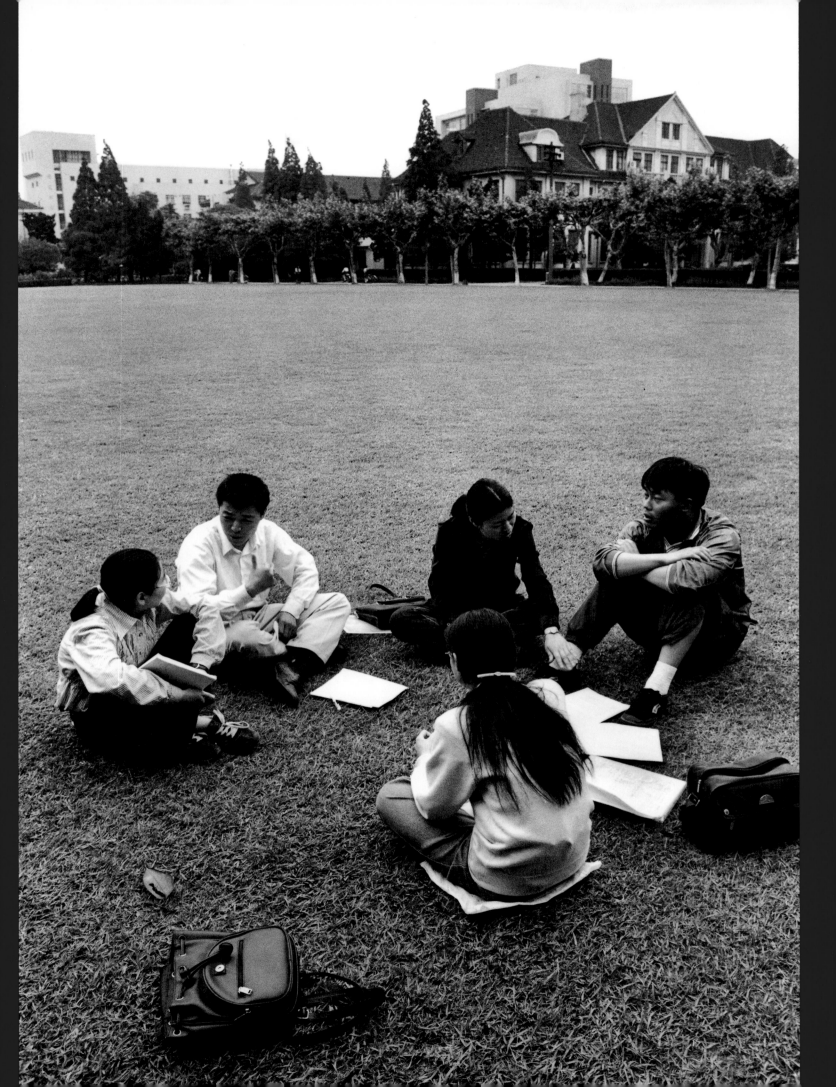

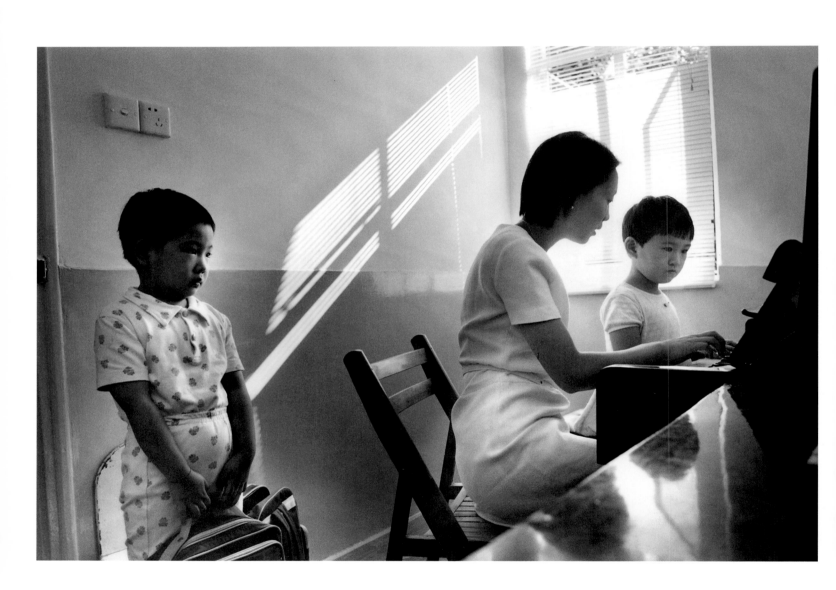

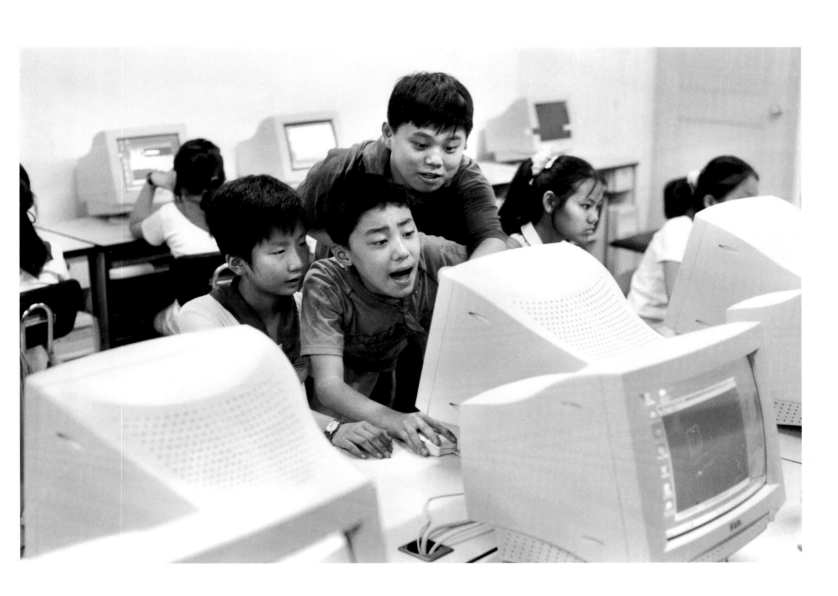

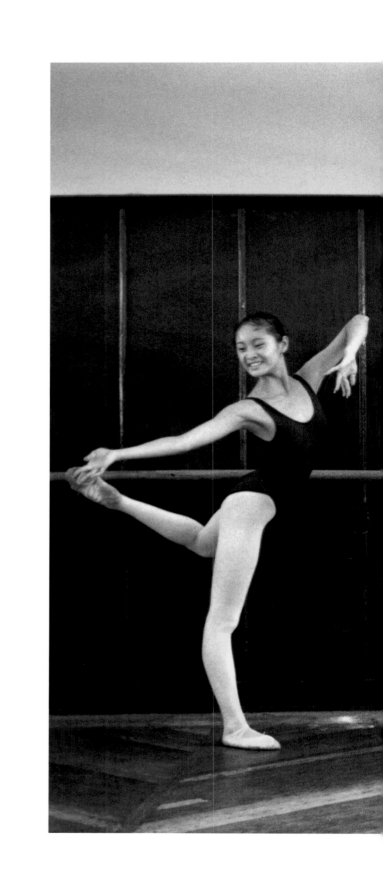

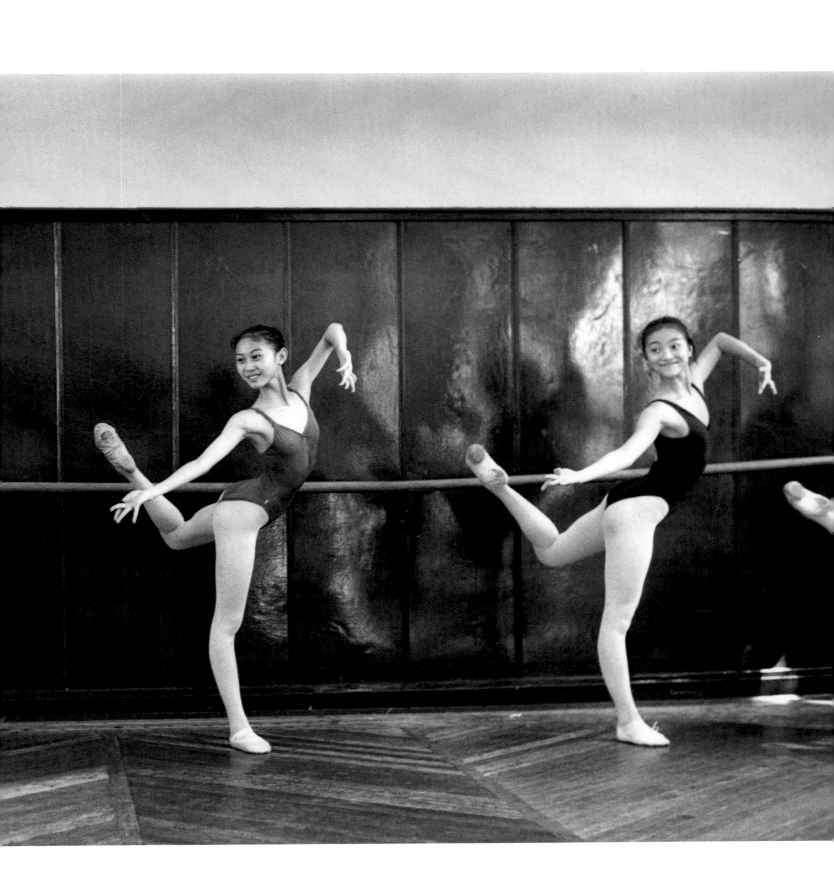

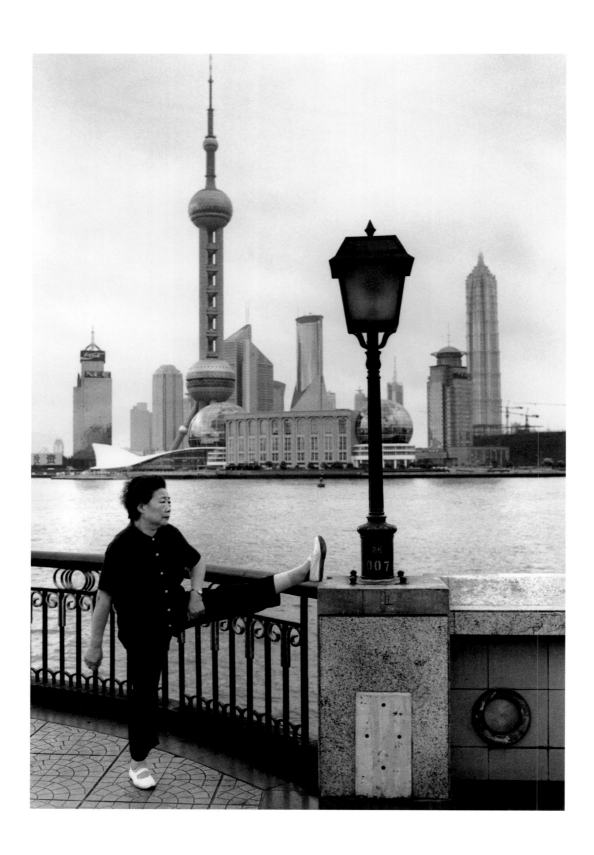

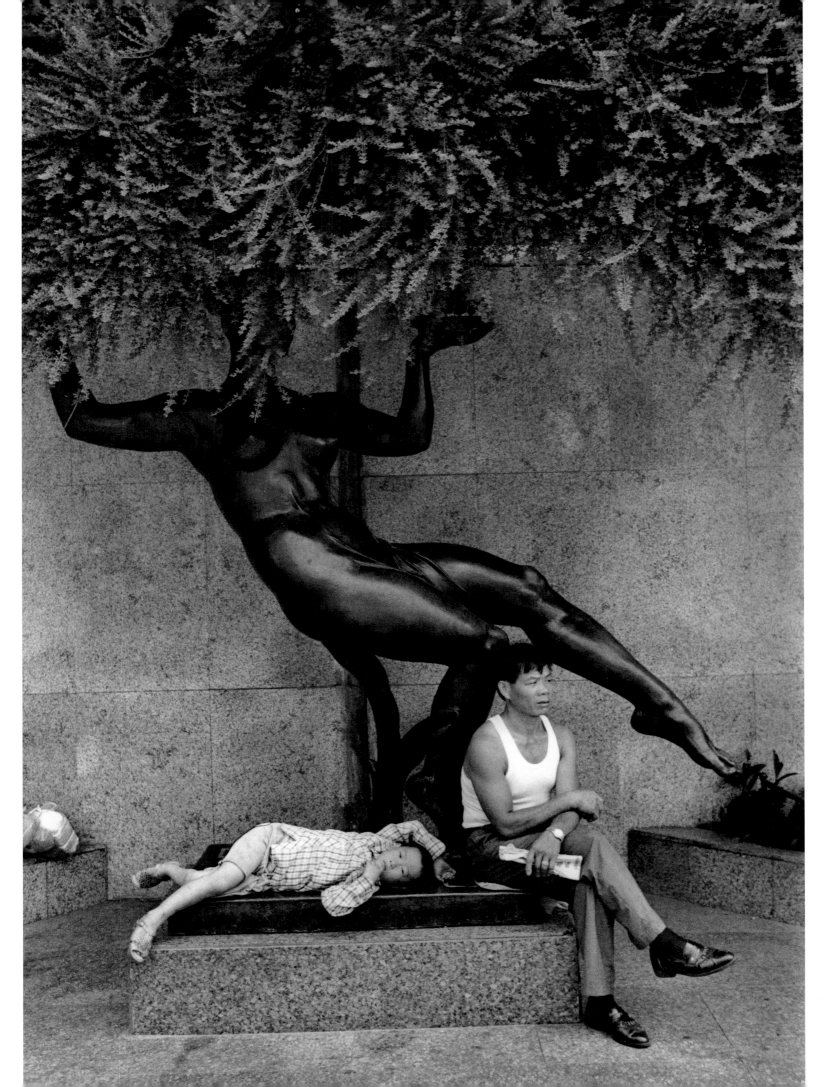

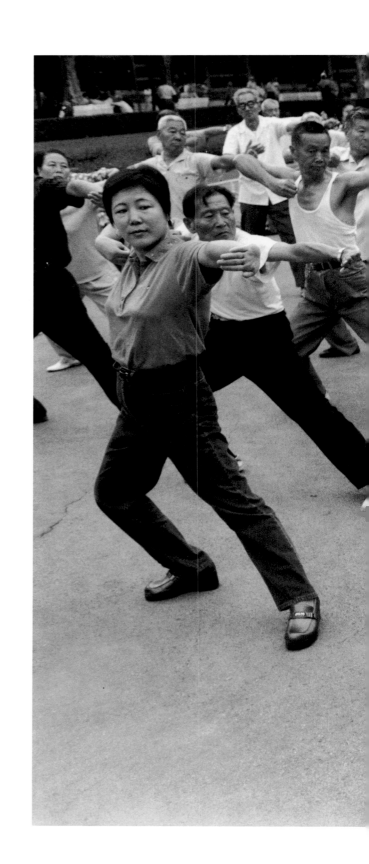

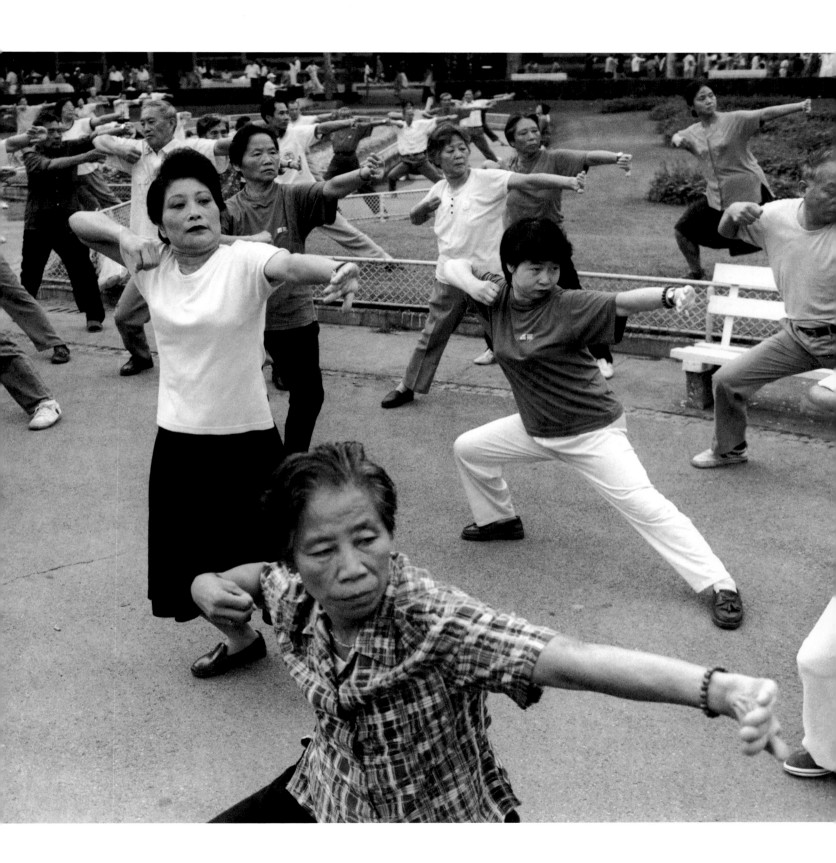

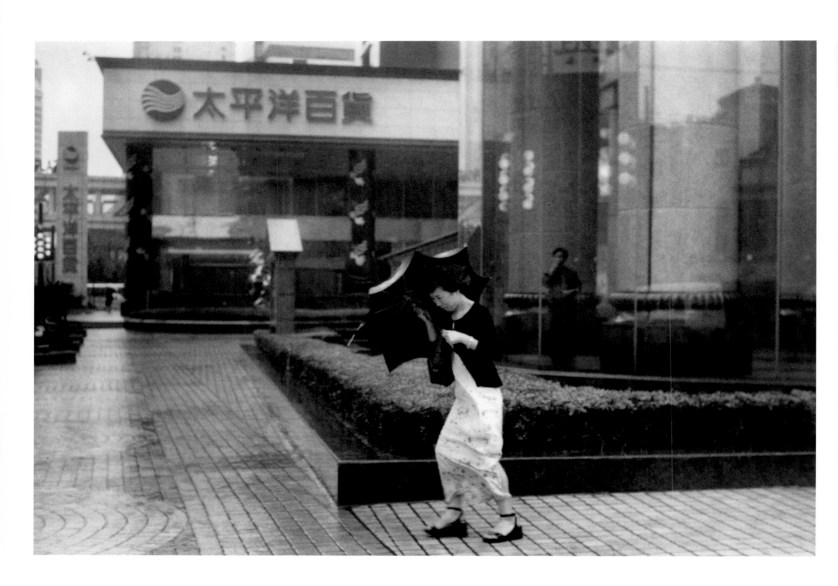

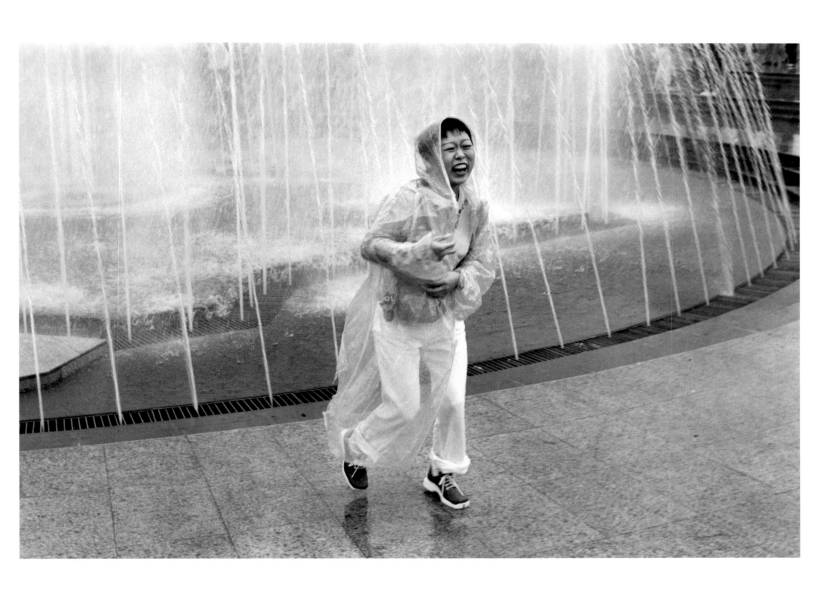

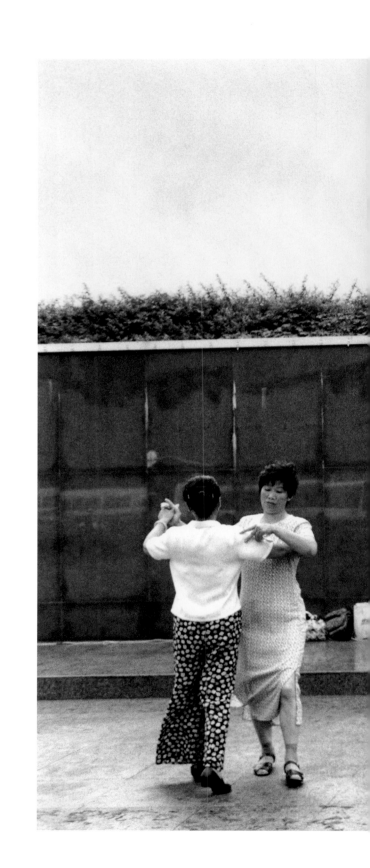

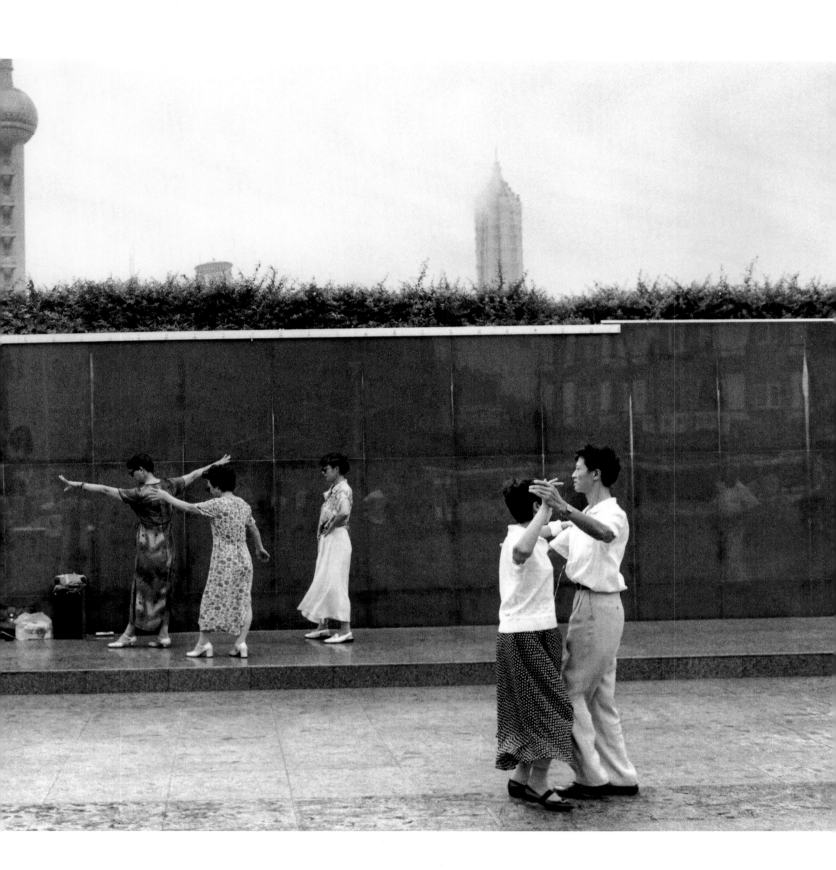

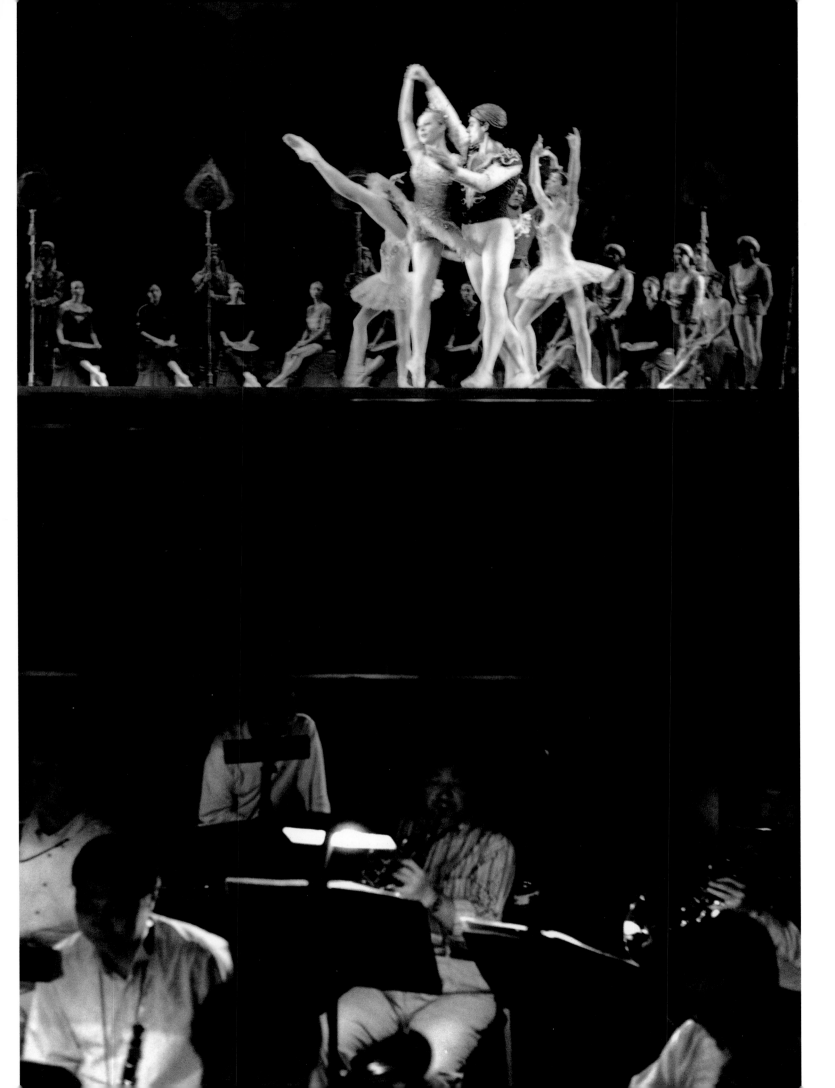

衣 帽 间

Cloak Room

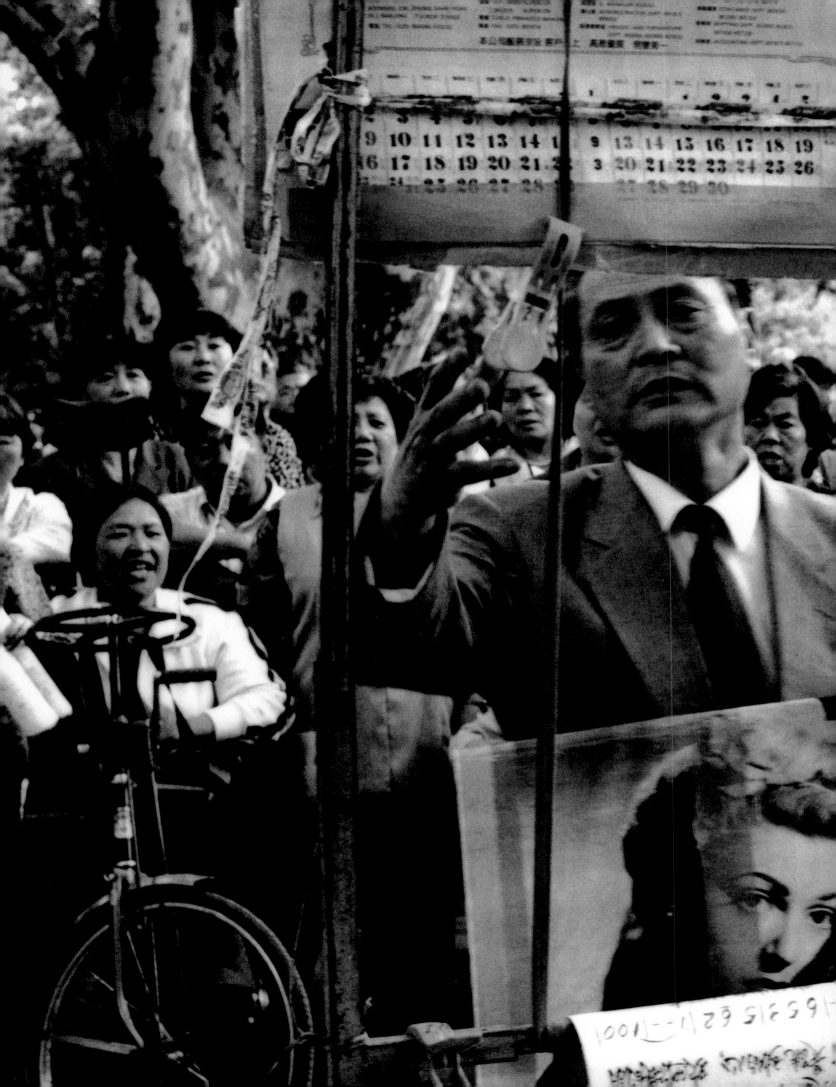

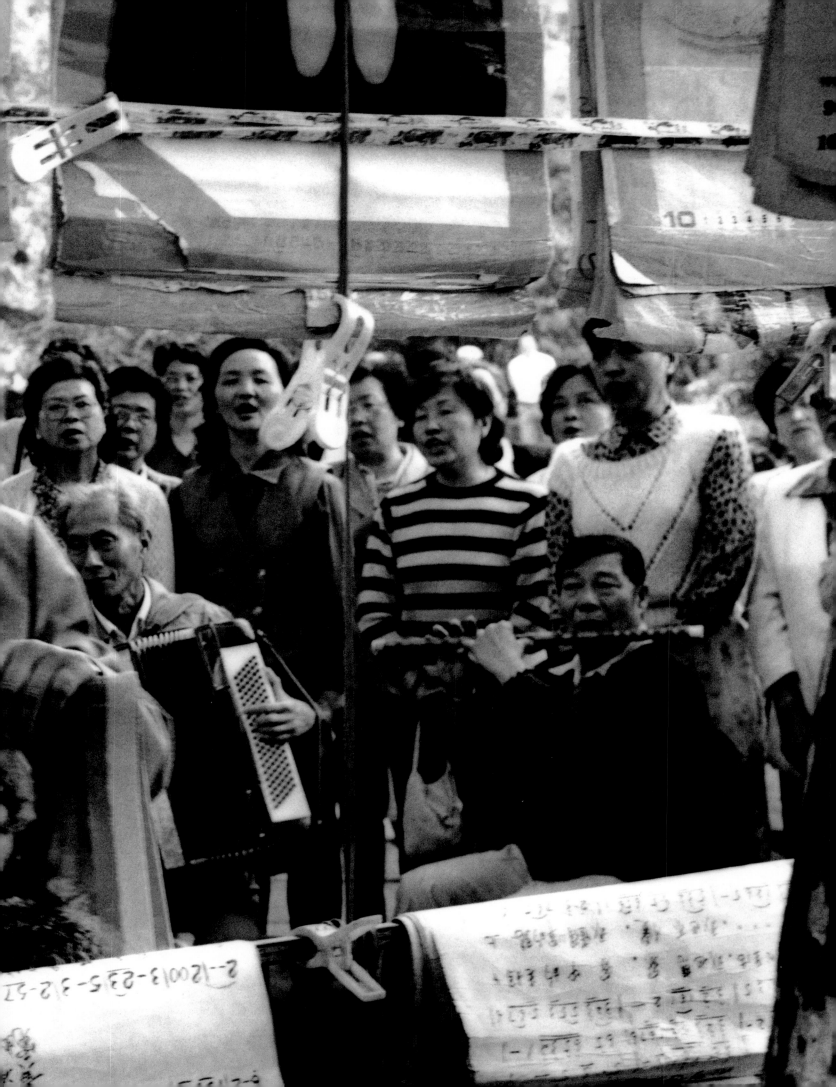

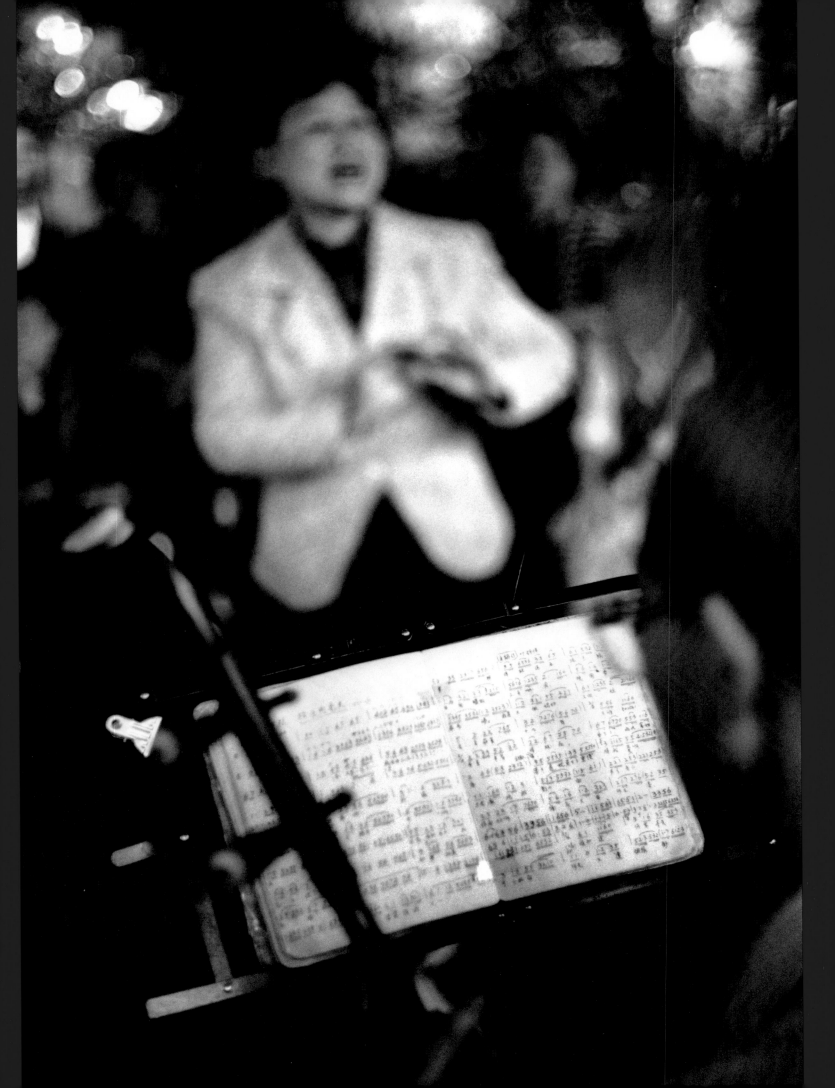

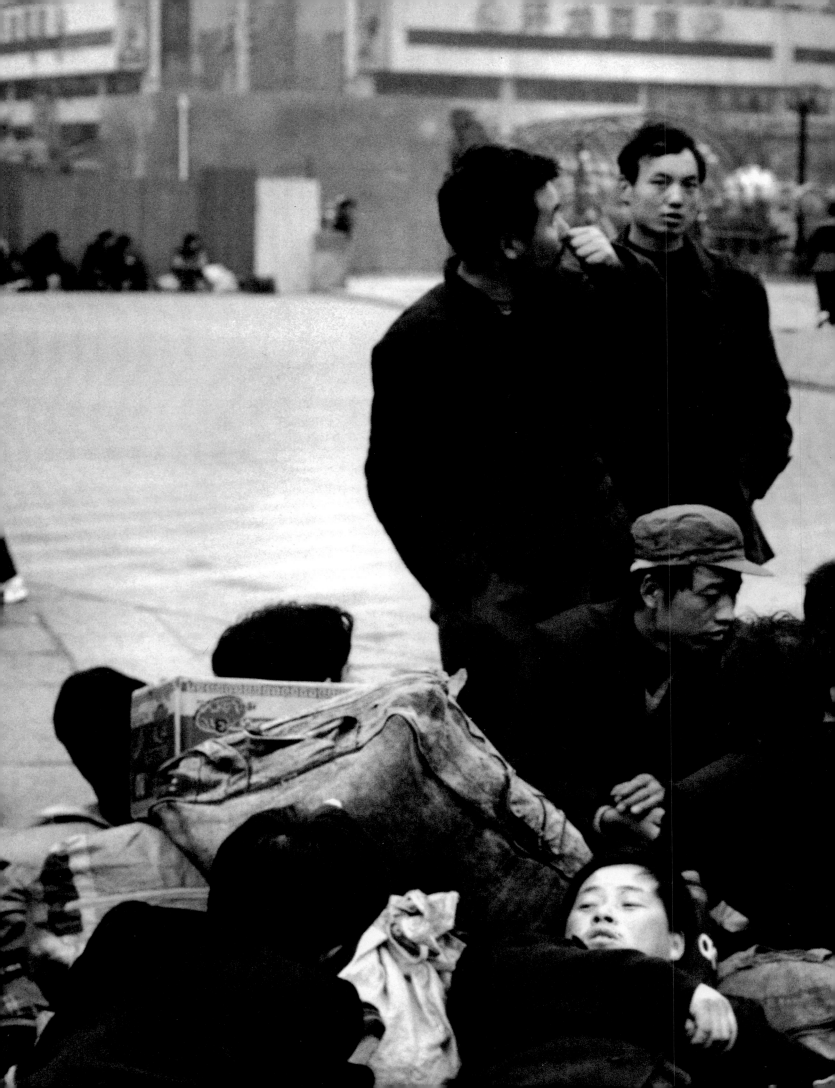

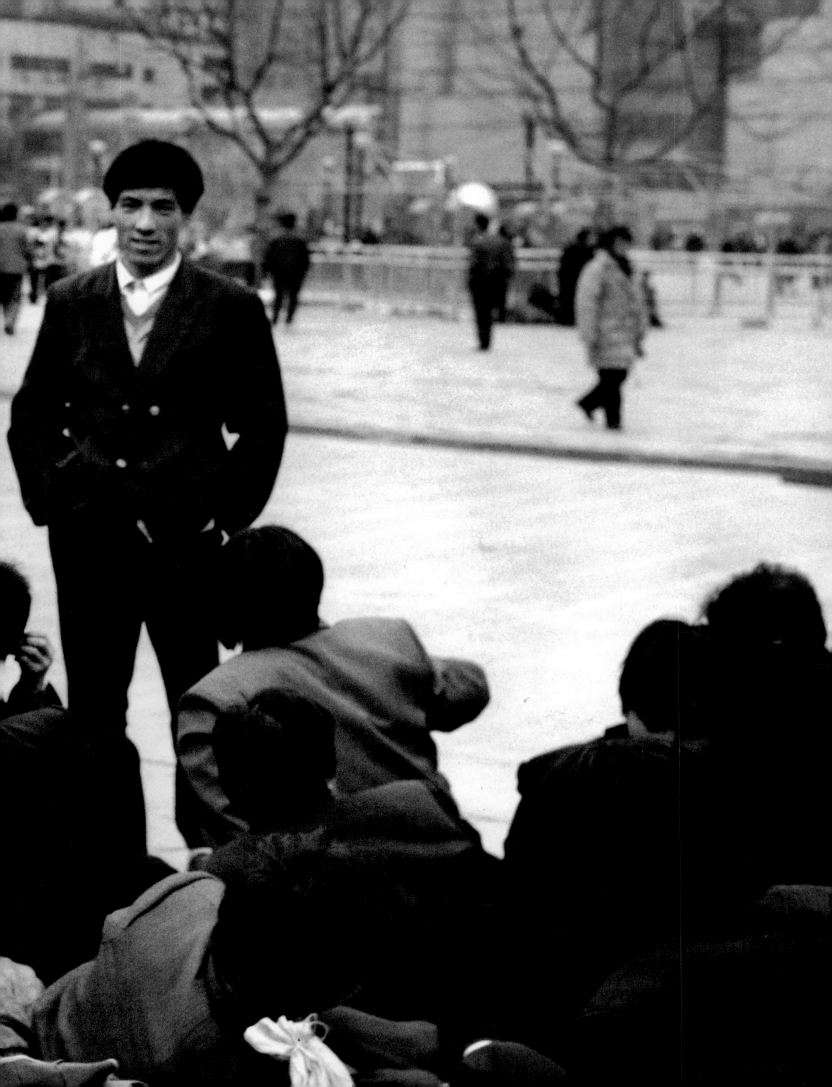

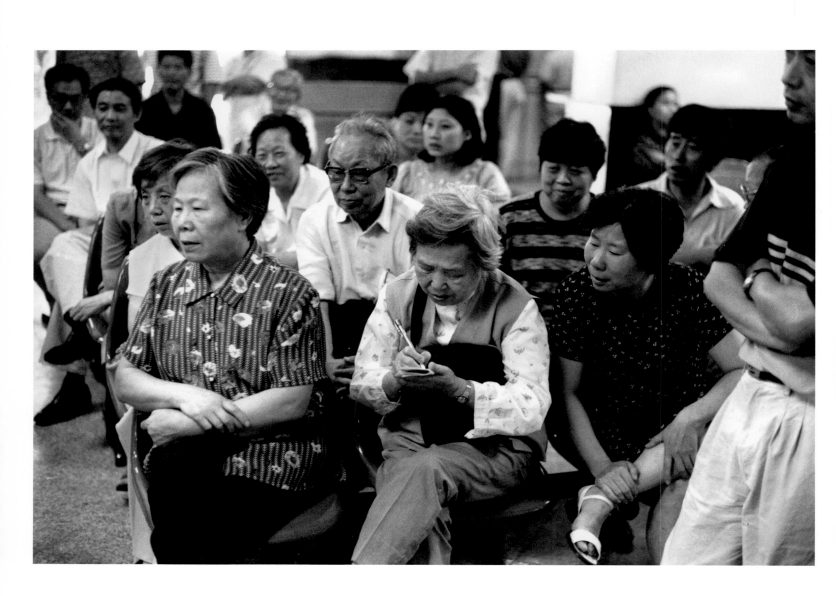

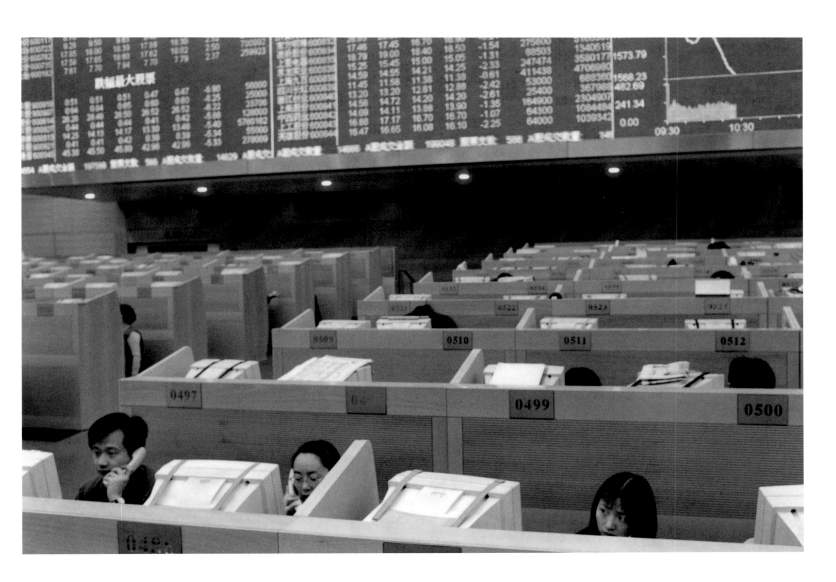

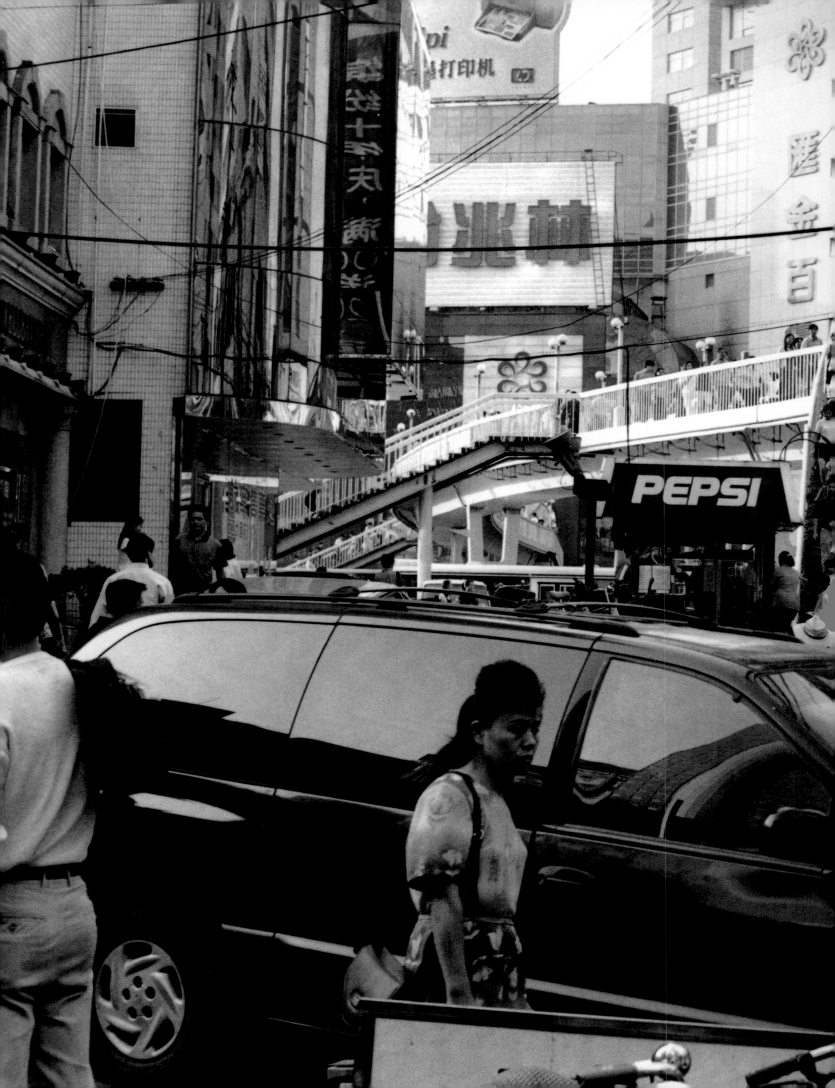

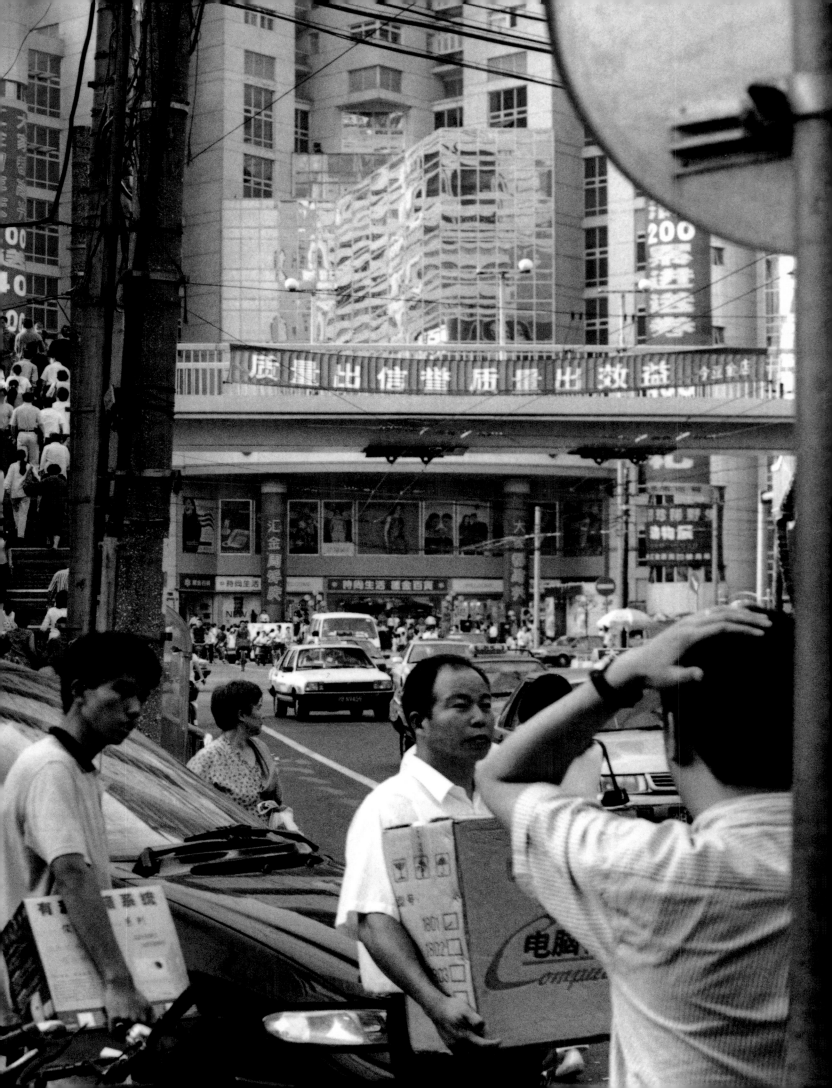

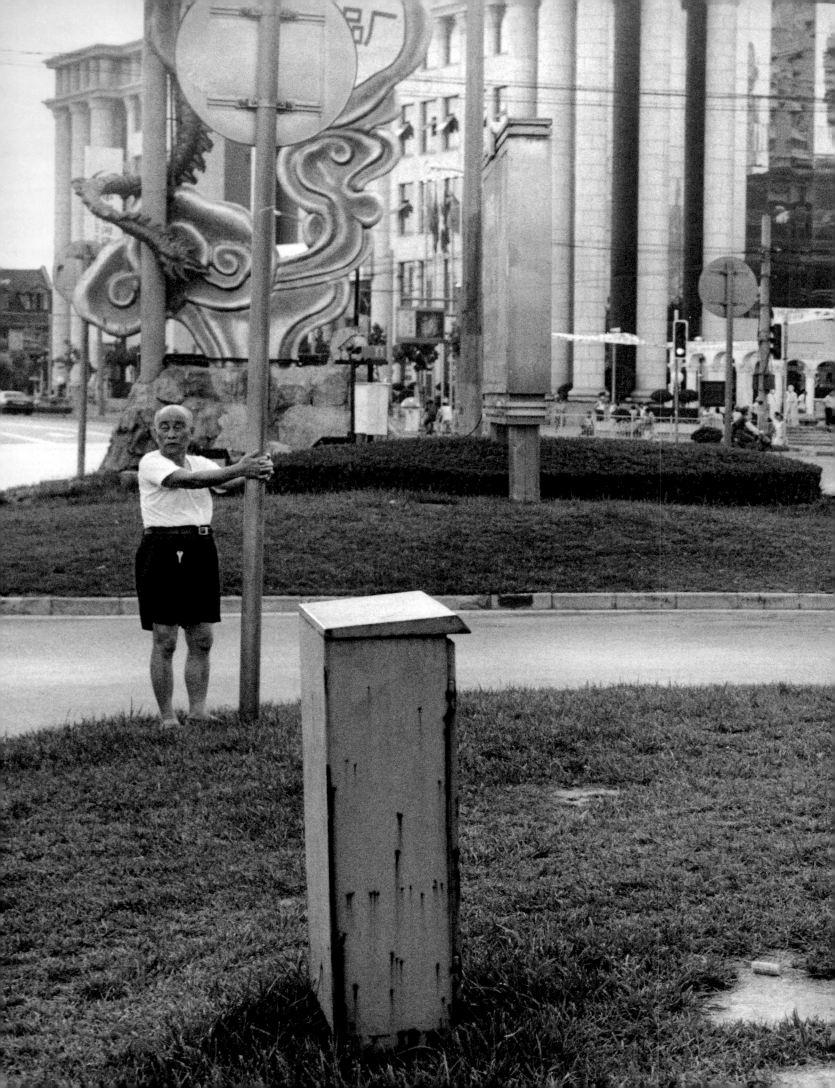

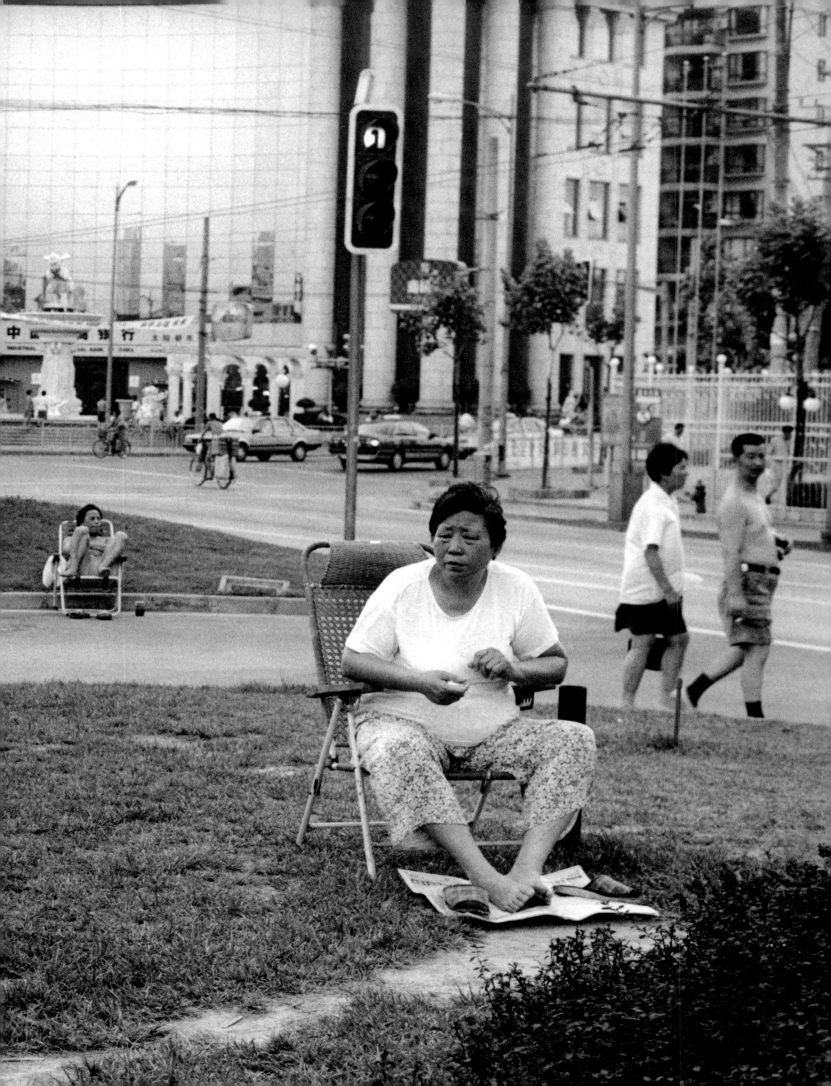

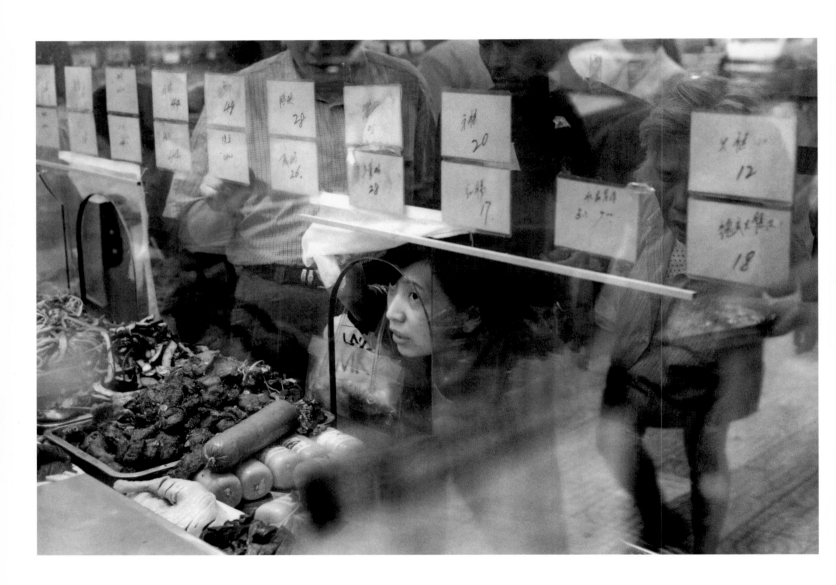

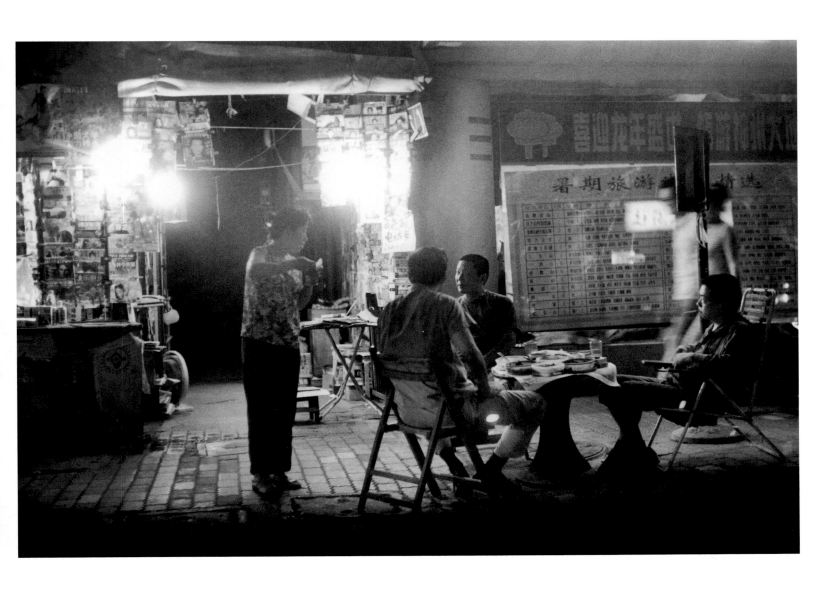

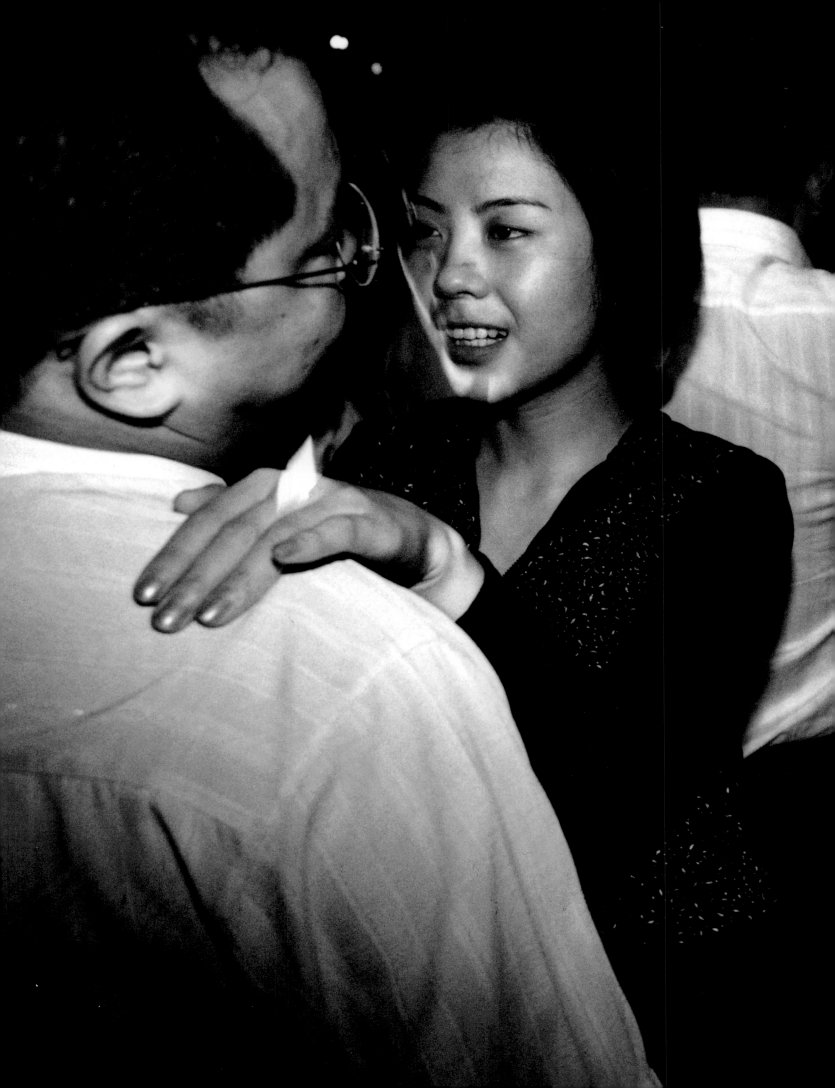

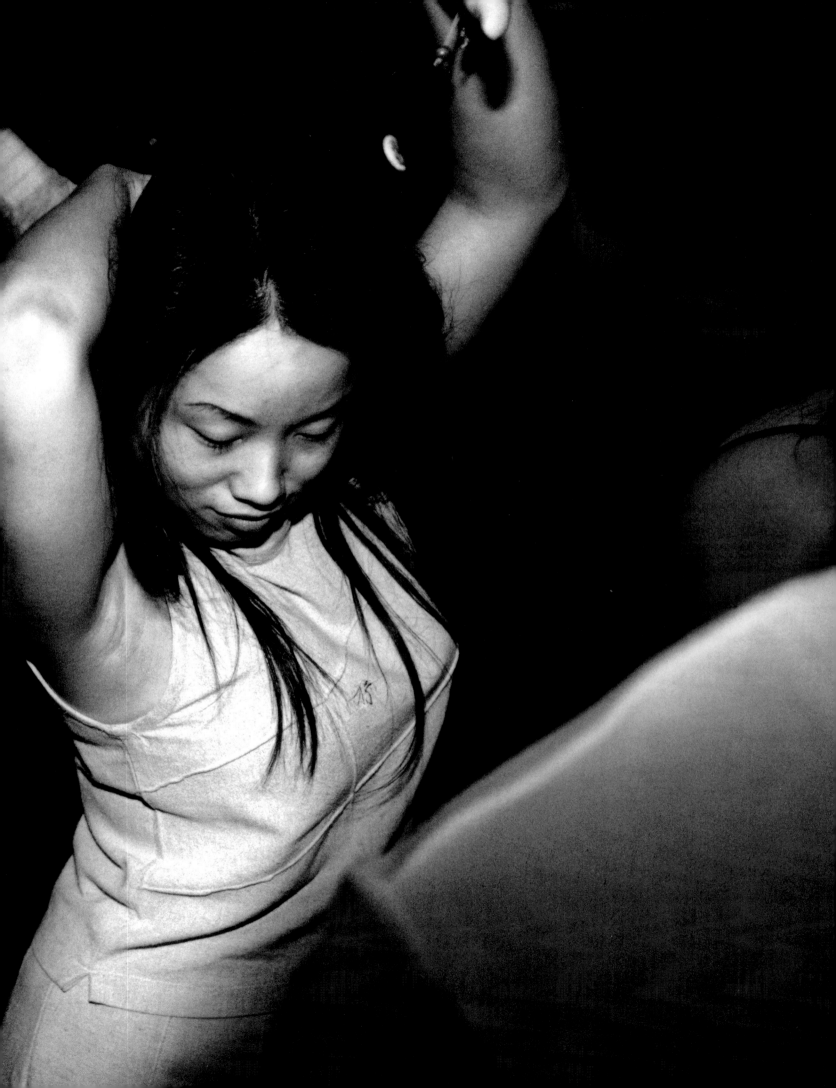

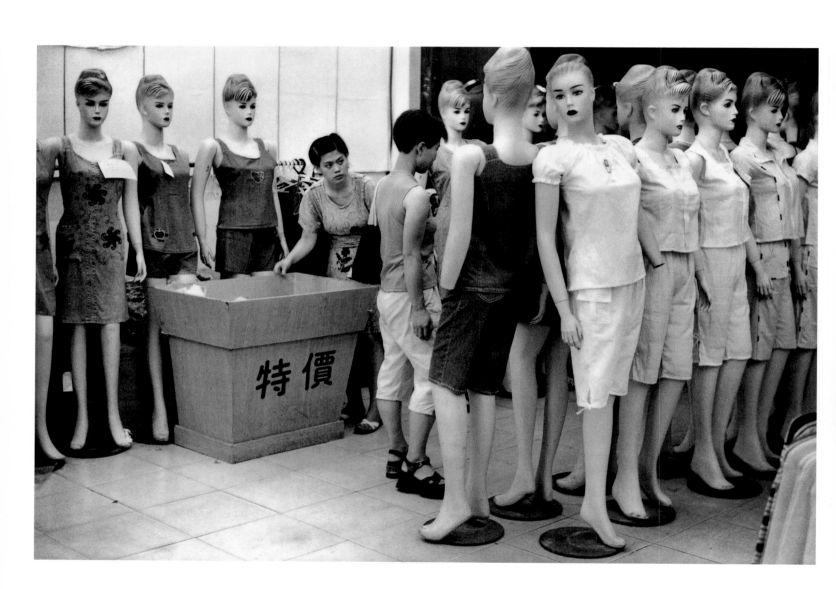

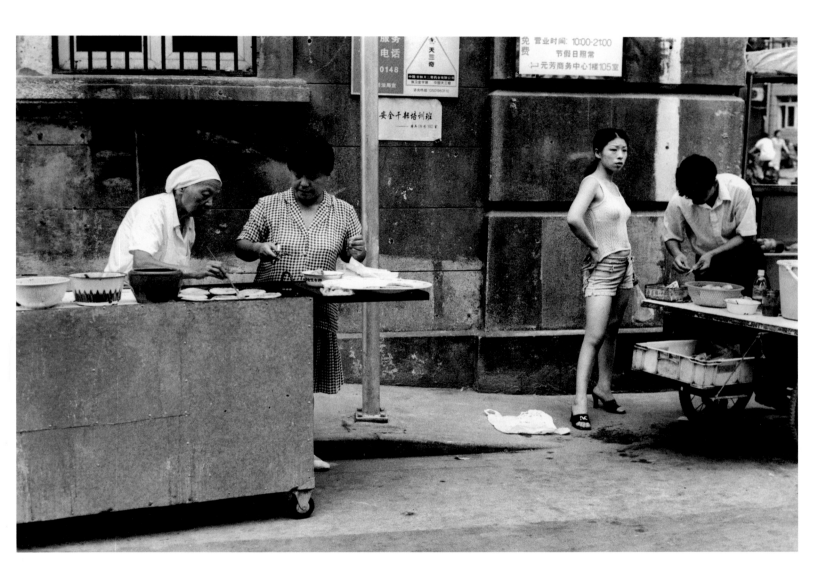

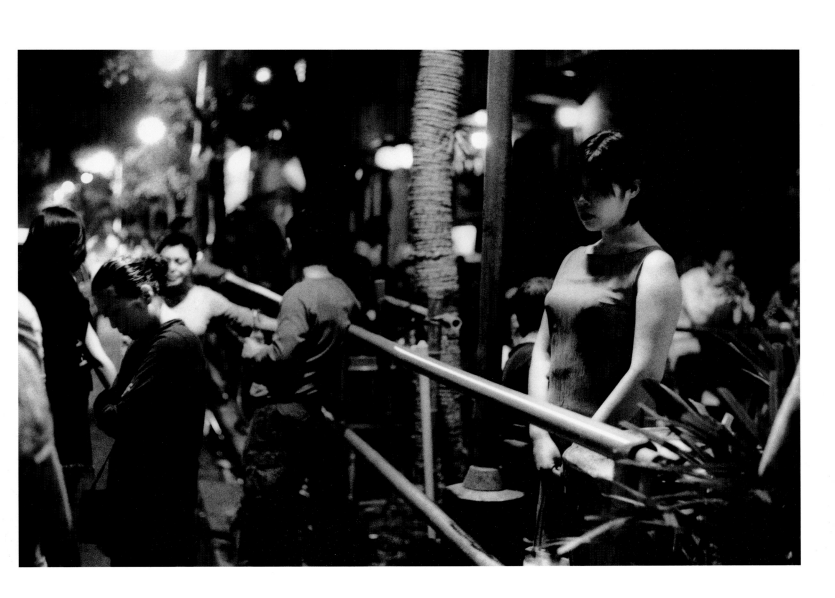

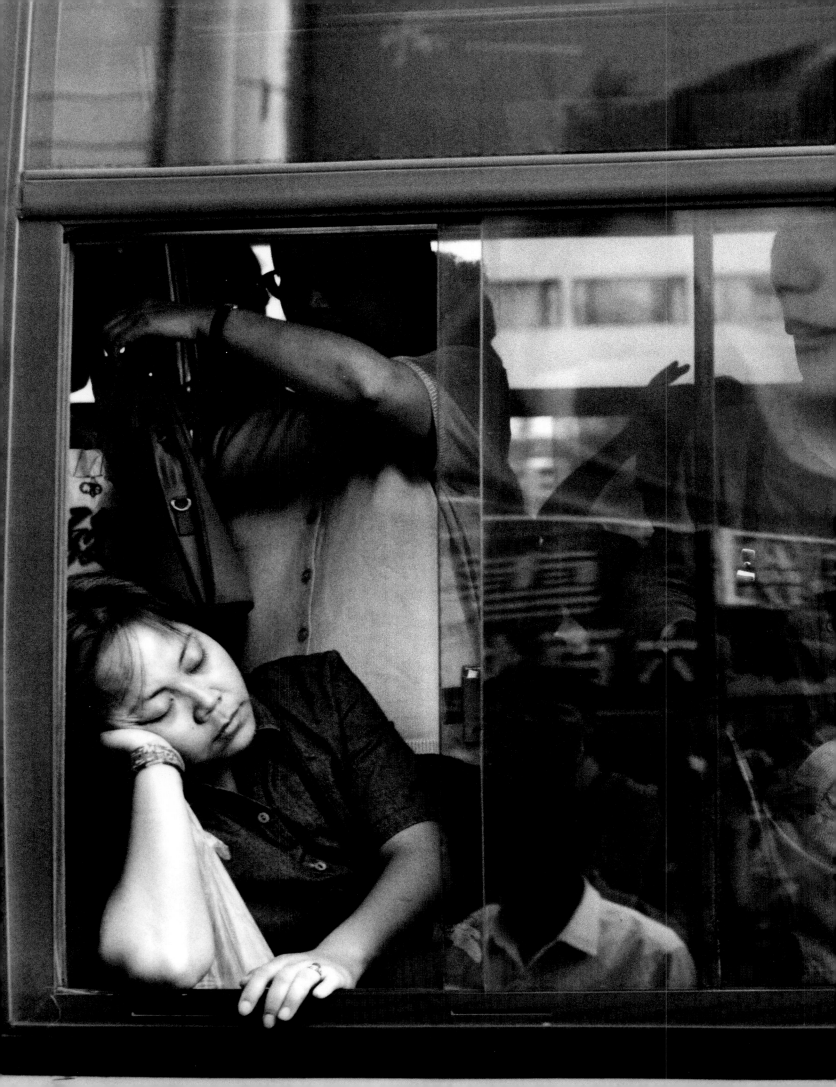

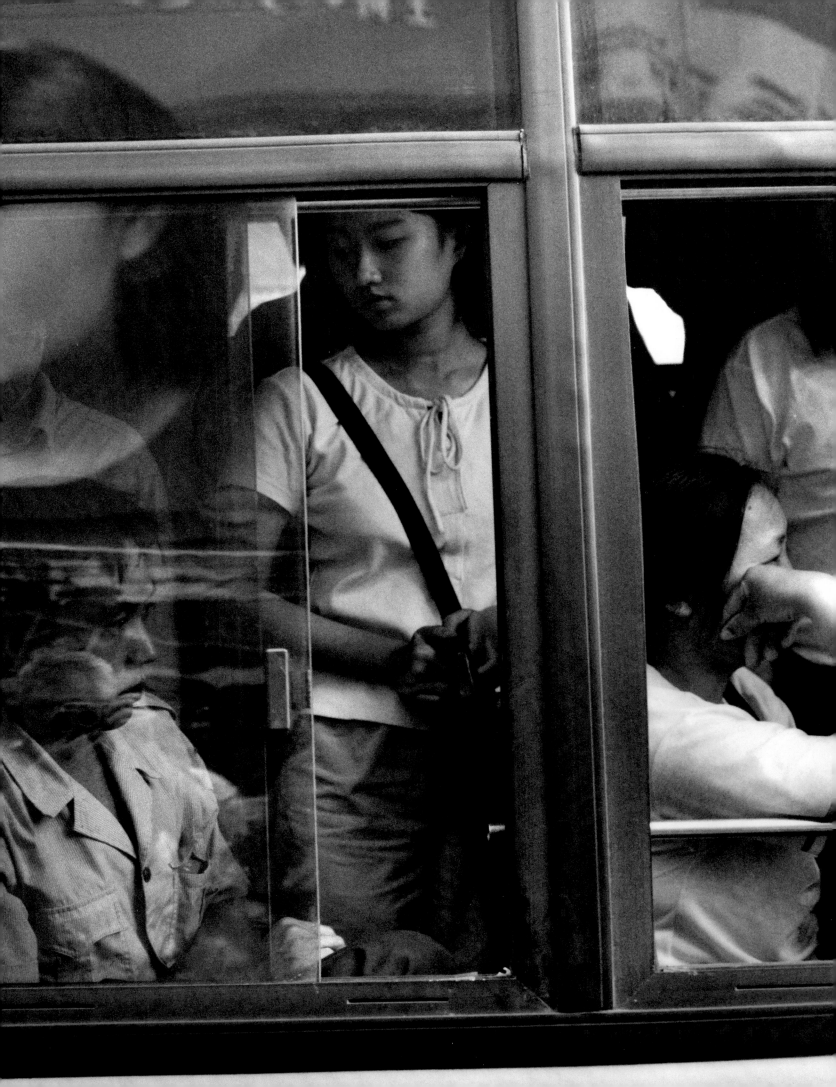

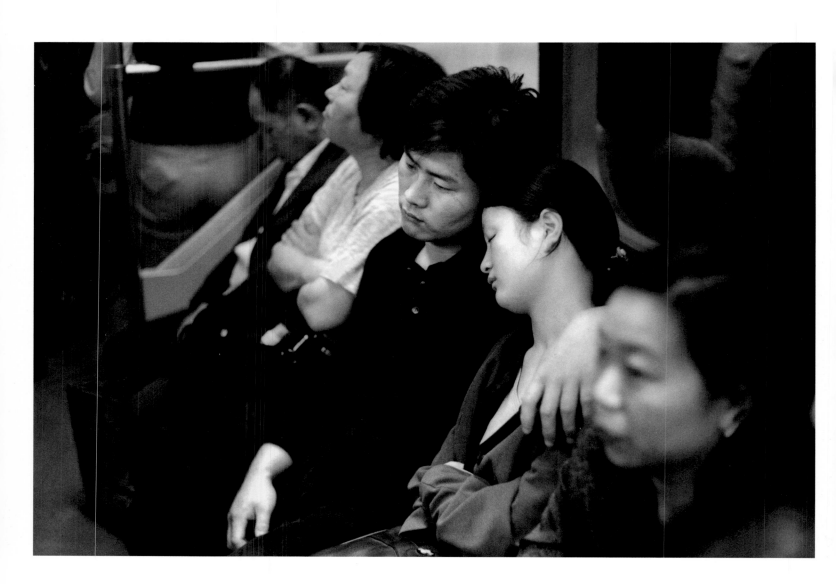

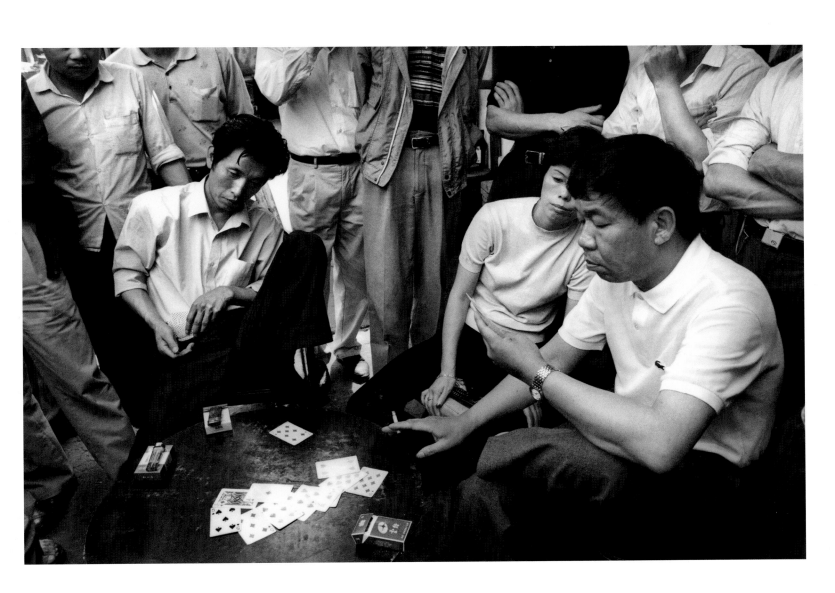

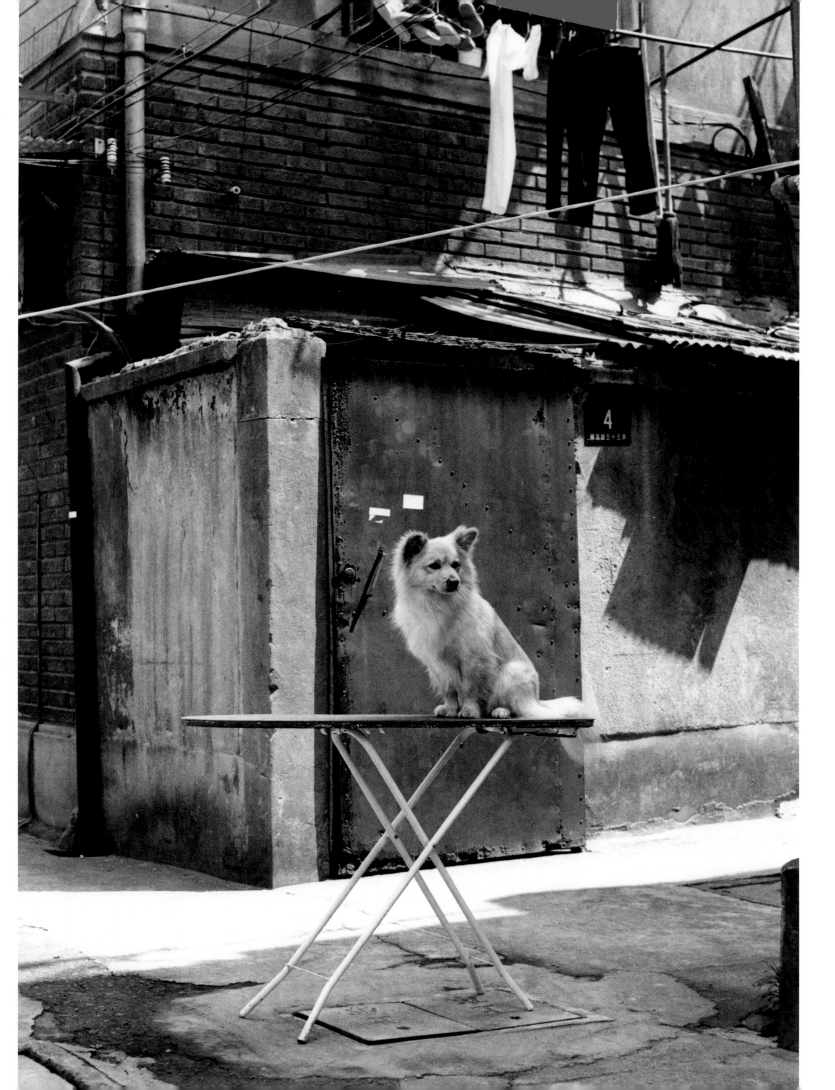

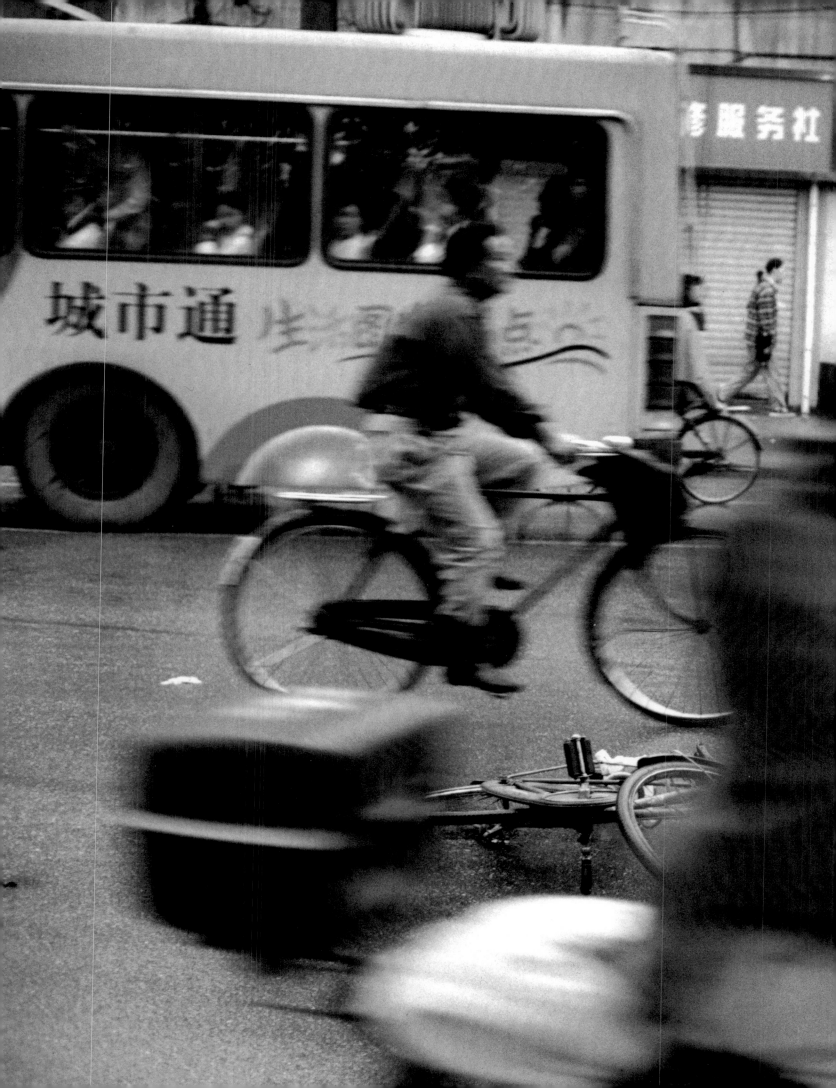

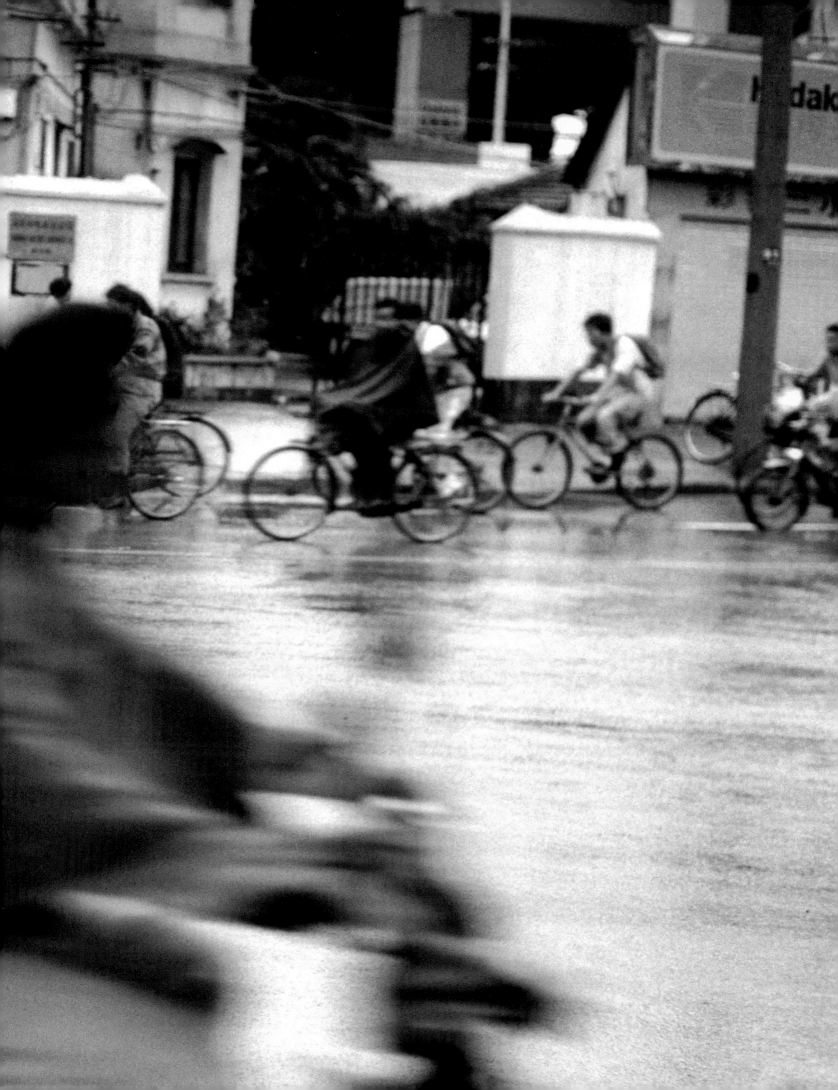

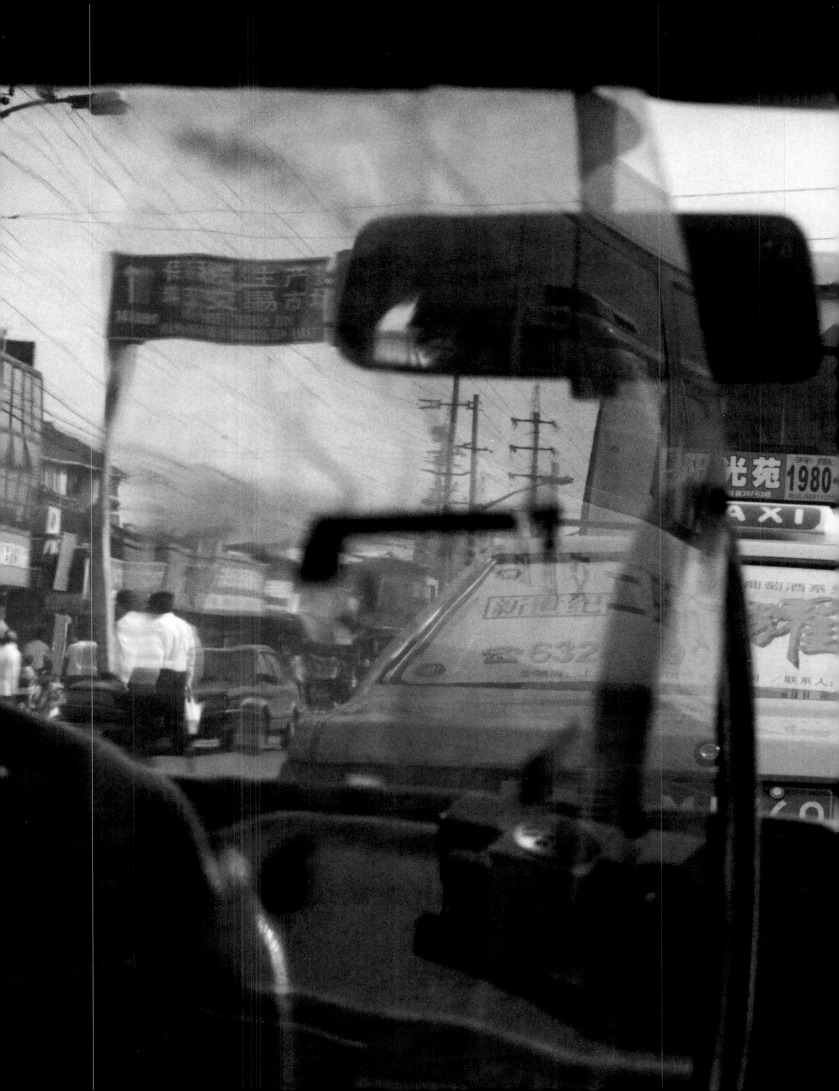

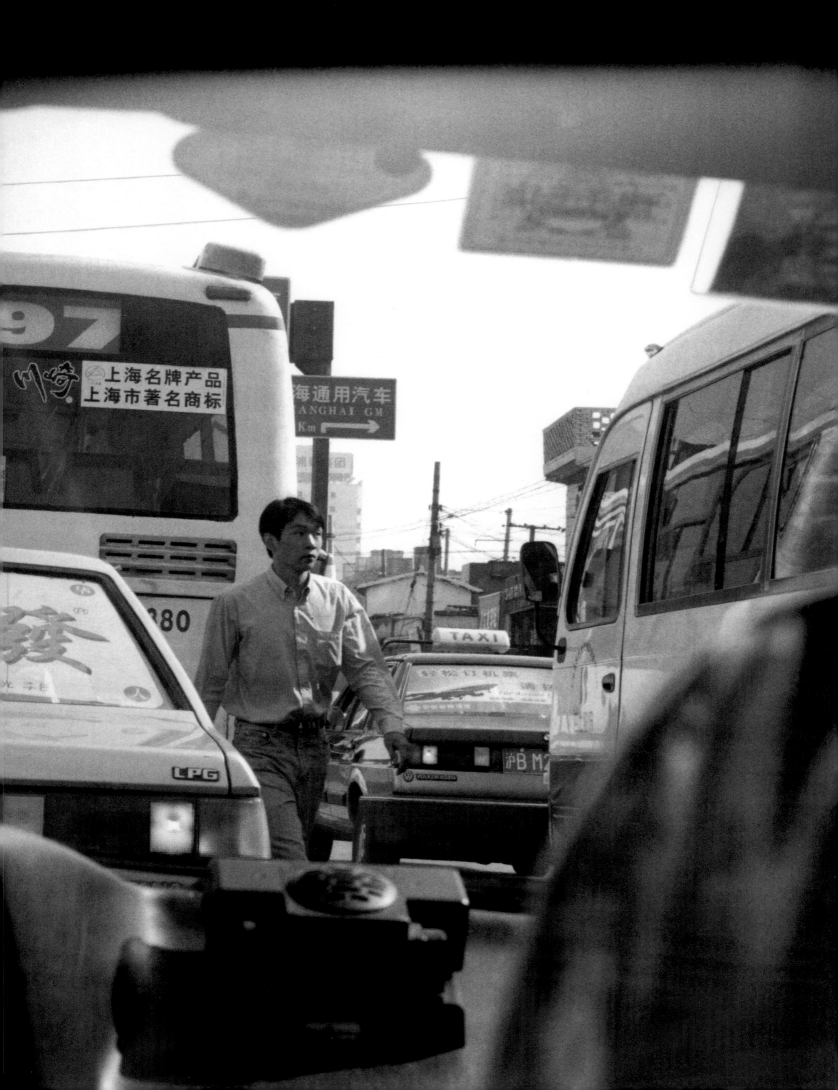

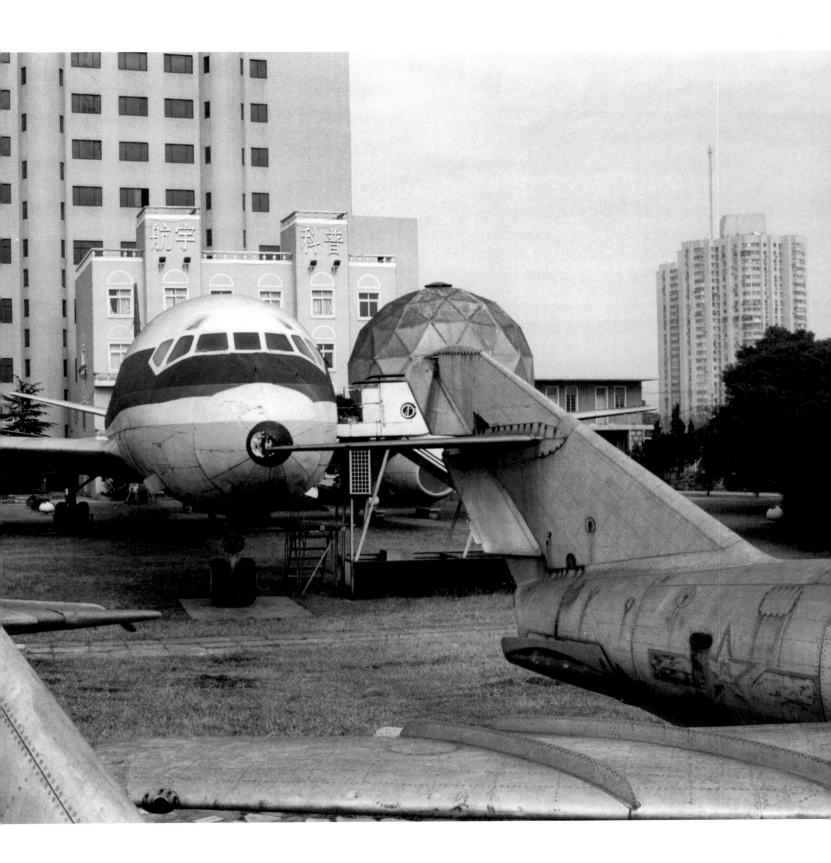

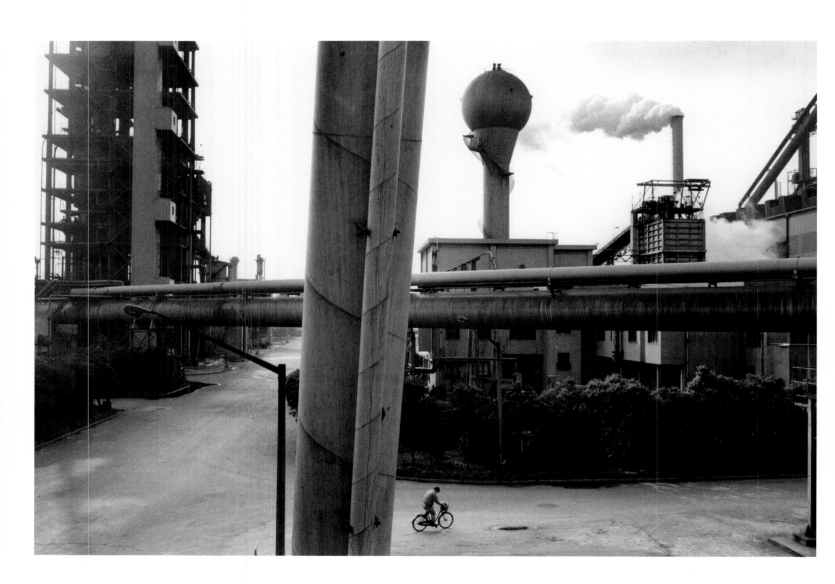

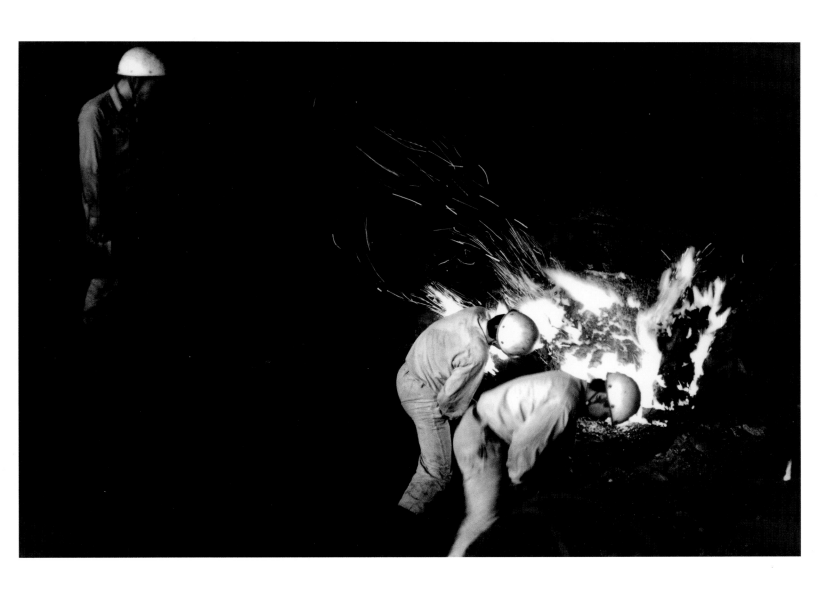

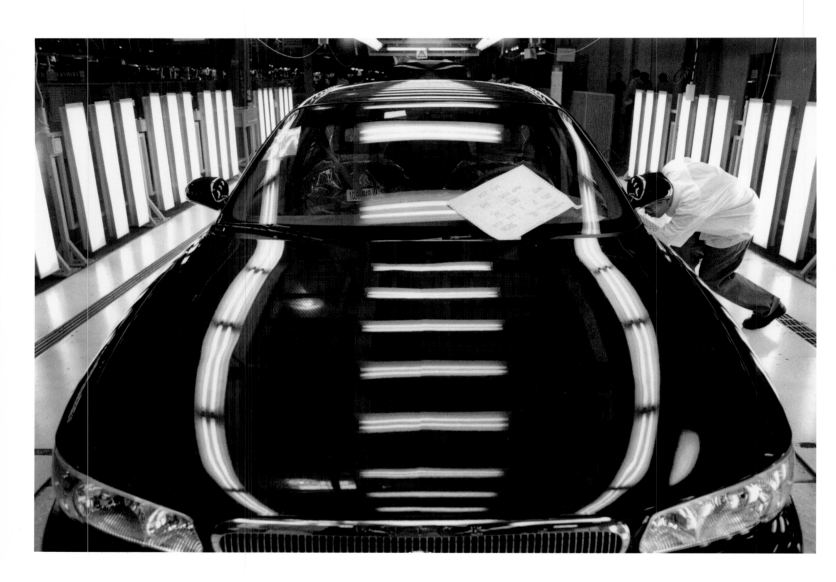

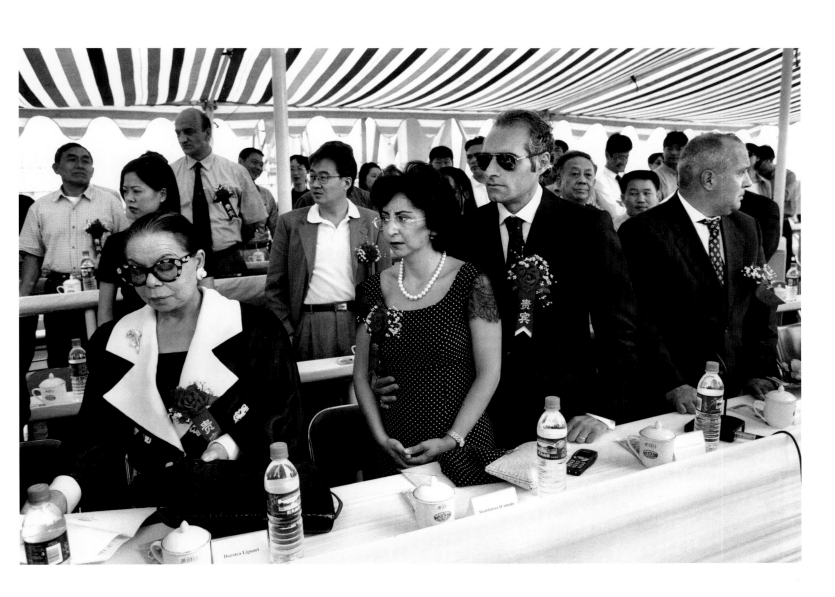

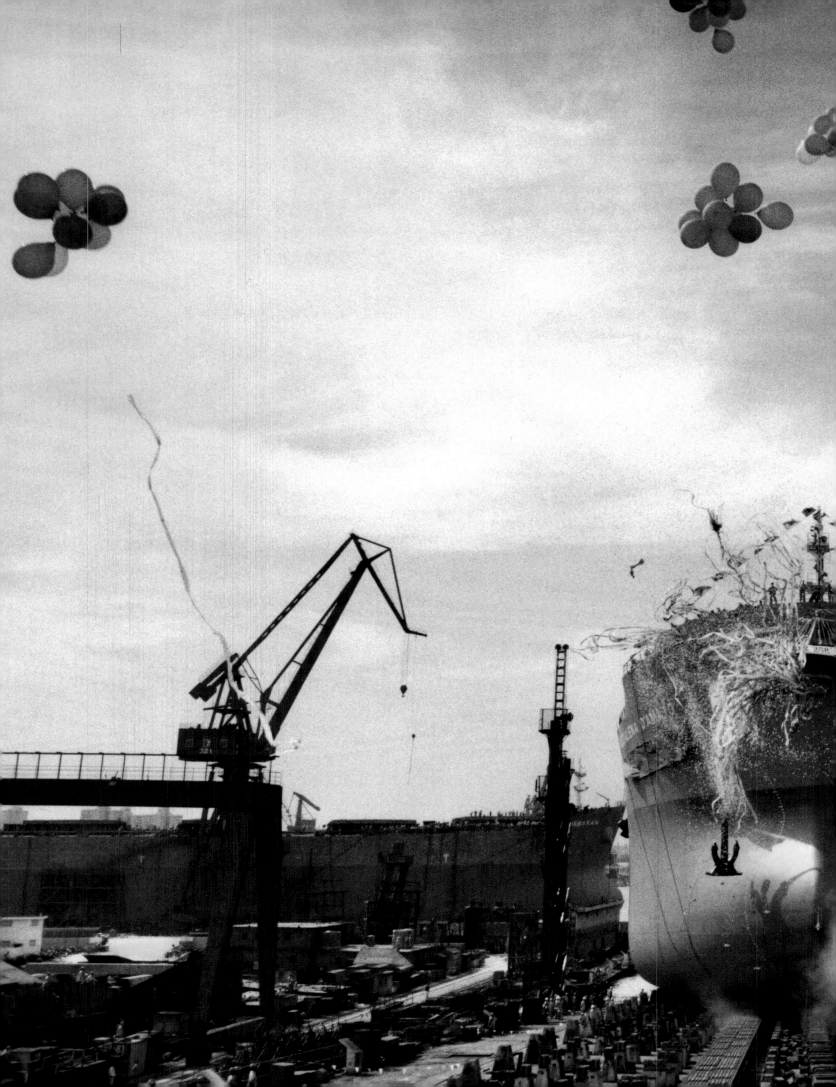

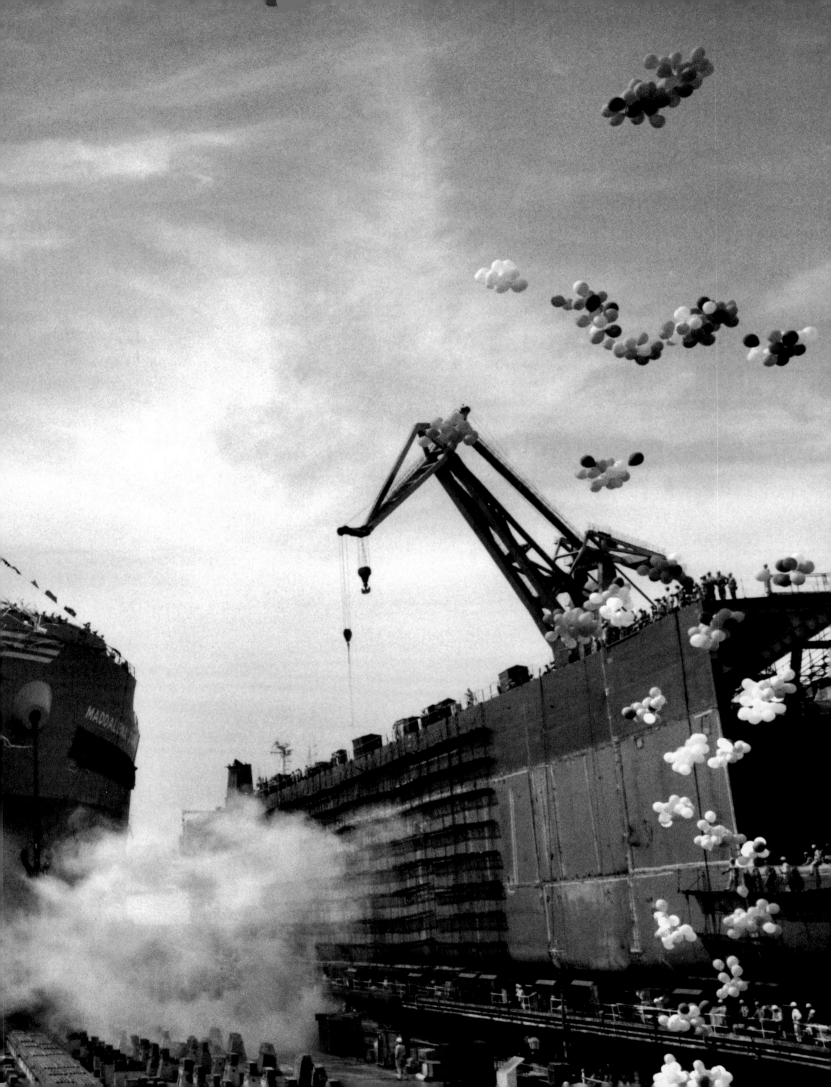

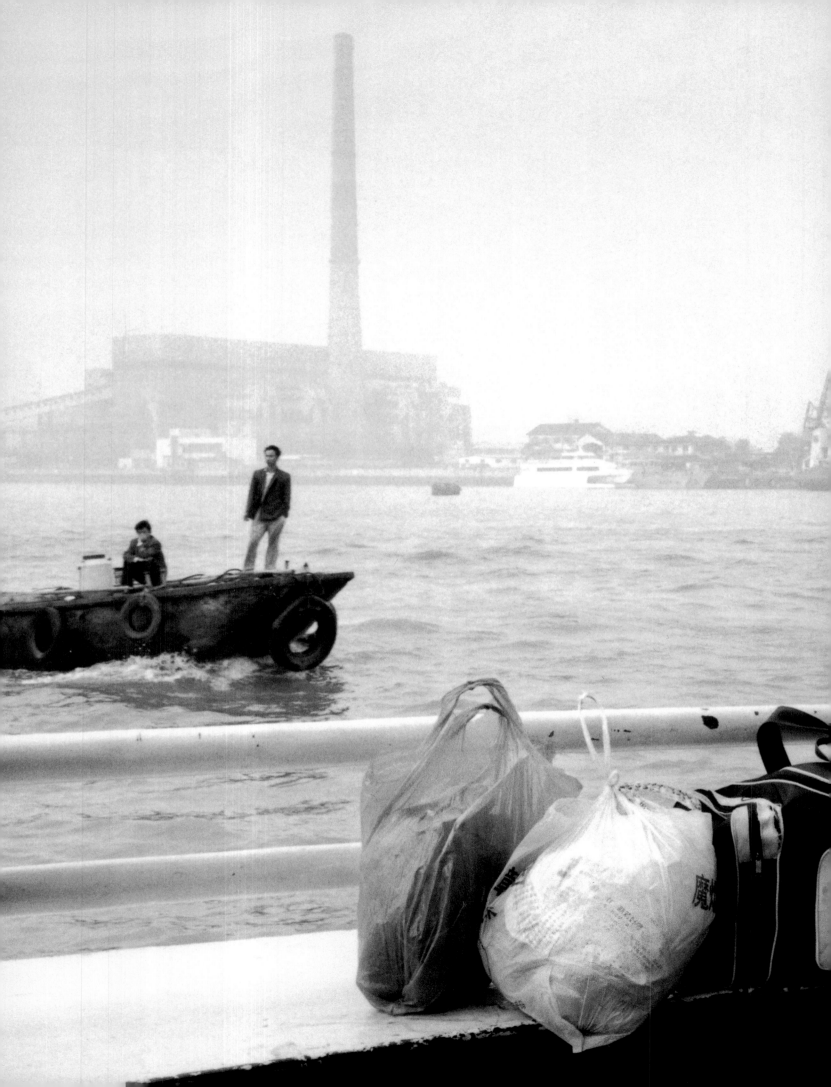

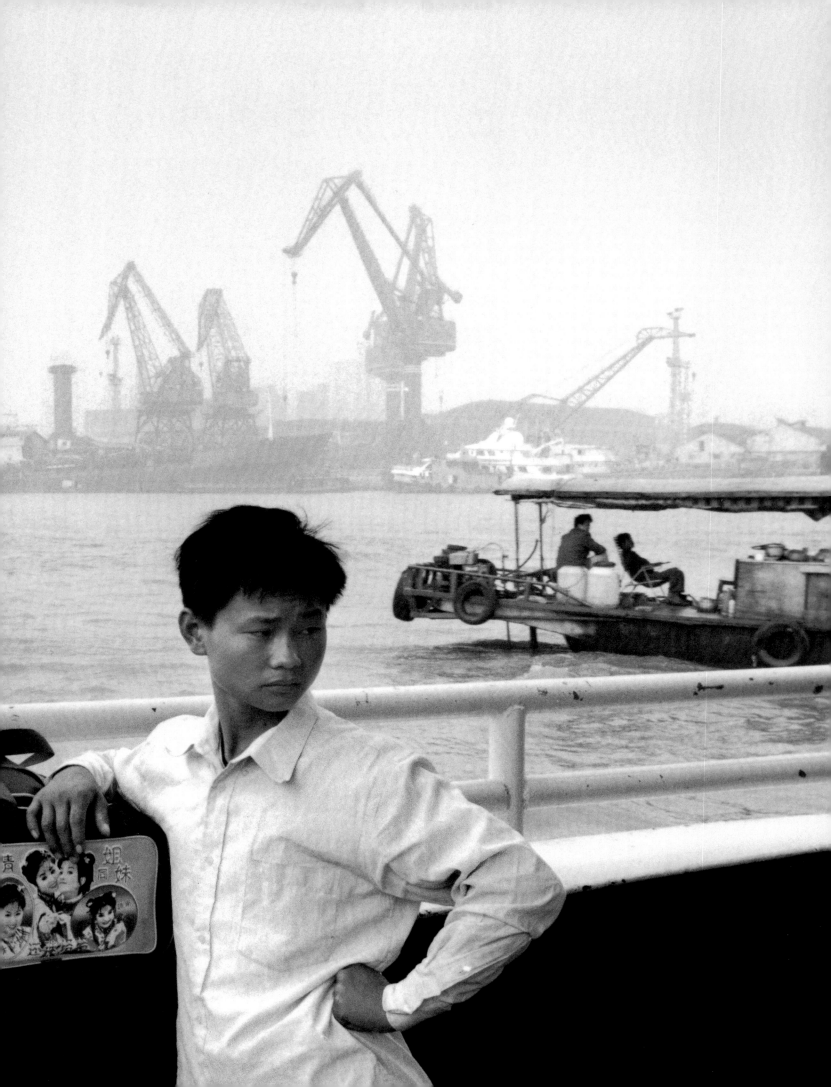

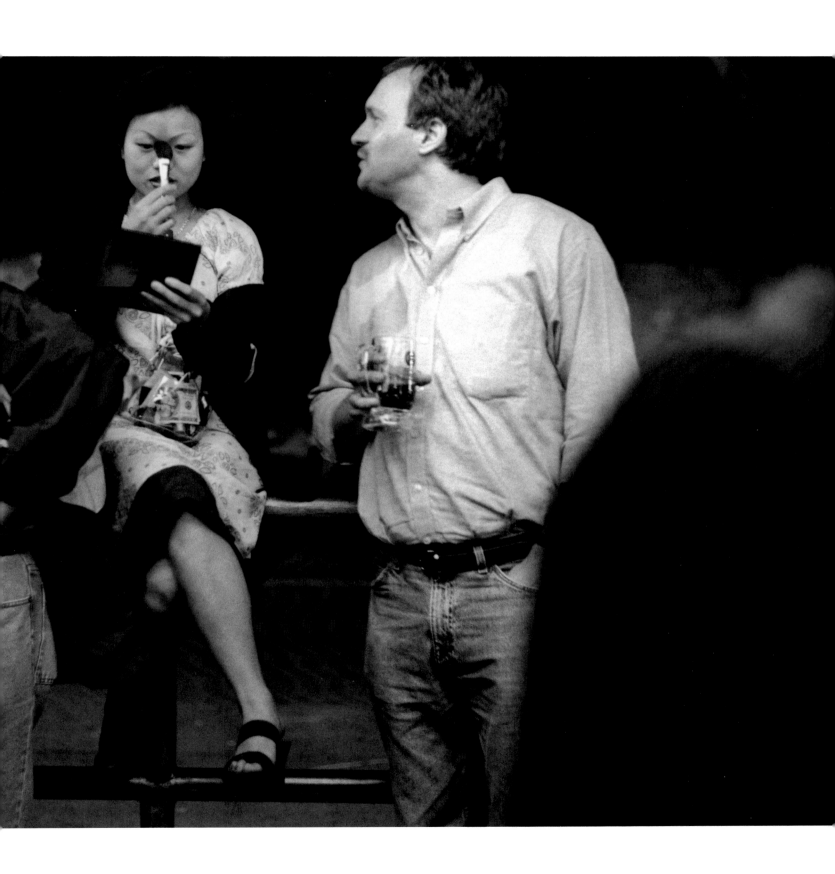

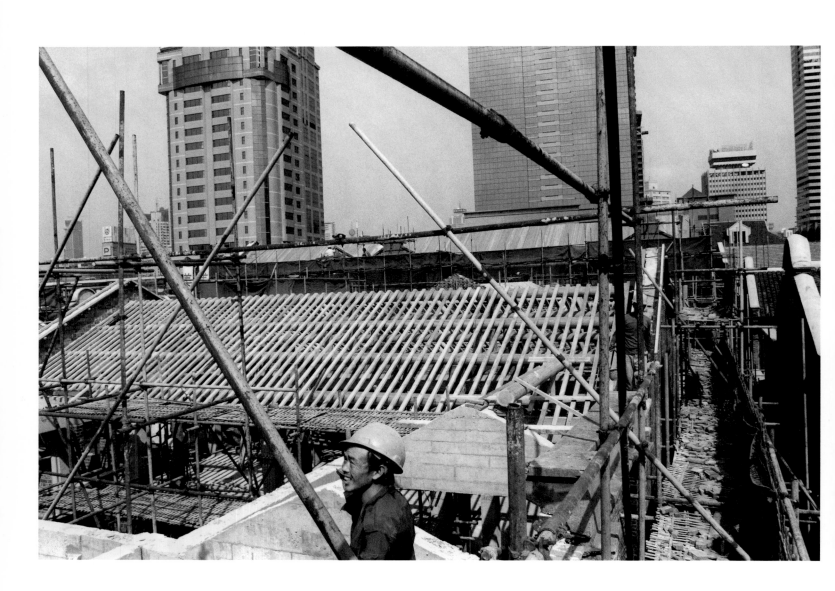

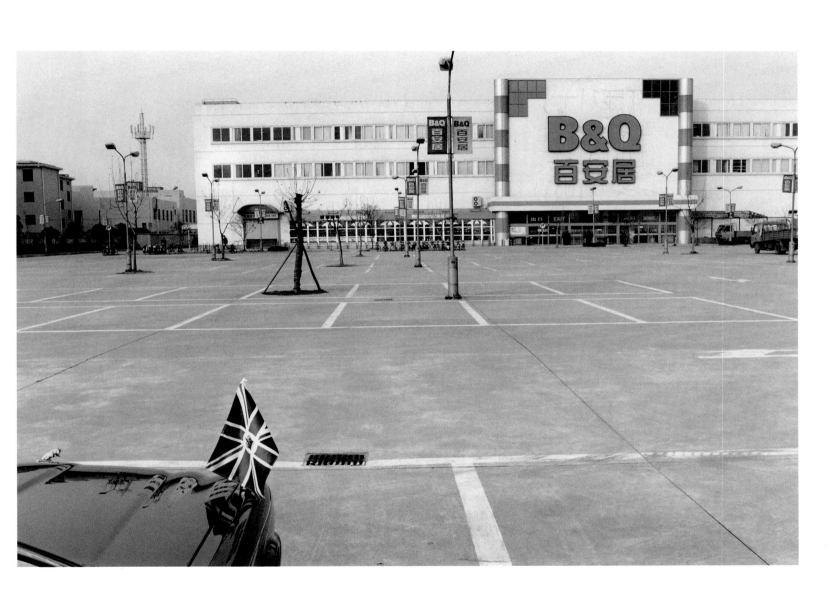

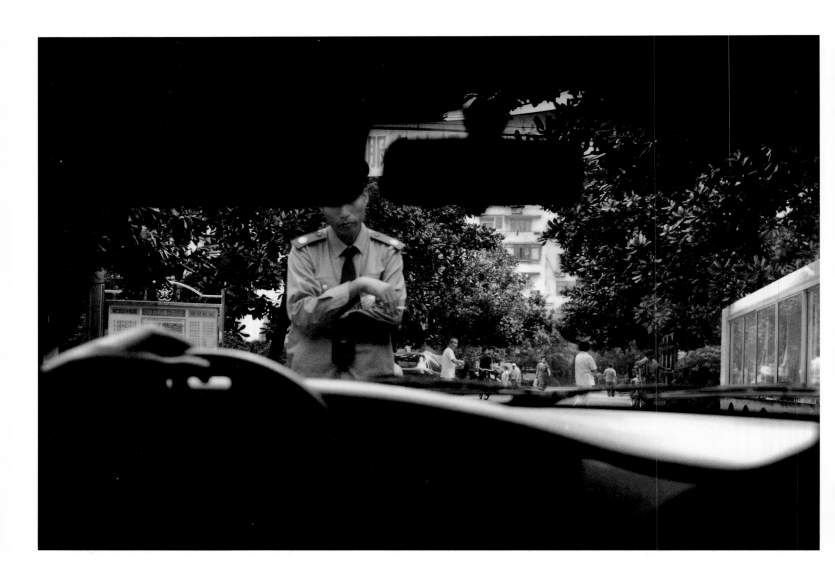

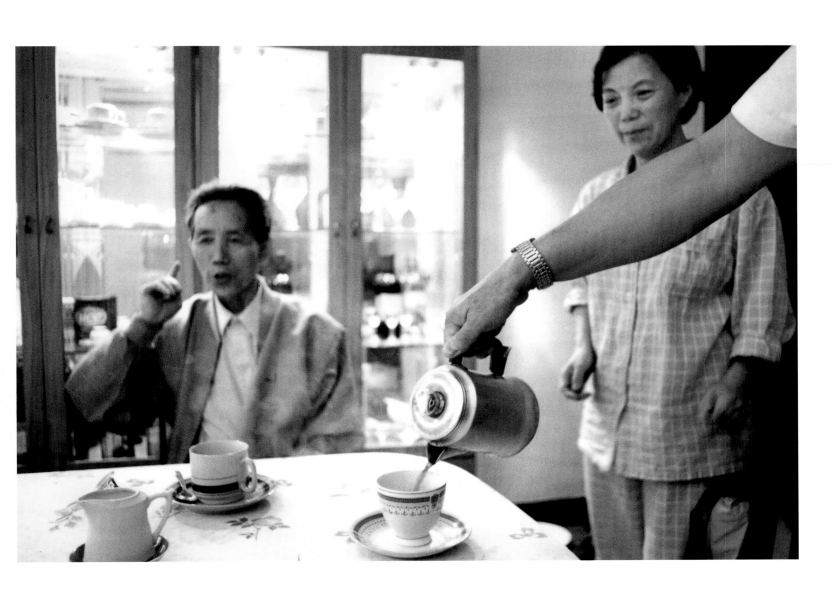

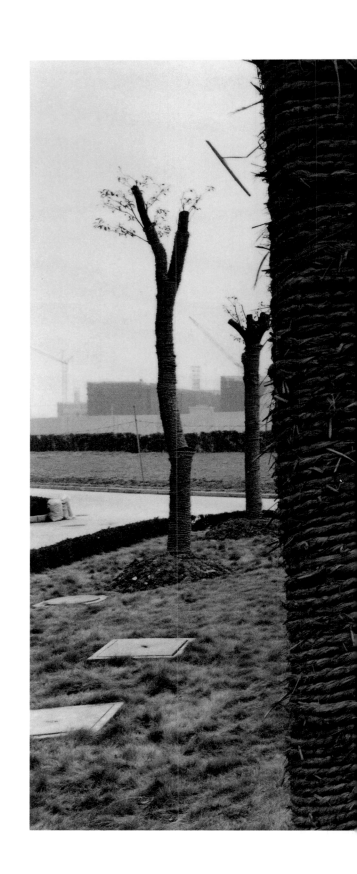

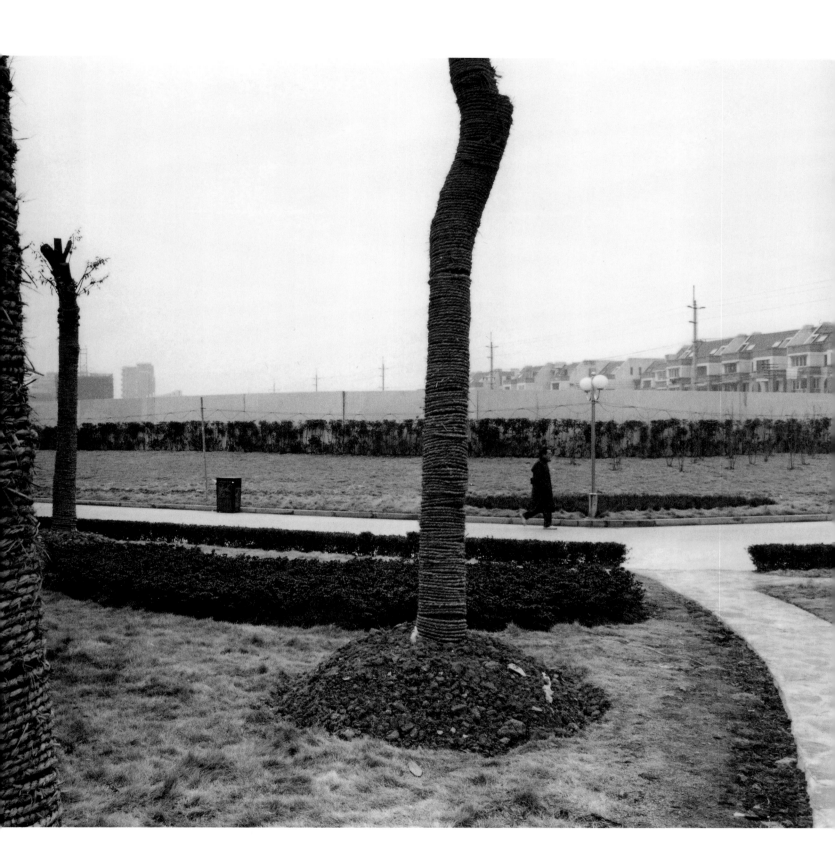

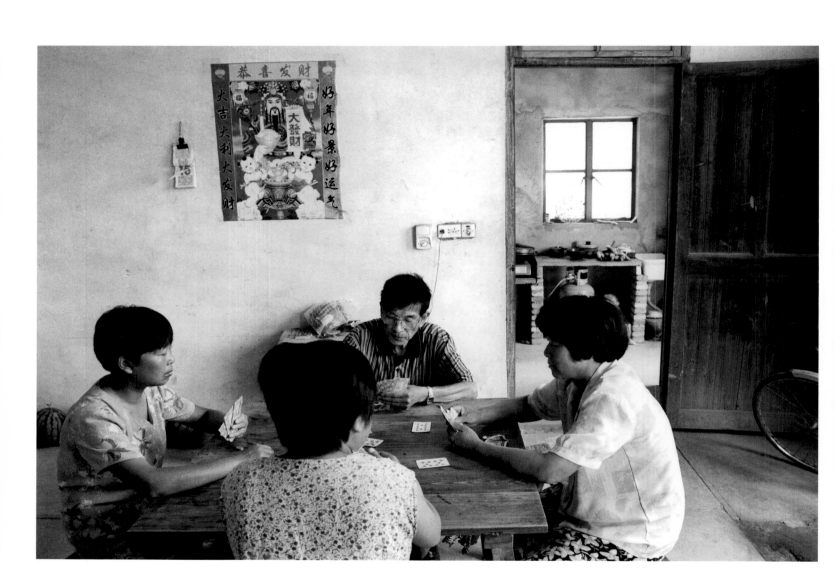

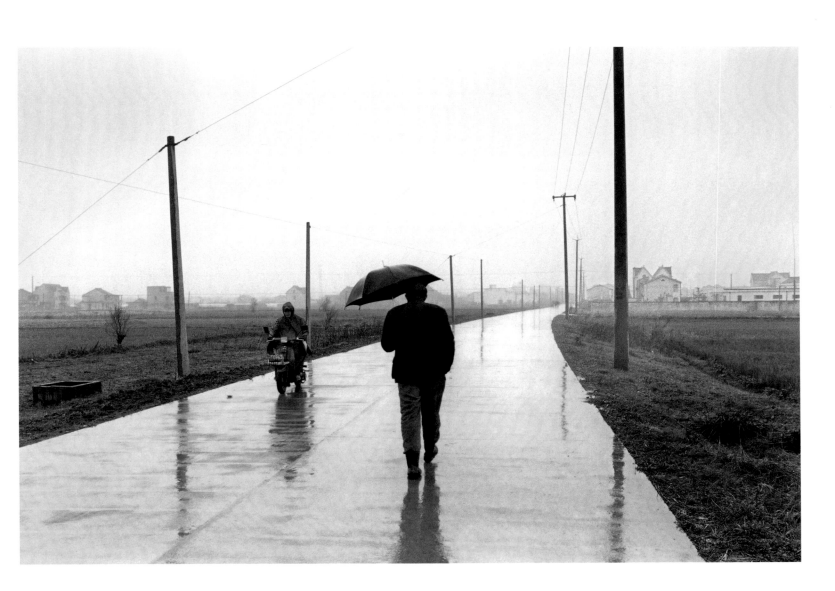

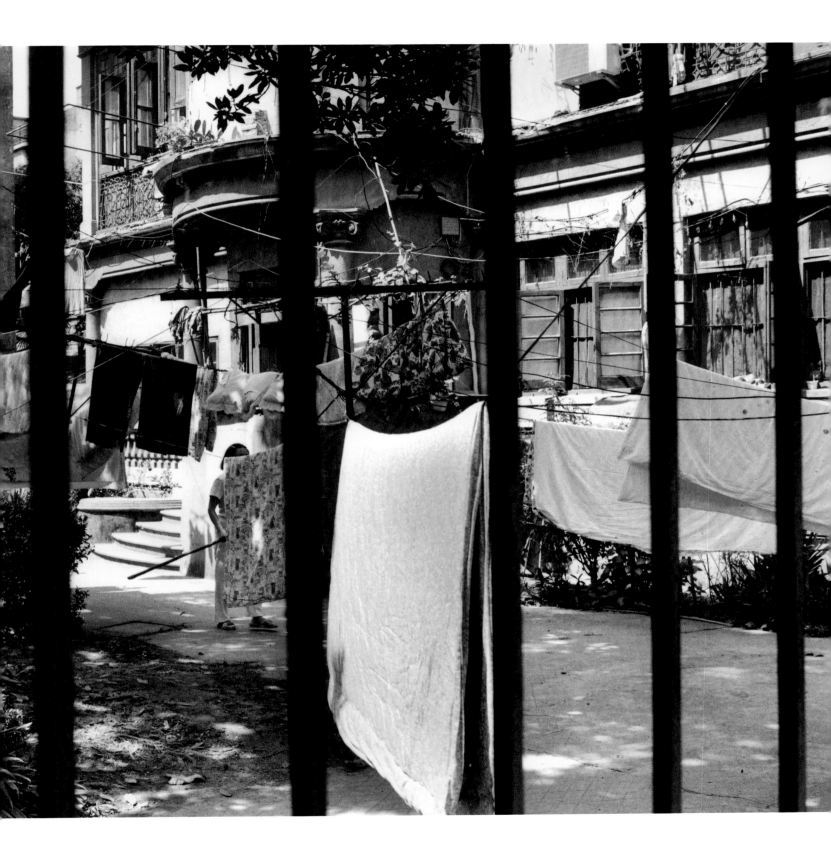

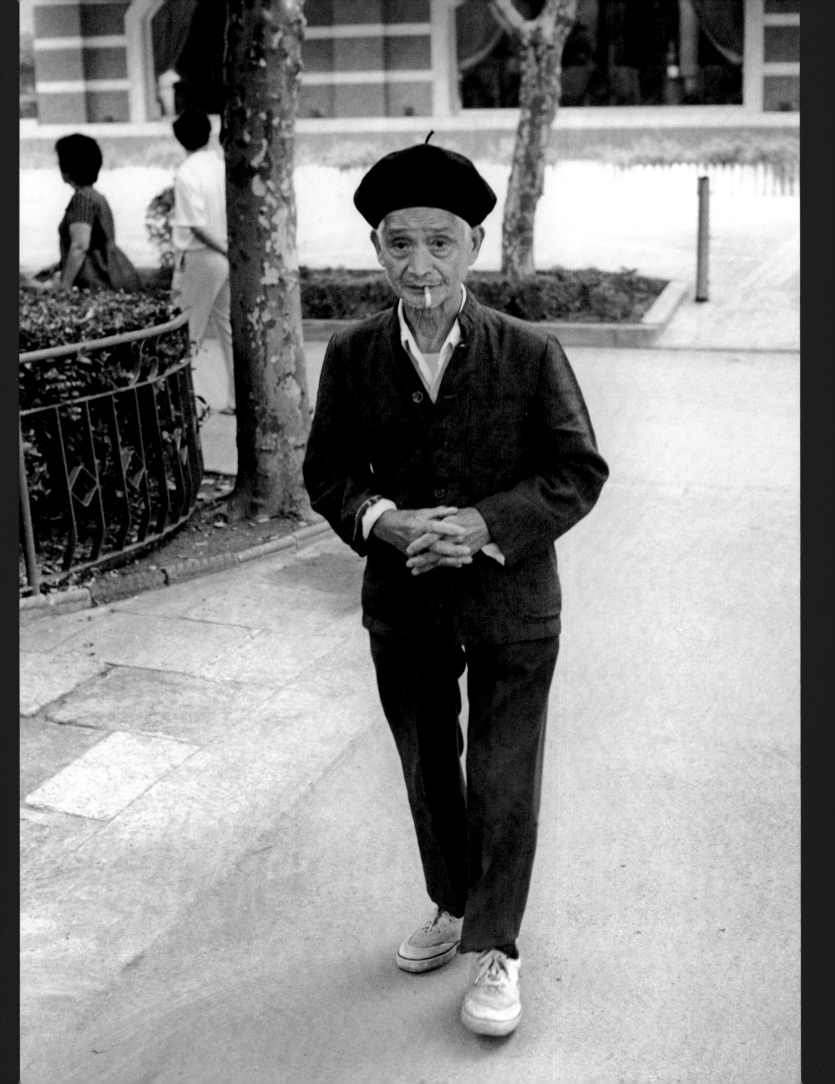

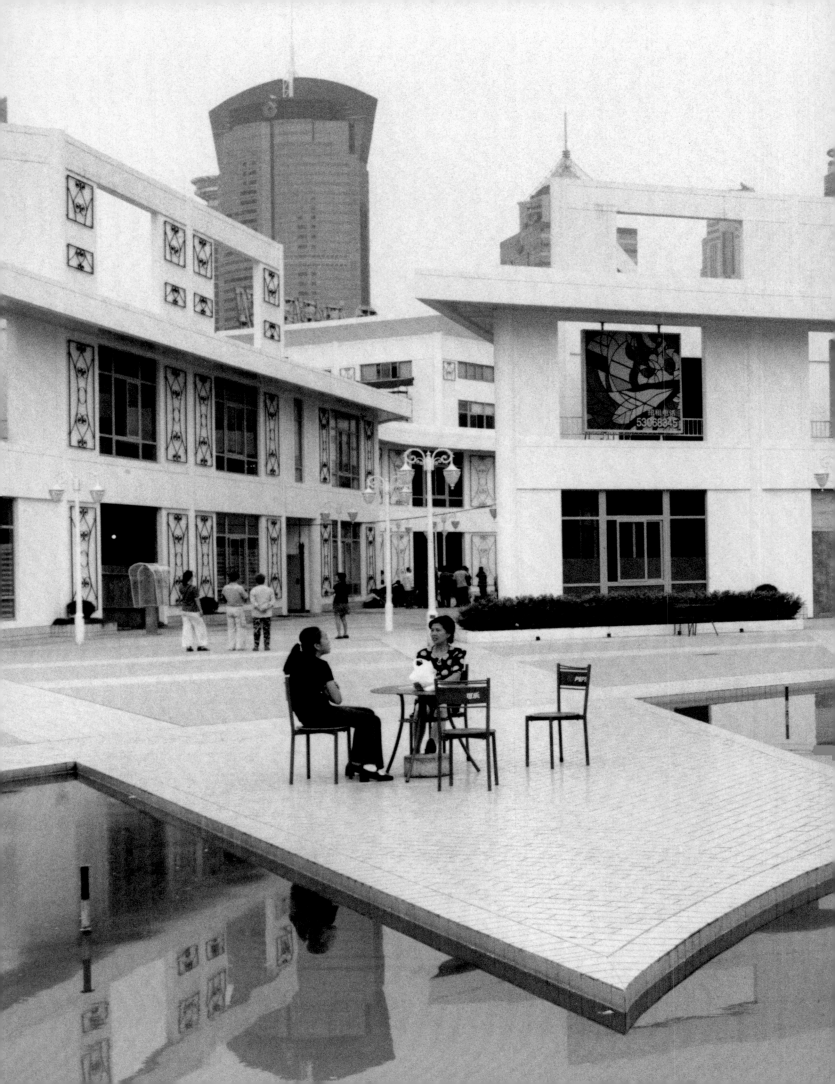

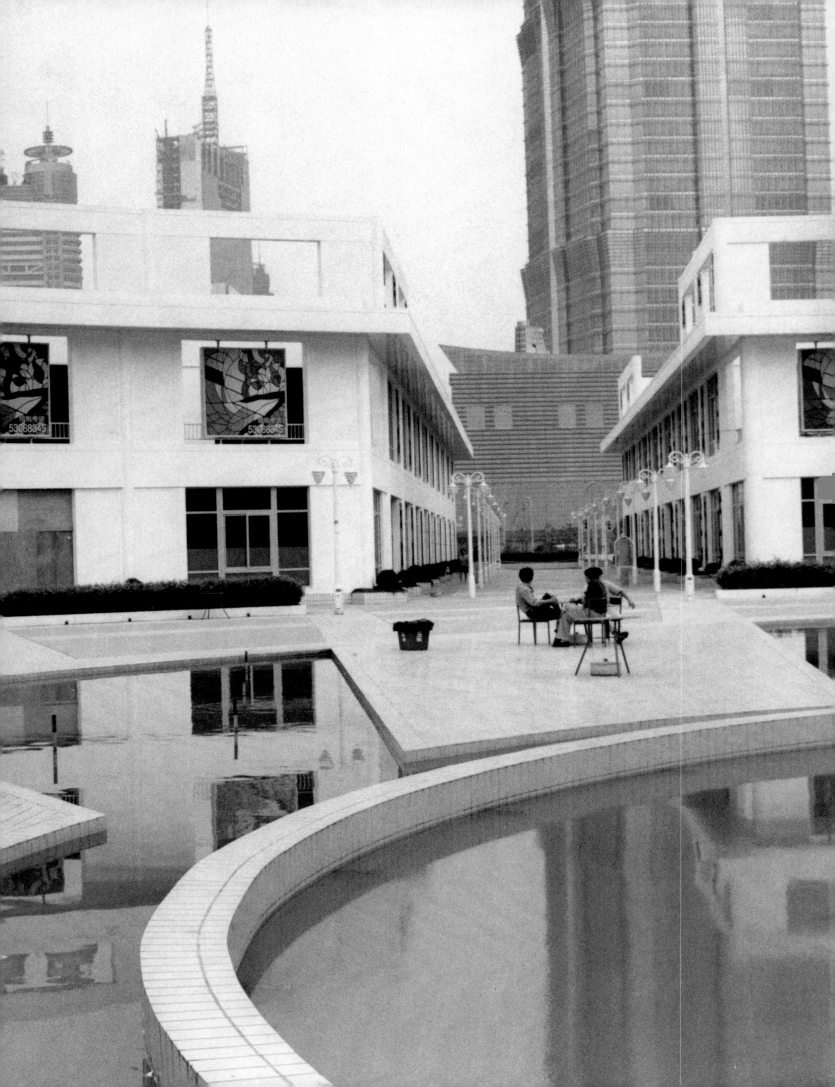

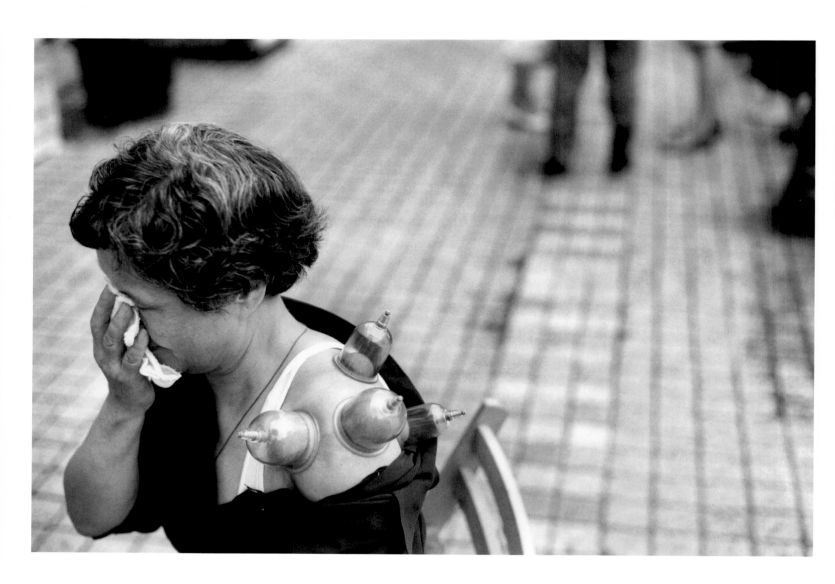

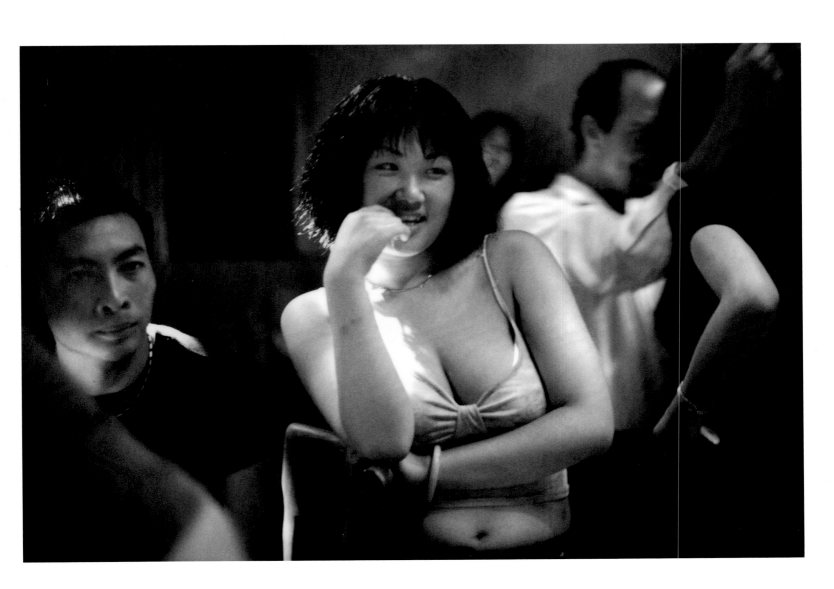

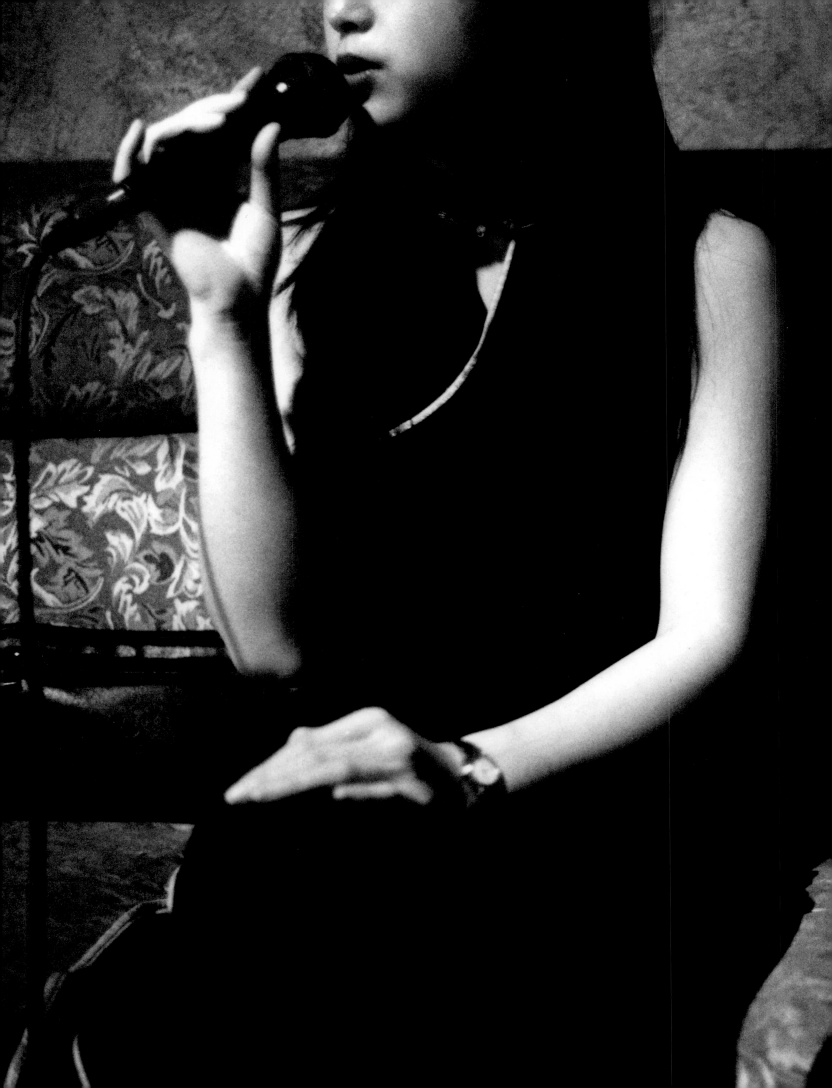

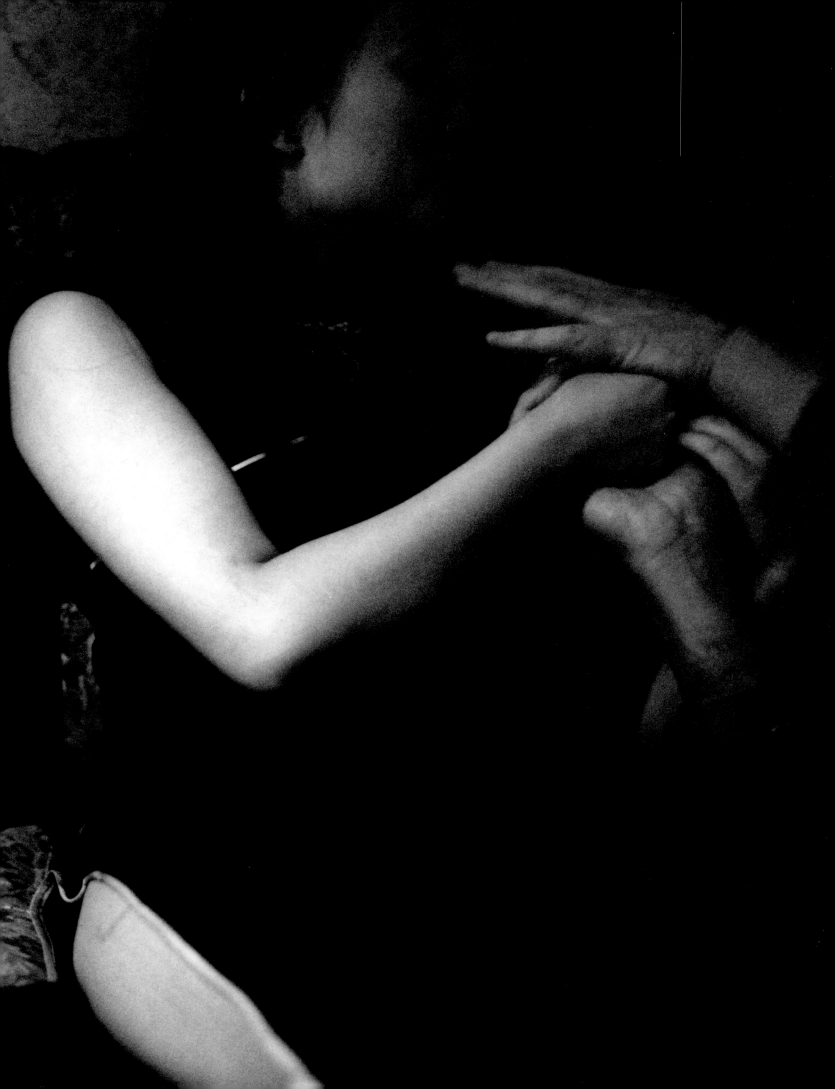

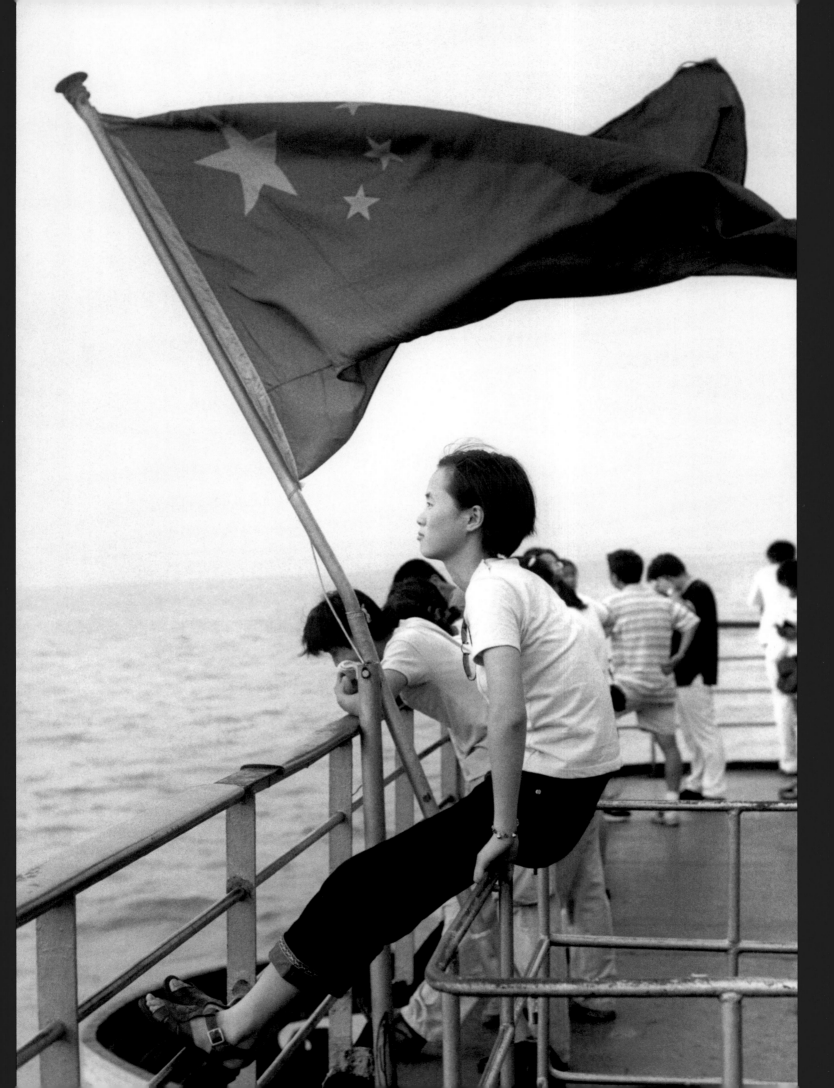

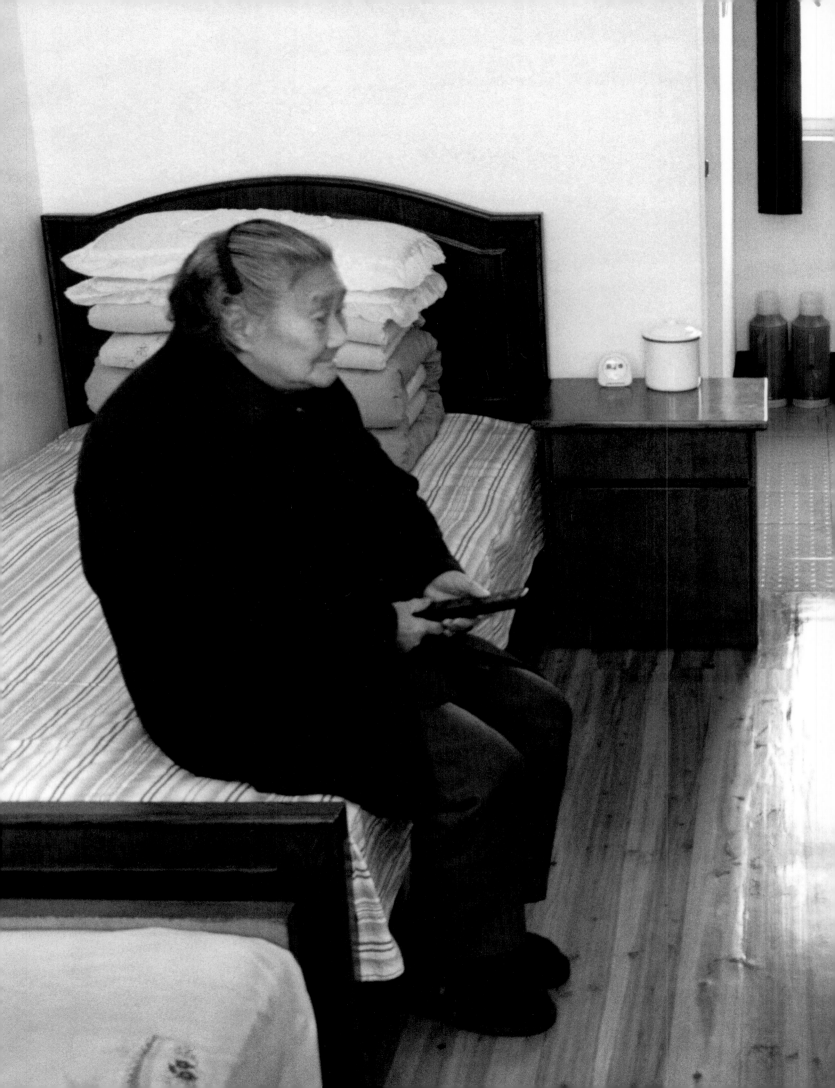

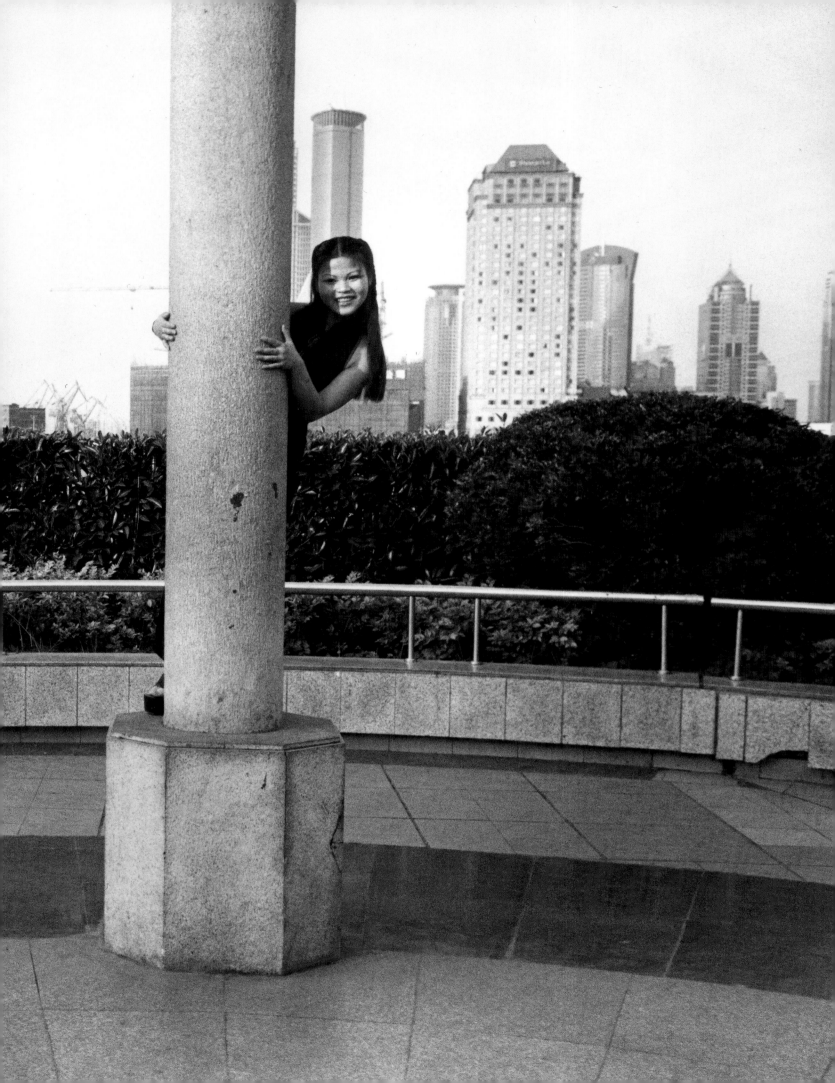

As dusk falls over Shanghai, tourists, primarily Chinese, gather on the Bund to look across the Huangpu river towards the lights of Pudong. The Bund fronted the International Settlement in Shanghai, founded in 1843, while the French Concession lay to the south, adjoining the Chinese city, and spreading out to the west. The whole area is known as Puxi, as distinct from Pudong across the river.

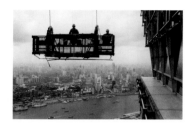

Window cleaners get a lift to the top of the Jin Mao building in Pudong. The elevated highway of Yan'an Zhong Lu can be seen snaking down to the Bund, while the dark area to the left is the site of the old Chinese city known as Nanshi.

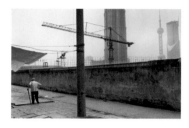

A quiet corner in Pudong. Twenty years ago Pudong was agricultural land growing vegetables and cotton, with only the river frontage built up. The former warehouses of the international companies that left in the 1940s fronted the river, mostly decayed or converted to light industrial use, while the shipyards had moved further down river.

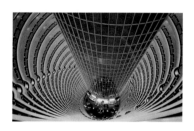

Inside the tallest building in Shanghai: the eighty-eight storey Jin Mao building, designed by the architects Skidmore, Owings and Merrill, and opened in August 2000. The Grand Hyatt Hotel occupies the top thirty-four floors with the reception on the fifty-third floor. The eighty-eighth floor is a visitors' observatory.

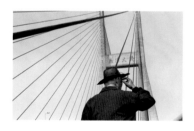

The Nanpu Bridge, opened in 1991, was the first of the two impressive cable bridges that now span the Huangpu river linking Pudong to the city. This is the southern, shorter one, that connects to the Zhongshan ring road completed in 1994. Sightseers can take lifts to the walkways that provide stunning views.

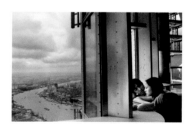

The observatory platform on the eighty-eighth floor of the Jin Mao building with the Huangpu river below. Eight is a lucky number in Chinese, and eighty-eight doubly so, therefore this is a very good place to make a proposal.

Laundry still hangs out to dry as traditional housing is torn down in Ruijin Nan Lu to make way for modern buildings.

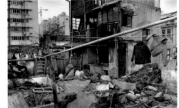

High-density, high-rise blocks tower over traditional-style Shanghai housing which will soon be demolished.

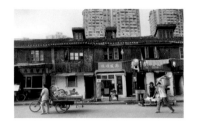

The view from the terrace of the Seagull Hotel looking out across the Huangpu river to the futuristic Pudong skyline. The hotel was built in 1985 as an addition to the International Seamen's Club. Just over the Waibaidu, or Garden Bridge, it is situated in the former American Concession, incorporated into the International Settlement in 1893.

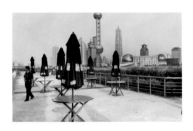

The Oriental Pearl TV tower and the Jin Mao building dominate the skyline of Pudong, seen from a roof garden behind the Bund. Work began on the Oriental Pearl TV tower in 1991 and it opened in 1994; the architect was Jiang Huan Cheng from the East China Architectural Design and Research Institute.

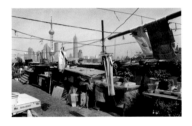

The Chinese flag flies on National Day from hundreds of buildings all over Shanghai. It was a Shanghai resident, Zeng Liangsong, who produced the winning design for China's national flag in a competition in 1949. The large star represents the Communist Party and the four smaller stars are the four classes as originally defined by Mao Zedung: workers, peasants, petty bourgeoisie and patriotic capitalists. Mr Zheng was still living in Shanghai in 2000, aged eighty-three.

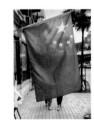

The Military Police Commanders Academy in a northern suburb of Shanghai.

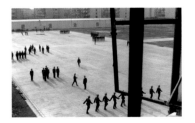

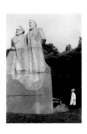

Marx and Engels dominate a corner of Fuxing Park. Erected in 1985 to the design of Zhang Yong Hao, this popular work can be seen in many Chinese cities. While the famous sculptures on the Bund, like the Angel of Victory, were destroyed by the Japanese during the Occupation, the sculpture in Fuxing Park, in the French Concession, survived more or less intact until the Cultural Revolution. 1985 marked the beginning of the return of sculpture to Shanghai.

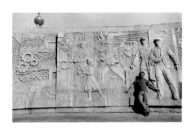

The Monument to the People's Heroes in Huangpu Gardens was begun on 31st December 1988 and completed 27th May 1994, the forty-fifth anniversary of Shanghai's Liberation. A tripartite concrete pylon rises from a sunken arena that contains a 120 meter carved frieze. Divided into seven sections, it commemorates the People's struggles between 1840 and 1949. In the final panel the people of Shanghai welcome the People's Liberation Army, the PLA. This is a popular area for football and sunbathing.

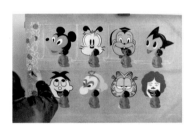

Artist Ji Wenyu, whose work is handled by ShangArt, engaged on a painting in his new home-cum-studio. The familiar Western cartoon characters: Mickey Mouse, Fido, Sonic the Hedgehog, Garfield and Ronald MacDonald are joined by three Chinese characters: Boshi Wa (Dr. Kids), Wong Wong, which translates as 'doubly great,' or 'prosperous,' and the most venerable, the ingenious, magical Monkey King. Boshi Wa and Wong Wong are the brand names of joint ventures making products for children.

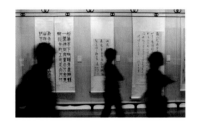

The Gallery of Calligraphy, Shanghai Museum.

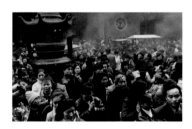

The Jade Buddha Temple during the Spring Festival, or Chinese New Year as it is known in the West. The diversity of Shanghai's population can be seen in the faces of those crowding into the Temple. According to the 2001 census there are fifty-four ethnic groups in the municipality.

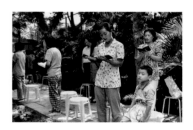

Shanghai Community Church in Hengshan Lu has welcomed all members of the Christian faith since it opened in 1925. There are two Sunday services, both attract a large congregation with overflow rooms filled to capacity. Close-circuit television screens enable the overflow congregation to participate in the service, while other members of the congregation prefer to worship in the extensive gardens.

The Venus Plaza Wedding Studio. The fashion for Western white weddings became popular among affluent middle class Chinese in the 1930s, and reappeared in the late 1980s. You will find the bride is still wearing traditional red shoes for good luck.

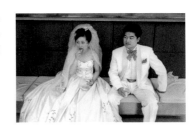

A father holds his newborn baby boy in the Shanghai Medical Obstetrics and Gynaecological Hospital. Deng Xiaoping introduced the 'one child' policy in 1979 – a complete reversal of Mao Zedung's policy that had promoted large families. Although accurate statistics are hard to come by, the current estimate of 117 male to 100 female births means that in twenty years' time this little boy will find getting a girlfriend is hard work.

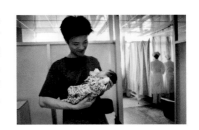

A 'three-car family': parents are being urged by the government not to spoil their 'little emperors'. With only one child for parents and grandparents to dote on this is not surprising and the market for child-orientated products is booming. Many children find it difficult when they discover they are not the centre of everyone's world. Yet when a family's hopes are all pinned on one child, there is also tremendous pressure on them to do well, which can be unrealistic and unfair.

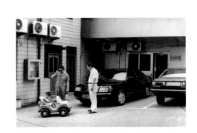

A small boy wearing an oversize NASA space suit while being photographed beside the Chinese 'Long March Number 3' rocket, at the Zhongshan Park rocket exhibition.

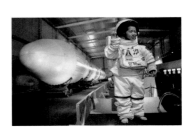

A seminar in progress on the lawns of Fudan University; the Mathematics Building is in the background. Founded in 1905 as a school, Fudan became a university in 1917 and is today one of China's top universities.

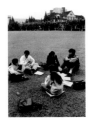

At the Shanghai Arts Kindergarten a student waits his turn for a piano lesson. It seems that in China, as in the rest of the world, piano lessons are more popular with parents than with children.

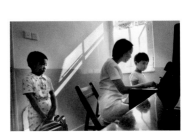

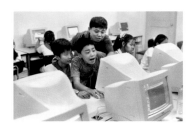

Young Pioneers at an after-school club enjoying a computer class. Known as 'Children's Palaces', there are thirteen of these arts and recreation centres in Shanghai. Each year some 250,000 children under sixteen attend classes in dance, music, crafts, calligraphy – and computers.

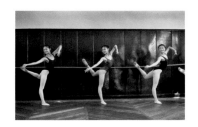

At the Shanghai Dance School students learn classical ballet and the many traditional Chinese folk dances. Formerly Chinese opera had many regional variations, but now the Beijing and Shanghai styles predominate. During the Cultural Revolution Mao Zedung's wife, Jiang Qing, promoted a new style of opera, *Yang Ban Xi*, or good example opera, which is rarely performed today. It is interesting that this 'revolutionary' opera involved dancing with blocked ballet shoes in the Western manner.

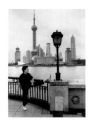

Morning exercises on the Bund. The distinctive balconettes overlooking the Huangpu are part of the new Bund embankment which was completed between 1991 and 1993. The Bund was enlarged by reclaiming land from the river, a process that began in the 1960s, and was later embanked. All the buildings visible in Pudong across the river have been completed since 1993.

Father and son relax beneath a statue by Yang Jian Ping, part of the beautification of the Bund after the completion of the new embankment in 1993. Up until the 1960s the Huangpu, a tidal river, had frequently flooded, submerging Nanjing Lu and leaving shipping stranded on the Bund.

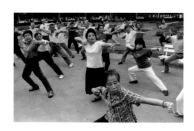

Around 6am each morning Fuxing Park begins to fill up. To the sounds of numerous cassette players, groups perform ballroom dancing, fan dances, *t'ai chi* and free-style exercises with great seriousness. This is continuing the tradition of communist collective activities. Exercises over, people walk around chatting and laughing which makes exercise very much a social activity.

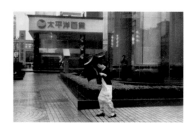

Typhoon! Heavy rain and the occasional typhoon occur during the summer months of June to August when it is very hot and humid. Due to climatic change and Shanghai's sheltered position, typhoons are now quite minimal and not as destructive as those experienced by Hong Kong or Taiwan. September and October are considered the best months in Shanghai, while winters are similar to those in southern England, which may seem surprising given that the city is on the same latitude as Cairo.

National Day 2000 and it rained, and rained. The Chinese have a
tremendous capacity to enjoy themselves, in this case by getting even
wetter in the fountains on Renmin Square.

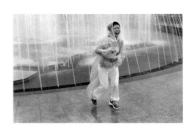

An early morning ballroom dance class on the Bund against the
backdrop of the Oriental Pearl TV tower and the Jin Mao building.
Ballroom dancing became popular during the 1980s and is either a form
of exercise or a competitive sport, not the social activity it was originally.

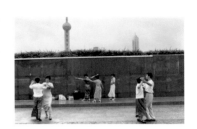

The American Ballet Theatre company in rehearsals for *La Bayadère* at
the Shanghai Grand Theatre with the resident orchestra, the Shanghai
Broadcasting Orchestra. Some young Shanghai dancers took minor roles
in this production and were able to experience first hand working with
one of America's most prestigious ballet companies.

The cloakroom at the Shanghai Grand Theatre. Designed by
Arte-Charpentier and opened in 1999, the Opera House, as it is
generally known, contains one large auditorium seating 1600 and two
smaller concert halls.

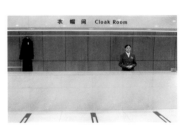

In Fuxing Park an informal choir gathers to sing from word sheets fixed
to a makeshift frame. Many of the Fuxing Park musicians transcribe music
and lyrics from tapes to share with their friends, especially Chinese opera.

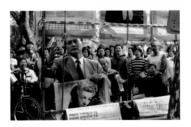

In Fuxing Park a group of friends meet to sing and play traditional Chinese
music. Here is the *erhu*, a two-stringed fiddle where the bow plays
against the inner edge of the strings, rather than the outer as with a violin.
Chinese music notation is a numerical system but increasingly Western
notation and music are being adopted.

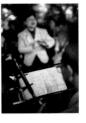

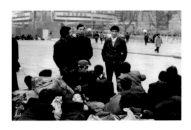

Migrant workers at the railway station, part of Shanghai's 'floating population' estimated at 3.4 million in 1997. Some are agricultural workers who come to the city illegally, seeking work during the winter months. Workers in China need permission to reside, called *hukou*, and if they wish to move they must get permission first. The effects that these restrictions on the movement of labour are having on the Chinese economy is the subject of some debate, and changes are currently being considered.

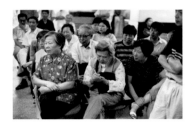

There are said to be 60 million shareholders in China getting a direct taste of capitalism. Here, at the end of the trading day, investors are briefed on the day's stock market movements by their broker. For the elderly and workers who have been laid off, the stock exchange provides not only a potential source of income but a social centre with air conditioning and the thrill of gambling. As yet investors pay no capital gains tax, whereas interest on savings is taxed at 20%.

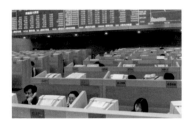

"Red vests" on the trading floor of the Shanghai Stock Exchange building in Pudong, which opened late 1997. The biggest in mainland China, the stock exchange was only re-established in Shanghai in 1990 but now has over 600 listed companies and is one of the largest in the Asia Pacific region. It is government policy to encourage people to be involved in the stock market, as many quoted companies are state-owned, or former state-owned, and in need of capital.

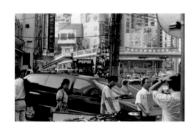

The Oriental Shopping Centre in Xujiahui, now a major commercial centre in southern Shanghai, but in the nineteenth century a small village to the south of the city occupying the only hill in the otherwise flat landscape. It was here at Siccawei, as it was then known, that the Jesuits set up a meteorological observatory and printing press which recorded their observations, among other things; for instance, in 1872 Shanghai experienced snow on six days of the year.

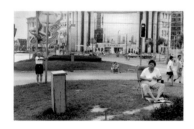

In summer the heat and humidity in Shanghai can be stifling. During the evening residents enjoy the green open space of the central reservation in Fuxing Dong Lu. This area is at the junction of the old Chinese city and the French Concession. The latter was famous for its plane trees that used to provide welcome shade in summer until they were swept away to widen the roads.

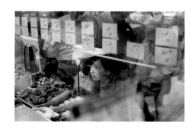

A queue at the *shu shi dian*, or 'scales shop' where one can buy ready prepared food to take home. Formerly this was only for special occasions, but now as people have more money and less time these 'convenience stores' are increasingly popular. The main meal of the day is supper eaten around five or six, while the lunch hour is between eleven and twelve.

A hot summer night and a family sit out on the pavement in front of their shop to eat the evening meal. A sign on the travel agency next door advertises trips and special offers for the summer season.

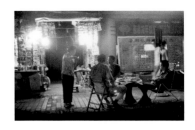

The Real Love Disco caters for predominantly Chinese 'bright young things'. The dance floor is packed until 2am most days of the week.

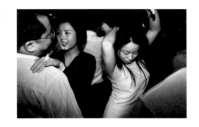

In a clothes shop in Nanjing Lu a line of European mannequins stand to attention, not unlike the grave offerings at Xi An. The large bin contains 'special offers'. Nanjing Lu is one of the busiest shopping streets in the whole of Asia and Shanghai throughout its history has been celebrated for trade and shopping. The first department stores in China, Sincere and Wing On, opened in Nanjing Lu in 1919 and one even contained an escalator, much to everyone's delight.

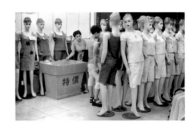

Fast Food is everywhere in Shanghai. From *bao zi* for breakfast: steamed bread-like dumplings filled with meat or vegetables, to tea eggs (*cha ye dan*) or glutinous rice (*zongzi*) wrapped in banana leaves or reeds, there is always something tasty to hand. Here the street vendor is frying Chinese pancakes (*jian bing*) made from shredded turnips, some flavoured with spring onions. Nanxiang steamed dumplings with vinegar are available opposite.

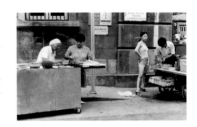

A group of wealthy Chinese chat at the opening of the new bar-restaurant, California Club, at Park 97.

A balmy summer's night outside Judy's Too in Mao Ming Lu. Local girls go to meet expatriates, and expatriates go to meet local girls and dance the night away. The action starts around midnight.

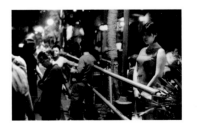

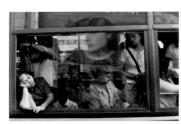

The bus home to the suburbs.

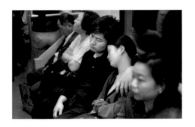

The metro, built at incredible speed by a German joint venture, has transformed the transport system. Metro Line 1 (opened 1995) runs north-south and Line 2 (opened 1999) runs east-west, crossing at Renmin Square. There is a third, Pearl Line, and an overground light railway called Track Line. For 3 RMB one can travel on 65 km of track, though the track has not yet crossed the river to Pudong.

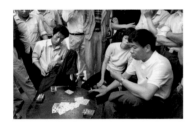

Start a card game and a crowd will gather. Spectators seem to get as much fun as the players. Whereas in Beijing the game will be Chinese chess and everyone gives advice, in Shanghai it's always cards and the crowd is as silent as the players.

The Shanghainese love their little white dogs, and also their laundry. All dogs have to be licensed, which costs 2000 RMB annually in the centre of Shanghai and 1000 RMB in the suburbs. Insurance is also necessary.

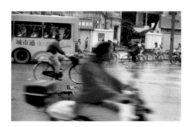

Evening commuters hurry to get home one rainy evening. Although normally the leader in transport revolutions, where bicycles are concerned Shanghai lost out to Tianjin, the location of China's first bicycle shop in 1915. Bicycles could not be purchased in Shanghai until 1932 when imported parts were assembled for the affluent few. In 1940 the Shanghai Forever Bicycle Company went into production and there are now over three million cyclists in Shanghai.

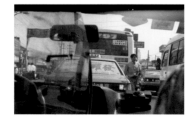

A traffic-jam seen from inside a taxi. A short journey in Shanghai costs 10 RMB. Taxi drivers can be both friendly and helpful. However it is unusual to find one who understands English so it is very useful to have written down in Chinese where you are going and your return address. Maps in English and Chinese are also handy.

The Shanghai Astronaut Universe Science Education Centre, Huming Lu, explains the development of the aeronautical sciences. Outside the Centre are parked a number of old aeroplanes, both military and civilian, that the children can explore.

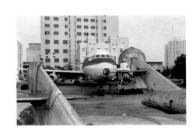

The steelworks in Baoshan on the outskirts of Shanghai cover a 20 km site. Nationwide the Bao Group employs 150,000 people but the Bao Steel Corporation about 11,000. The latter was floated on the A-share market in December 2000. One commentator declared this blue-chip, state-owned company would have a calming effect on the volatile Shanghai stock market: 'like a big ship coming down the line'.

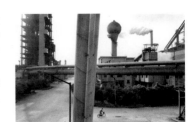

Working among the furnaces at Baoshan Iron and Steel, or Baosteel, China's largest and most profitable steelmaker. The company is a major producer of flat steel products, used by the motor industry among others. China is the world's largest steel producer.

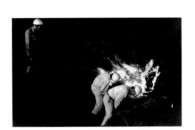

One of the 250 Buick cars that daily come off the production line at the New Century plant in Pudong. This state-of-the-art factory went into production in April 1999 as part of a joint venture between General Motors of America and the Shanghai Automotive Industry Corporation (SAIC) to produce upmarket cars for the Chinese domestic market.

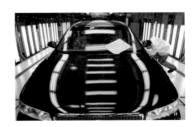

The Italian owners of the *Maddalena D'Amato*, a Panamax bulk carrier, at the launch ceremony. The ship is named after Signora D'Amato (centre). This is one of seven ships that the D'Amato di Navigazione S.P.A. are having built by the Hudong Shipbuilding Group. In April 2001 Hudong merged with Zhonghua Shipyards in Shanghai to form the largest shipbuilding base in China.

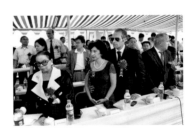

Hudong Shipyard: the launch of *the Maddalena D'Amato* on the 16th of September, 2000.

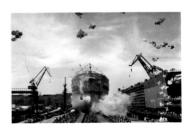

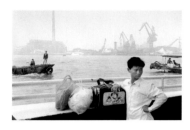

There are still numerous ferries that cross the Huangpu river and until the late 1980s this was the only way to reach Pudong. This young traveller has on his bag pictures of Princess Huan Zhu from the highly popular film of the same name *Huan Zhu Ge-Ge* (1999); a Hong Kong-China production. This is one of those films that has everything – action, comedy, songs, historical drama; and all the most interesting characters (good and bad) are female.

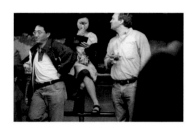

Outside the former Manhattan Bar in Julu Lu which claimed to be the oldest in Shanghai. Those with a taste for historic bars can visit the former Shanghai Club on the Bund, now partly occupied by the Dong Feng Hotel. Enter the former Club lobby and turn left though the surviving Smith's Patent swing doors and you will find yourself facing what was once the longest bar in the world, now a Kentucky Fried Chicken outlet.

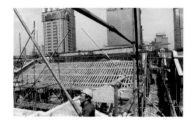

Elements from old *shi ku men* housing have been incorporated into new, low-rise buildings with trees and landscaping in Xin Tian Di. The mixture of housing, shops and restaurants is proving very popular with residents and tourists alike. Foreigners in particular find the scale of the development pleasing as the contrast between the narrow, crowded *li longs* and the neck-straining skyscrapers in Shanghai can be exhausting.

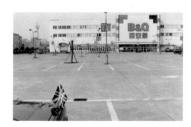

The British Consul General, Paul Sizeland, and his team visit the main branch of B&Q in Shanghai. The empty appearance of the carpark is misleading. B&Q, the first building materials joint venture in China, already has two home improvement centres in Shanghai with plans to open another five by 2005.

A security guard blocks the photographer's entrance to a 'new community village' – a housing development in the Mayfield district of Pudong, built in the early 1990s with government aid but now owner-occupied. Since 1991 the government has been promoting home ownership and trying to divest itself of the role of landlord.

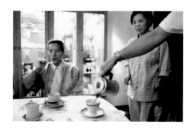

The acclaimed Shanghai miniature sculptor, Zhou Changxing, takes coffee at a friend's house. It is considered very westernised for people of his generation to drink coffee. Since the appearance of Starbucks Coffee in Shanghai in 1999 coffee shops have become popular places for the young to meet. Loose and comfortable clothing in the form of pyjamas are often worn indoors in Shanghai, as in the 1920s, and wearing them out of doors is not uncommon, especially in the summer.

Newly planted trees are wrapped up with rope to protect them from the cold and insects. During the winter, trees from warmer climates such as the camphor tree are also protected. In 1998 a project began to give all trees in Shanghai an identity number and most are now 'card-carrying' trees. An ambitious tree-planting scheme is underway and in places like Yan'an Zhong Lu, houses along the roadside are being demolished to make way for trees.

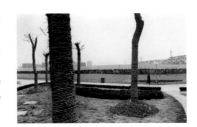

A family play cards in their spacious farmhouse on Chongming Island; the God of Wealth presides. This popular deity is frequently found prominently displayed in the living room, or on the front door of Shanghai homes.

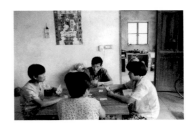

Pudong in February. Soon after the breakup of the agricultural communes in 1985 many farmers, especially in Pudong, found they were able to sell their land very advantageously to developers. The farmland that they kept in Pudong is now mostly worked by tenant farmers who have moved in from the provinces and rent small, one acre plots. They grow produce to sell in the free markets in Shanghai which is only a 30-40 minute bicycle ride away.

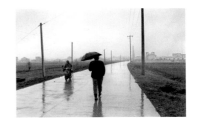

After 1949 all land and buildings belonged to the State. Large villas belonging to foreigners and the Chinese bourgeoisie were either confiscated or their owners relegated to a backroom while several other families moved in. Since 1991 some descendents have been able to buy back their properties.

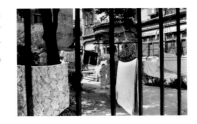

An elderly man sporting a beret in the former French Park, now Fuxing Park. He is wearing the so-called Sun Yat-sen suit, a single-breasted jacket with soft collar and four large pockets, adopted as the modern Chinese male costume after the 1911 Revolution in place of the long gown. Before 1911 the Chinese male costume had no pockets.

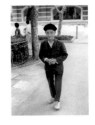

Lujiazui Food Corner in Pudong provides space age surroundings for Shanghai's favourite entertainment: eating out.

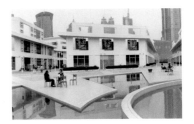

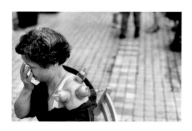

Visitors to Shanghai have always commented on the wide range of activities that go on outside in the street; everything is to be found including Chinese traditional medicine. Here glass suction cups are placed on the shoulders and back of this rheumatism sufferer to draw out the negative energy: 'the fire and bad blood'.

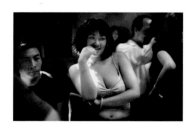

A wild and exuberant party marked the opening of the new bar-restaurant, California Club, at Park 97 in October 2000.

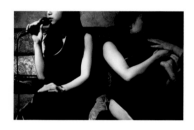

Jacqueline playing in an up-market karaoke bar that is popular with Japanese businessmen in Huashan Lu. Karaoke was imported from Japan in the early 1980s and has been popular ever since in Shanghai. Karaoke bars contain numerous private rooms where parties of friends can sing and drink – though not so private as all have glass windows onto the public corridors. The karaoke hostesses continue some of the traditions of the geisha girl, singing and entertaining tired businessmen.

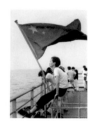

A young girl travels back to her studies in Shanghai from her parents' home on Chongming Island. The silt-created island at the mouth of the Yangzi is famous for its small and very tasty crabs available in the local restaurants. They breed out at sea but live in the fresh water of the many rivers and inlets on the island.

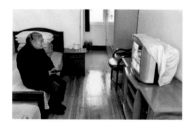

At the Old People's Home in Tan Zhi, a small town near Pudong in Nan Hui county, each of the thirty-four residents pay 500 RMB per month to share a double room. The home has been built by the local community. As a consequence of the 'one child' policy many of the increasingly ageing population will have no relatives to care for them in old age and many more homes like this will be needed.

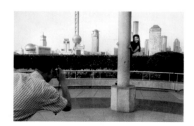

On the Bund a young Chinese tourist poses for her photograph.

The editors provide the following notes in the hope that they will clarify some points that might otherwise confuse the reader. However, they are only too aware that well-intentioned attempts at simplification often only lead to greater confusion.

Shanghai, like Beijing, is one of the four municipalities in China. The official population figures for the year 2000 are 16.7 million for the municipality of Shanghai, which covers 6,340 sq km, and for the city itself, 11.3 million in an area of 3,924 sq km. (These figures may underestimate the total population.) By comparison, Greater London covers an area of 1,590 sq km and has a population of 7.3 million. Shanghai municipality includes small towns like Tan Zhi and much agricultural land, as well as Chongming Island. This book covers the city of Shanghai and the municipality.

Many streets in Shanghai are laid out on the grid system and can be of considerable length, so they are often divided into *Zhong* middle, *Bei* north, *Nan* south, *Dong* east and *Xi* west; hence *Nanjing Dong Lu* (Nanjing Road East) is continued as *Nanjing Xi Lu* (Nanjing Road West). Streets bear the names of towns and cities in China, though before 1949 many were named after individuals.

Pinyin is the official Chinese government romanization system for Chinese characters that evolved in the 1950s and was formally adopted from about 1979. It is now the world standard and a great improvement on the Wade-Giles system, hitherto the most comprehensive attempt to transliterate the sounds of Chinese characters into a readable form. This is a difficult task as Chinese has many sounds that do not occur in Western languages, and since each character can have five different sounds, without the tone marks it is hard to transliterate *pinyin* back into Chinese. Non-English speakers had also evolved their own forms of transliteration, particularly in Shanghai which had such an international population. Hence Pootang and Putong, Soochow and Suchow, and Whangpo are found for Pudong, Suzhou and Huangpu.

In the text the *pinyin* system of romanization has been used instead of the earlier Wade-Giles, except in the case of names that are considered so well-established that they maintain their Wade-Giles style, such as Sun Yat-sen and Chiang Kai-shek. Thus Nanking becomes Nanjing, Paoshan becomes Baoshan, and Peking Beijing. In the Chronology places have been referred to by the name that they were known to Westerners at the time. This may seem confusing but the aim is to help readers consulting other, earlier publications. Some authors continue to use Wade-Giles, such as the ongoing *Cambridge History of China*. The U.S. Library of Congress *Pinyin* Conversion Project currently in progress is tackling this complicated subject.

Although Mandarin Chinese is the official language based on the Beijing dialect, there are over fifty other dialects in China. Some, such as Cantonese and Shanghaiese (*Wu*), have great tonal differences: thus Siccawei in Shanghai, now officially called Xujiahui, is the romanization of the Shanghaiese place name. There are also words in use of non-Chinese origin, for example from the Manchu, Tibetan or Japanese.

As yet there is no consistency as to whether the characters are transliterated separately, or run together to form a word. Generally speaking, geographical names of two characters like *Bei Jing* or *Shang Hai* are run together, otherwise the characters are written as separate words, for example *li long*. The characters of given names, when transliterated, are written as one word.

In China the family comes first, before the given name, so it would be Mr Mao, or Chairman Mao, whose given name was Zedong (or Tse-tung in Wade-Giles). Married Chinese women keep their own family name, so Mao's third wife, Jiang Qing, was known as Miss Jiang. Many Chinese now add a Western name before their family name. This whole system creates difficulties when compiling bibliographies, particularly as sometimes the family name has been placed after the given name in the western manner to facilitate matters! This is one of the problems being addressed by the Library of Congress *Pinyin* Conversion Project, which can also be consulted online regarding the question of whether a romanized word is in *pinyin* or Wade-Giles. One tip is that Wade-Giles used hyphens whereas *pinyin* does not.

C13

Shanghai is already an important port in the region. The name translates as 'city floating on the water' or 'above the sea' a reference to its position on the flood plain of the Yangzi river delta, on the left bank of the Huangpu river where it is joined by the Wusong river (Suzhou Creek). The latter connects Shanghai with more ancient cities such as Suzhou, which is also the junction with the Grand Canal. 20 km from the mouth of the Yangzi, the longest river in China, the land surrounding Shanghai is flat and fertile, criss-crossed with many small streams, and the water table is very high.

1550s

The city walls are completed to protect against pirates and free-traders. This includes the Japanese and those who disagree with the Emperor's ban on foreign trade.

1590s

Hsu Kuang-ch'i (1562-1633) from Shanghai becomes the most important convert to Christianity at the Ming Court. A friend of the Jesuit missionary Matteo Ricci, he introduces the new religion to his home city and his granddaughter reputedly builds several chapels in Shanghai in the first half of the C17. Christianity later suppressed by the Kang Xi emperor (1662-1722).

1620s

Pian Yu-tuen creates a garden for his father inside the city, now known as the Yu Garden. In the 1750s it becomes the Western Garden of the Temple of the City Guardian.

1644

Manchu invaders overthrow the Ming dynasty and establish the Qing. Non-Manchu males are obliged to wear their hair tied in a plait, or 'pig-tail'.

1684

The British East India Company establishes a factory at Canton (Guangzhou) for very limited trading with China.

1715

The Merchant Shipping Association, Shanghai's earliest guild, erects its headquarters outside the East gate of the City. Textiles, primarily cotton but also silk, are the city's main product and the textile merchants build a teahouse adjoining what is now the Yu Garden. Some claim that this pavilion with its zigzag bridge is the source of the 'willow pattern plate' design so popular in the West.

C18

The establishment of Chinese-style banking facilities in Shanghai, dominated by clan members from Ningpo who establish a powerful guild. Over the years, this pattern of immigration and settlement in Shanghai is repeated by groups from other parts of China and, until the 1940s, from other parts of the world.

Late C18-early C19

British attempts to trade with China blocked by the Chinese government. Increasing amounts of illegally traded opium are used by Westerners to offset Chinese exports of tea, silk, etc. which have to be paid for in silver in the face of Chinese refusal to buy imported goods.

1840-2

First Opium War concluded with the Treaty of Nanking that designated Shanghai as one of the ports open to foreign trade and residence.

1843

The British Concession is mapped out between Suzhou Creek and the Yang King Pang Creek (now Yan'an Dong Lu). The Huangpu river frontage is embanked with a quay known as the Bund, a common feature in Anglo-Chinese ports.

1845-9

French attempt to reclaim the land held by the Roman Catholic mission in the C17 leads ultimately to the creation of a separate French Settlement between the Old City and the British Concession. The main Jesuit settlement at Siccawei, now Xujiahui, develops over the years to include an observatory, school, children's home and publishing centre, as well as a church – the headquarters of Roman Catholic missionary activities in China south of the Yangzi river.

1848

Holy Trinity Church constructed (timber-framed), but two years later the roof falls in, necessitating expensive repairs.

1849

The American Concession established on cheaper land north of Suzhou Creek, in the area now known as Hongkou. Missionaries as well as traders are involved.

1853

During the Taiping Uprising, another dissident group known as the Small Swords occupies the Chinese city in Shanghai and burns down the Chinese customs house. Subsequently the International Settlement takes on the administration of the Imperial Maritime Customs on behalf of the Chinese government.

1854

Foundation of Shanghai Municipal Council to administer what later becomes the International Settlement; it develops public health, police, and public works departments and is dominated by the British.

1858-60

The *Arrow* or Second Opium War culminates with the destruction of the Summer Palace in Peking.

Between 1850 and 1880 Chinese artists such as Chow kwa produce paintings of Shanghai, mainly of the Bund with shipping, for the export market. Chow kwa makes use of the new technique of photography to aid his compositions, but ultimately the panoramic photography destroys this school of painting.

1860

The Taiping attack Shanghai causing an influx of Chinese into the foreign settlements (and again in 1862). The Chinese Shanghai Municipality created from Shanghai County making, together with the International Settlement (from 1863) and the French Concession (from 1862), three municipalities in Shanghai.

1863

British and American Concessions merge to form the International Settlement where many other countries also have consulates to represent their nationals.

1865

The Hongkong and Shanghai Bank opens the year after it is established in Hong Kong. First gas company in China opens in Shanghai – there is gas street lighting on the Bund.

1866

The first telegraph line in China set up by the American trading company Russell & Co., Shanghai.

1866-9

Holy Trinity Church rebuilt to the designs of Sir George Gilbert Scott, modified by a local architect, William Kidner.

1868

The Public Gardens, now Huangpu Gardens, opened on reclaimed land; an area formerly known as the 'consular mud-flat' at the junction of the Huangpu river and Suzhou Creek where an abandoned hulk had encouraged the build-up of river silt.

1871

The Great Northern Telegraph Company lays marine cables between Shanghai and Hong Kong. First recorded use of the verb: 'to be shanghaied' – an American nautical term whereby a sailor on shore-leave is rendered unconscious and taken as crew on another ship. This is a double disaster for the victim as not only does he find himself on a ship no-one wants to crew, but he inadvertently breaks his contract, and loses the pay owed to him on completion of the original voyage.

1872

China Merchants' Steam Navigation Company founded to challenge foreign dominance in shipping. Complaints arise that the privately owned Willis Bridge over Suzhou Creek, now Waibaidu Bridge, charges Chinese pedestrians to use it but not foreigners. (In fact foreigners never pay cash for anything but sign a chit which is settled at the end of the month with the aid of a Chinese intermediary, or 'schroff'.) The Municipal Council pays for foreign pedestrians and it is not until a new municipal bridge is built that the crossing is free to all.

1874

First rickshaw imported from Japan.

1876

Completion of first stretch of railway line between Shanghai and Wusong in the face of Chinese government opposition. Track torn up the following year.

1879

St John's Missionary University established. The first modern textile mill in Shanghai established by Li Hung-chang; it is financed by Chinese capital and acquires the latest technology from America.

1882

Electric light in the Public Gardens, now Huangpu Gardens. The first public telephone in Shanghai is located on the Bund.

1883

Waterworks supply clean drinking water and also water for the fire brigade.

1885

Publication of *English Life in China* by Major Henry Knollys, which includes a chapter entitled 'Shanghai: A Model British Republic'.

1893

Tower added to Holy Trinity Church.

1895

Mrs Little starts the anti-footbinding movement. Sino-Japanese war ends in defeat for China and, by the Treaty of Shimonoseki, Taiwan is ceded to Japan. The Japanese set up textile factories in Shanghai, in the Hongkou area, and accelerate industrialisation. Up until now Shanghai has been primarily a trading port with profits invested locally in real estate. Increasing numbers of Japanese in Shanghai who by 1920 outnumbered the British by 2:1.

1896

First film is seen in China – in public gardens in Shanghai, probably at the instigation of the Lumière brothers. Imperial Post Office established in Shanghai replacing the existing six national post offices, each of which had had their own street names for Shanghai and methods of transcription for Chinese characters.

1897

The first Chinese-owned, Western-style bank, the Commercial Bank of China, opens in Shanghai.

1898

The French Concession and International Settlement enlarged. Failure of the 'Hundred Days of Reform' leads many Chinese reformers to travel abroad. Some, notably Sun Yat-sen, have already travelled widely in Europe and Japan. Many later choose to return to Shanghai as the most progressive city in China.

1899-1900

Boxer Rebellion and the Siege of Peking. Russia obtains a 25-year lease on Port Arthur and obtains concessions in Manchuria, now of more importance because of the railway.

1902

First motor cars seen in Shanghai – two Oldsmobiles. British and American tobacco companies in Shanghai merge to form B.A.T., rolled cigarettes having been introduced into Shanghai by the Americans in the 1890s. Textile and cigarette factories employ workers on a scale not found elsewhere in China.

1904-5

Japan defeats Russia and acquires Port Arthur and the Manchurian concessions.

1905

The Kuomintang, or Nationalist Party, founded by Sun Yat-sen.

1907

The new Garden Bridge, now called Waibaidu Bridge, replaces the earlier municipal bridge over Suzhou Creek. It is a prefabricated iron and steel bridge cast in Consett, England.

1908

Death of the Dowager Empress. The last Emperor Puyi, aged three years, ascends the throne. First trams in Shanghai, but regrettably high incidence of injury to passengers as the operating companies refuse to stop long enough at tram stops to allow passengers to alight with safety.

1909

The French Park opened, the design inspired by the gardens at Versailles; renamed Fuxing Park fifty years later. First aeroplane seen in Shanghai, piloted by a Frenchman.

1911

Fall of the Manchu, or Qing, dynasty. A republic declared with Nanking the national capital. The 'pig-tail' is abandoned.

The period 1911-1937

has been described as 'the golden age of the Chinese bourgeoisie' in Shanghai. Considerable rebuilding during this period, including a type of housing unique to Shanghai that had developed in the latter half of the C19, known as *li long* or alley housing, also called 'the lanes'. The plan is of narrow, pedestrian-only streets, entered through a gateway opening off a main street and containing terrace housing fronting the lanes. Each dwelling has an imposing gateway, *shi ku men*, literally 'stone gate', set in a blind wall. This gives access to a tiny courtyard with a two or three-storey dwelling behind. The buildings are an adaptation of Chinese vernacular housing with European architectural features, and mostly ouilt of brick. The Museum of the First Congress of the Communist Party is a good example of a *shi ku men*.

1911-12

Shanghai city walls levelled and moat filled in to create what is now Renmin Lu on the north and Zhonghua Lu on the south, following the lines of the old fortifications.

1912

Era of the Warlords begins, but this affects Shanghai only indirectly as it is a rural phenomenon. However the city already suffers serious problems from organised crime, which get worse over the years. The Anti-Kidnapping Society founded by Chinese merchants, one aim being to try to stop the trafficking in children of both sexes. China's search for stability and good government is hampered by Japanese encroachments.

1913

First film production company set up in Shanghai, which soon becomes known as the 'Hollywood of the East'.

1914

Jessfield Park, now Zhongshan Park, is opened; until 1949 it included the campus of St John's University. Yang King Pang Canal filled in and becomes Avenue Edward VII, now Yan'an Dong Lu. First trolley bus goes into operation in Shanghai. With the outbreak of the First World War, Japan takes the German concessions in China. War stimulates the already expanding economy in Shanghai with demand for raw materials and for locally made goods as foreign products are unavailable.

1915

The President, General Yuan Shikai, agrees to the Japanese 'Twenty-One Demands' that strengthen their hold on Manchuria and give them further economic concessions. The General declares himself Emperor, but dies the following year.

1917

China declares war on Germany hoping to get back the German concessions that Japan, one of the Allies, had annexed. The years following the Russian Revolution see an influx of destitute White Russian refugees into Shanghai – the first time that there has been a significant number of unemployed, or poor, Westerners in Shanghai. Russian bodyguards become *de rigueur* for Chinese gangsters and there are Russian night club hostesses and beauticians, as well as furriers and dress designers. The underworld in Shanghai is dominated by the Green Gang who control gambling, drugs and prostitution. One of their leaders, Du Yuesheng or 'Big-Eared Du' as he was known to associates, can be said to have raised money laundering to a fine-art form.

1919

The May Fourth Movement – Chinese students in Shanghai and elsewhere demonstrate against China's treatment at the Versailles Peace Conference, but the movement is more about reform in China and nationalism. Workers in Shanghai at the British-American Tobacco Company go on strike.

Shanghai is the centre for intellectuals and the avant-garde in China during the '20s and early '30s, and home to the most celebrated Chinese writer of the C20, Lu Xun, author of *The True Story of Ah Q*.

1920

The Security and Goods Exchange opens, but there had been active trading in stocks and shares in Shanghai since the 1880s.

1921

Workers in Shanghai at the British-American Tobacco Company go on strike, this time some 10,000 in number. The Communist Party is founded in Shanghai with the meeting of the first Congress of the Chinese Communist Party at 70 Xingye Lu (the building is now a museum). Mao Zedong is one of the delegates. Marxism and the class struggle offer an alternative to nationalism.

During the '20s and early '30s most of the buildings on the Bund are rebuilt for the second or third time. In 1923 the rebuilt Hongkong and Shanghai Bank opens. Perhaps the most splendid of them all, this now houses the Pudong Development Bank.

1925

Sun Yat-sen dies. Chiang Kai-shek becomes leader of the Kuomintang. General strike in Shanghai and boycott of British goods following the deaths of unarmed demonstrators, the May Thirtieth Martyrs.

1926

Civil war between the Communists and Nationalists (Kuomintang) for the next decade.

1927

General strike and massacre of Communists in Shanghai following an alliance between Chiang Kai-shek's Nationalists and the Green Gang with the collusion of the foreign community: the White Terror. The journalist Arthur Ransome, now best remembered as the author of *Swallows and Amazons*, visits China and his articles are republished in *The Chinese Puzzle*. He observes that for the British in Shanghai time has stopped in 1900 – it is as if the Great War had never happened.

1929

The first civil airline in China set up in Shanghai with an inaugural flight between Shanghai and Nanjing. Victor Sassoon opens the Cathay Hotel, now the Peace Hotel, an Art Deco masterpiece that for the next few years entertains all the celebrated visitors to Shanghai.

1931

Japan invades Manchuria.

1932

The Japanese attack Shanghai: the Zhabei district north of the railway station is razed to the ground in the face of spirited resistance from the Chinese. A young American airman, Robert Short, who has joined the Chinese air force as an adviser is shot down by the Japanese in an air-battle over Suzhou station. Japanese troops later withdraw from Shanghai. Hergé sets his latest Tin Tin adventure, *Le Lotus bleu*, in contemporary Shanghai (published 1934). Josef von Sternberg's film *Shanghai Express* with Marlene Dietrich and Anna May Wong packs cinemas in the West and provokes a protest from the Chinese government.

1934

The Metropole Hotel and Hamilton House (apartments) opened; they are developments typical of the period (architects Palmer and Turner). Broadway Mansions also completed. The Long March by the Communist army begins, ending 8,000 km later at Yan'an the following year.

1935

The city is plunged into mourning after the suicide of the twenty-four year old film star Ruan Linyu.

1936

Nationalists and Communists form an uneasy United Front against the Japanese.

1937

Japan takes Peking and occupies Shanghai apart from the International Settlement and the French Concession. 'Bloody Saturday' in Shanghai when the Chinese airforce in an unsuccessful attempt to bomb Japanese cruisers at anchor in the river hit Nanking Road (Nanjing Lu) and Avenue Edward VII (Yan'an Dong Lu) with a terrible loss of civilian life. For a picture of Shanghai at this time see the novel *Shanghai '37*, originally published in German, by Vicki Baum.

1939

Outbreak of Second World War. German Jewish refugees arrive in Shanghai.

1940

British troops withdrawn from Shanghai, and from China.

1941

The Japanese attack Pearl Harbour and occupy the International Settlement. The French Concession is under the control of the Vichy government and therefore nominally an ally of Japan. The Nationalists become the official ally of the United States. British and Americans in Shanghai interned; for a description of life in Shanghai at this time see J.G.Ballard *Empire of the Sun* (1984).

1943

Britain and America sign treaties with China ending 100 years of the treaty ports. 'Stateless persons' in Shanghai, namely German Jews, sent to live in a restricted area in Hongkou, part of the original American Concession.

1945

Sudden Japanese surrender ends World War II and the Sino-Japanese War that has cost over 20 million Chinese lives. Russia occupies much of Manchuria and gives support to the Communists. During the next eight months prices increase elevenfold in Shanghai. American troops are billeted in Shanghai and roads are changed from left to right-hand drive.

1946

Renewal of the civil war between Nationalists and Communists. Brief renaissance of the Shanghai film industry: *San Mao the Little Tramp* is a popular success (he still lives on today in cartoon books).

1947

General Marshall attempts unsuccessfully to reconcile the warring parties.

1949

In January, Peking falls to the Communists. 25th May the Communists take Shanghai without any opposition from the Nationalists. Mao Zedong declares the People's Republic of China. Chiang Kai-shek and the Nationalists flee to Taiwan (Formosa). During the late 1940s and early 1950s, exodus of foreigners and then of many Chinese residents of Shanghai.

1950

Outbreak of the Korean War. Tibet becomes an Autonomous Region of China.

1950-1

Suppression of Counter Revolutionaries involves liquidation of former members of Kuomintang, members of religious groups and proletarian 'secret societies' and unions.

1951

Private transactions in foreign currency, gold and silver are outlawed. Police raid Shanghai stock exchange to 'arrest speculators'.

1953

Shanghai workers not allowed to travel to other parts of China.

1955

Reorganisation of agricultural land into peasant communes, with the surplus to the State. Migration to the cities; the population of Shanghai swells and industrial depression and unemployment lead to new attacks on the private sector with the liquidation of counter-revolutionaries and landlords. For an insight into the lives of one Shanghai family – those who left and those who stayed behind: see Lynn Pan *Tracing it home: journeys round a Chinese family* (1992). Completion of the Sino-Soviet Friendship Centre in the grounds of what had been the largest private garden in Shanghai (the home of Silas Hardoon built in 1909) now the Exhibition Centre, and one of the most extraordinary buildings in Shanghai.

1956-7

Hundred Flowers Movement. Brief period of liberalisation that includes the promotion of criticism of the Party; many critics live to regret their words.

1957

Death of the celebrated singer and actress Zhou Xuan aged thirty-eight. Known as 'the golden voice', she had been the most popular singer in Shanghai in the late '30s and '40s.

1958

The Great Leap Forward sets unrealistic objectives for fast-track industrialisation; backyard steel furnaces are used to increase steel production. Government agricultural policy creates problems with food production and distribution followed by widespread famine 1959-62, with the unreported deaths of an estimated 30 million people.

1960

Russia withdraws aid from China.

1963

The cult of Chairman Mao propagated by *The Thoughts of Chairman Mao* – known as 'The Little Red Book' compiled by Lin Biao.

1964

Completion of Shanghai International Airport (Hongqiao). First performance of *The East is Red*, a new style of Chinese opera celebrating the history of the Chinese Communist Party and Chairman Mao. In Shanghai the army expands its role throughout society and helps with the harvest in Pudong and elsewhere in the municipality. 'Love the people months' to promote the popularity of the police. Militarisation of society a feature of the 1960s and '70s.

1965-8

The Cultural Revolution launched in Shanghai by Mao whose third wife, Jiang Qing, plays an active part. Violence and the destruction of the physical evidence of China's past ensue. For a moving eye-witness account see Nien Cheng *Life and Death in Shanghai* (1986). Anchee Min's *Red Azalea* (1993) gives another perspective.

late 1960s

Flood barrier built along the Bund.

1969

Campaign in Shanghai against the doctrines of Mencius and Confucius, which predates the national campaign orchestrated by Lin Biao. Rejection of Chinese cultural traditions and academics; the universities are closed for four years. China and Russia on the verge of war.

1971

Lin Biao, Mao's heir-apparent, dies in a plane crash, allegedly following an attempted coup against Mao. Visit of US table tennis team to China, so-called 'Ping-pong diplomacy'.

1972

President Nixon visits China.

1973

Jiang Qing with the three most prominent Shanghai leaders: Zhang Chunqiao, Wang Hongwen and Yao Wenyuan, form the Gang of Four and gain the upper hand in the struggle for power within the Party leadership during the last years of Mao's life.

1976

April Riots in Beijing following the death of Zhou Enlai, the widely respected leader of the Chinese Communist Party. In September the death of Mao Zedong aged eighty-three. The Gang of Four arrested.

1978

Deng Xiaoping becomes leader. Announcement of a huge steel works to be built by the Japanese at Baoshan.

1979

Promotion of one child policy. Four Special Economic Zones designated as an experiment to facilitate direct foreign investment and assess its impact; three of the cities are near Hong Kong and one adjacent to Taiwan. In Shanghai the Roman Catholic Cathedral at Xujiahui reopens.

1980

China is admitted to the International Monetary Fund and World Bank and begins to open up to foreign capital. The collective agriculture system policy is abandoned, and by 1985 the People's Communes have been disbanded.

1984

Economic and Technological Development Zones (ETDZs) established in fourteen coastal cities, including Shanghai, to facilitate the introduction of foreign capital and technology.

1985

Jiang Zemin becomes Mayor of Shanghai and officially inaugurates an ambitious 5-year plan for the city. Another key figure is the architect and vice-mayor from 1983 until his death in 1992, Ni Tianzeng.

1986

In Shanghai shares and bonds are traded once again after a break of nearly fourty years, although the Stock Exchange is not officially re-opened until 1990.

1988

Zhu Rongji becomes Mayor of Shanghai. Opening of the first Yan'an Dong Tunnel under the Huangpu river, connecting Pudong for the first time to the left bank, Puxi.

1989

Tiananmen Square Incident.

1990

Pudong New Development Area approved by Deng Xiaoping. The transport infrastructure is already under construction and the area attracts considerable foreign investment.

1991

The publication of *Wild Swans* by Chang Jung, chronicling the lives of three generations of a Chinese family, generates considerable interest in the West.

1995

Xu Kuangdi appointed Mayor of Shanghai. *Shanghai Triad* released, a film by Zhang Yimou set in the Shanghai underworld of the 1930s. MacDonalds opens its first fast-food outlet in Shanghai.

1996

Shanghai Museum opens (architect Xing Tonghe). Chen Kaige's film *Temptress Moon* set in Shanghai in the 1920s.

1997

Death of Deng Xiaoping aged ninety-three. Jiang Zemin becomes President. First terminal at the new Pudong International Airport opens. Britain hands back Hong Kong to China. New public library opens in Shanghai.

1999

Shanghai twinned with Liverpool. First direct flight London-Shanghai with Virgin Atlantic. Shanghai Opera House completed.

2001

China wins bid to host 2008 Olympic Games in Beijing.

This book would not have been possible without the generous and loyal support of Gerry Grimstone and the Grimstone Foundation. *Shanghai Odyssey* was his idea. He gave me a completely free hand to photograph what I wanted on my visits to Shanghai between May 2000 and March 2001.

I have only scratched the surface of Shanghai, but I hope that I have captured some of the atmosphere of this amazing city. The people of Shanghai are the most wonderful, gracious and friendly people; they make their city a fabulous, safe and friendly place to work in, and explore. Our book, I hope, will stimulate and surprise the reader and show Shanghai as it is, and what it has come to mean for me.

Patricia Reed acted as editor, compiled the chronology, checked the captions and fleshed them out with some wonderful detail. Jennifer Song has been our consultant editor: she has been my contact in Shanghai and was able to arrange translations and generally fix things up for me. She also did much of the research and her assistance has been invaluable. Both editors have given their time unstintingly and laboured long and heroically to the immense benefit of the book and the Foundation.

I owe a debt of gratitude to Frank Peng and Bob Xu, who were friends and colleagues of Gerry Grimstone at Schroders. Frank introduced us to the Information Office of Shanghai Municipality and both he and Bob couldn't have been more helpful.

Many thanks also to Mr Xia Dao Ling of the Xinhua News Agency Shanghai branch, and Senior Photographer of the Shanghai Overseas Chinese Photographers Association, and former Vice Chairman Judge of the World Press Photo Contest. Mr Xia was my 'fixer', he was able to get me access, and offered advice that was absolutely essential.

Shen Chun Xiao, otherwise known to me as Sam, was a great companion, translator, and friend. His immense enthusiasm, and willingness to learn was only matched by his desire to improve his English. Good luck Sam!

Special thanks must go to Beth Bluck: poet and public relations consultant in Shanghai, for her enthusiasm and advice.

Many thanks also to Fritz Hoffmann and his wife Tianran Wang of RedChop.com. Fritz is a Network colleague who runs, and indeed is, Network Photographers' Shanghai office.

Ms. Jiao Yang, Deputy Director of the Information Office of Shanghai Municipality, and Zhang Xiao-Yu, Division Chief, also Chen Zhi-Qiang and Xia Yi, Deputy Division Chiefs, and Zhang Yu, Section Chief: their co-operation and ability to cut through some of the red tape, sort out the paper work and allow me access was of inestimable value.

Thank you to Paul Sizeland, the British Consul General in Shanghai, and to his wife Vas. Paul was an enormous help with all things British in Shanghai. Thank you both.

Many thanks also to Geoff Howard, and Peter and Diane Baistow, long-standing friends, who advised on the picture selection; Theo Sykes, who helped with the picture selection, Jacob Sykes who tried to drag me away to France to ski, and Tallulah Sykes for making a crucial picture decision that I was unable to cope with.

Thank you to Roger Hutchings, a friend and colleague at Network Photographers, who looked at my picture sequence one evening, and who gave me good advice on picture sequencing over a bottle of wine, or two, which I in part followed; to my colleagues at Network Photographers, who gave me support and encouragement; and to all the staff who work incredibly hard for us, keeping the office running, and Network Photographers alive and well. Also to Neil Burgess for his assistance, and to Chris Boot who introduced us to Dewi Lewis.

Not last, and not least, thanks are due to Jonathan Towell and Nicoletta Stefanidou of Black Sun plc who designed Shanghai Odyssey.

Glen Brent did a great job making all the prints for this book. All my film was processed by Genesis in Chelsea.

The editors would also like to extend their personal thanks to Johnny Reed and Eveline Loh of Wilmington Capital Limited, Shanghai office, and to Pamela Li in Shanghai, for their general help, support and good company; and they are most grateful to Alex Woodhatch, Jean Cootes, Dr Patrick Connor, Tony McIntyre, Peter Khoroche and Dr Barbara Heinzen who kindly answered specific queries relating to the text.

In the course of working on this book I photographed, and made, lots of friends. All asked for nothing in return. Thank you.

Sponsored by the Grimstone Foundation:
U.K. Registered Charity No. 1069550

Editor: Patricia Reed
Consultant Editor: Jennifer Song

Designer: Nicoletta Stefanidou
Black Sun plc
9 Burlington Lodge Studios
Rigault Road
Fulham, London SW6 4JJ
email: jtowell@blacksunplc.com
website: www.blacksunplc.com

First published in the United Kingdom in 2002 by

Dewi Lewis Publishing
8 Broomfield Road
Heaton Moor
Stockport SK4 4ND
+44 (0)161 442 9450

www.dewilewispublishing.com

ISBN: 1-899235-14-0
Printed in Italy by EBS, Verona